Creative Flash Photography

Tilo Gockel

Creative Flash Photography

Great Lighting with Small Flashes

40 Flash Workshops

rockynook

Tilo Gockel (fotopraxis.net)

Editor: Joan Dixon
Translator: Jeremy Cloot
Copyeditor: Jeanne Hansen
Layout: Jan Martí, Command Z
Cover Design: Helmut Kraus, www.exclam.de
Printer: Friesens Corporation
Printed in Canada

ISBN: 978 1-937538-46-0

1st Edition 2014
© 2014 by Tilo Gockel

Translation © by Rocky Nook, Inc.
802 E. Cota Street, 3rd Floor
Santa Barbara, CA 93103
www.rockynook.com

This is an authorized translation of the German 1st edition © 2013 by Galileo Press GmbH. This translation is published and sold by permission of Galileo Press GmbH, the owner of all rights to publish and sell the same.

Library of Congress Cataloging-in-Publication Data

Gockel, Tilo.
 Creative flash photography : great lighting with small flashes: 40 flash workshops / by Tilo Gockel. -- 1st edition.
 pages cm
 ISBN 978-1-937538-46-0 (softcover : alk. paper)
 1. Electronic flash photography. I. Title.
 TR606.G63 2014
 778.7'2--dc23
 2014013449

Did you know that I am an available light photographer...?
I look in my bag, see that my Vivitar 285 or Sunpak 180j or
Nikon Speedlite is available to me and I use that.
~ Zack Arias

You've gotta taste the light. And when you see light like this, trust me,
it's like a strawberry sundae with sprinkles.
~ Joe McNally

Table of Contents

What Every Strobist Needs to Know

The Fun Starts Here!
40 Lighting Workshops

Workshops 1–13:
Portrait and Fashion

Workshops 14–17:

Macro with Flash

Workshops 18–24:

Still Life and Product Shots

In Depth Tutorials

Appendix A:

Appendix B:

Appendix C:

Appendix D:

Index

Author's Foreword

Maybe you feel the same way I did when I first came across flash. I was certainly skeptical and had the harsh look of the typical mug shot in mind, and I had reservations about tackling the technology. My first flash was a computer flash with functionality that eluded me. But after I repeatedly saw the fantastic images by David "Strobist" Hobby, Zack Arias, Joe McNally, Ryan Brenizer, and Neil van Niekerk, my curiosity got the better of me. The Strobist blog (strobist.blogspot.com) and David's Lighting 101 and Lighting 102 tutorials offered a perfect introduction to the world of flash technique. I am especially proud of the fact that the "Strobist" himself has contributed an exclusive foreword to this book. Thanks, David—this book probably wouldn't exist without you!

I quickly learned that flash doesn't have to automatically kill an image with bright light, red eyes, and hard-edged shadows. In fact, it is more like a pocket sun that can—with a little practice—be used to emulate and enhance natural light in a range of situations. I soon began to keep a diary of the lighting setups that are now part of this book. It includes lighting diagrams, the photos that resulted from each session, and a wealth of information describing how I took each image.

The book is divided in two main sections. Part 1 contains a crash course in basic flash technique. There is also an introduction to the flash gear I have found useful over the years, which I hope will save you the time and money I spent trying out a lot of useless accessories.

Part 2 contains 40 workshops with detailed explanations of various flash scenarios, including people, portraits, high-speed flash, macro, products, food, and more. The workshops highlight specific lighting and flash techniques—such as cross lighting and high-speed sync, or dragging the shutter—and give you a solid set of tools that will allow you to light any scene effectively. The techniques range from the simple use of your camera's built-in flash to stroboscopic setups with seven or more off-camera flashes. Other sections address techniques such as pseudo-HSS/Supersync, key shifting, infrared triggers, projecting patterns with gobos, and much more. Things get really interesting when you begin to practice and combine the techniques to develop your own unique style.

I have never found an adequate explanation of how to precisely and easily calculate an exposure when using both flash and ambient light, so appendix A contains real-world sample exercises (and solutions) to help you get the hang of calculating exposure values and guide numbers. Although these exercises might seem uninspiring, they will help you learn how to precisely produce the lighting effects you like. Appendix B introduces some useful tools for creating lighting diagrams. Additional appendices contain a valuable list of additional resources and a glossary of useful terms for the strobist.

Because I am a Canon user, you might find this book somewhat specific to Canon gear, although I refer to the Nikon equivalents wherever possible. Gear manufactured by Metz, Pentax, and others is just as effective as the equipment I describe, and as soon as you switch to manual mode you are free to use whatever brand you want anyway.

And now I wish you great lighting and a constant stream of wow moments with your own flash images.

Tilo Gockel

Please send your comments, criticisms, and other feedback (including inquires regarding the models shown in this book) to kontakt@fotopraxis.net.

Foreword by David Hobby

I was seven years old the first time I can remember using a camera. It was 1972. We were at a family reunion, and my uncle let me use his new Canonet G-III. To me it seemed like magic, and I was hooked. Just one year later I had my own camera and a small darkroom in a shed in my backyard. Watching an image appear in the developer tray was yet more magic. From that point on I was rarely seen without a camera in my hand. In high school, a staff position on the class yearbook meant two things: first, I had license to explore the school with my camera; second, someone else was paying for my film. Five years later I was a newspaper photojournalist, a career that I would enjoy for 25 years. Many of those years were spent shooting black-and-white film, where light quality was a luxury and the color of the light really didn't matter.

That all changed when we switched to color film, especially because we shot transparencies. All of a sudden, light mattered. It mattered a lot. We needed to learn how to improve the lighting by combining ambient light and electronic flash. If you kept the flash on your camera, the results were fairly safe and predictable. For a newspaper photographer shooting in lots of run-and-gun situations, safety and predictability were good things. A flash on a camera is good at one thing: illuminating detail; but you are essentially lighting with all the creativity of a photocopier. We quickly learned that if we took the small flashes off our cameras, safety and predictability were replaced by magic and surprise. The magic was that our photos could capture the world in a much more three-dimensional way. With a difference between lens position and light position form and texture could be shown. The surprise was that the results were pretty unpredictable, thanks to the unforgiving exposure latitude of transparency film and the fact that we had to wait until the film was processed to see the results of our lighting experiments. So we played it safe and over time learned how to light.

Being both curious and patient, through trial and error we slowly filled our bag of lighting tricks. The photos from our assignments began to look better, cleaner, and more interesting. But because of the slow learning pace, the results were still predictable. That all changed in 1988 when we switched to digital cameras. Now we had instant feedback. We could try anything with our lights and immediately see the changes to our photos. The result was a sort of Cambrian explosion for our lighting techniques. Our skill level grew quickly with each passing assignment. We were studying the work of other photographers to learn as much as we could.

The effects previously attainable only with big, expensive, heavy lights tied to power cords could be achieved with small battery-powered flashes—or, as we called them, speedlights, which were about the size of a sandwich. We quickly grew to think of these lights as being near magic that could light anything. The magic had always been there, of course, but just like in a fantasy tale, we now had the ability to see the magic. The flash happens in just 1/1000 second or less, which is much faster than the human eye can perceive. But since we could instantly see the results on the backs of our cameras, we could quickly adjust the power or position of the light to achieve the effect we wanted. That led to the development of our lighting intuition. With experience, we began to see and predict the quality of our off-camera lights before we captured an image. When I held a tiny little speedlight in my hands, I saw it with the familiarity of a very powerful, continuous light source. We had made the

leap of understanding what happened too fast for our eyes to see. In early 2006 I decided to share what others and I had learned, just as others had helped me build my photographic skills more than 20 years earlier. The Internet had become ubiquitous, and companies like Google allowed people to create a blog for free.

In 2006, I started Strobist.com with the goal of creating the first website about photographic lighting that was both 100% open about small flash photographic lighting and absolutely free. It seemed like a neat idea for an experiment and since it cost me nothing to try, there was no risk other than my lost time. As it turned out, there were many, many photographers who wanted to understand the light from their small flashes. By the end of the first day, Strobist had received over 5,000 views. Within a month, that number had grown to 250,000. There was no turning back. As a result, now tens of millions of people have learned from Strobist to better understand the devices that allow them to control the most important variable in their photographic world. Other websites have sprung up all over the world to echo the idea that lighting can be easily taught—and learned.

Entrepreneurial photographers who saw solutions to lighting problems have created amazing new lighting products and modifiers. Other photographers had a passion for lighting and a desire to teach others, so they wrote books. Like the one you are now holding in your hand.

If you are just beginning the journey of learning about photographic lighting, welcome. The path is fun and the rewards are many. The only requirement is a willingness to believe in something that happens too fast for you to truly see, and to be open to the magic that can happen if you are willing to let it.

David Hobby
Strobist.com

What Every Strobist Needs to Know

- **Flash Basics**
- **Choosing Your Equipment**

You have a lot to learn before you can use flash in your sleep, and getting started can be tricky. This chapter provides a crash course in flash basics and introduces the gear you need to effectively use flash. You will learn how to fine-tune your skills using the sample setups in the individual workshop chapters that follow. If you find this chapter difficult, whet your appetite by looking at some of the workshops, then refer back to this chapter to find the answers to questions you may have. Of course, you can spend a lot of money on flash gear, but you don't have to spend a lot to get started. I'll show you what I keep in my camera and tripod bags, and I'll explain which equipment has been invaluable during my career.

Flash Basics

Even without flash, you need plenty of practice to successfully juggle exposure times, ISO values, and apertures while you shoot. Flash adds even more variables to the mix. The routine of everyday photography becomes more complex with the introduction of flash output, subject distance, angles of emission, and light-shaping tools. When you use flash, rusty old friends like exposure times need to be reviewed and you will need to learn new techniques like high-speed sync and second-curtain sync. The following sections explain the relationships among all these factors, and appendix A on page 266 includes some sample calculations for you to try.

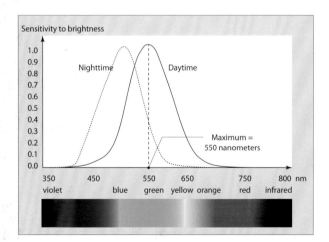

▲ *The sensitivity curve for the human eye and the corresponding visible spectrum*

Let There Be Light!

Along with the main subject in an image, light is the most important aspect of the photographic process. If the light is right, you can make great photos, even using a simple cell phone camera. In extreme situations you may have to deal with too little or too much light, and this means that the sensor of your camera only delivers the tonal values black or white. Light can communicate information and evoke emotions. After you learn to work with light, you will be able to accentuate important parts of a scene and let less important elements disappear into the background.

Physically speaking, light is the part of the electromagnetic spectrum that can be visually perceived. The sensitivity curve for the human eye shows that we are capable of seeing wavelengths between 400 and 800 nanometers (nm) and that we are most sensitive to green tones. Dogs and camera sensors see light differently. Dogs, for instance, are red/green color blind, and digital image sensors can pick up near-infrared waves that the human eye cannot see.

Light propagates in space according to the inverse square law, which states that the intensity of light close to its source is proportional to the inverse square of the distance to the source.

The inverse square law: If you double the distance between the subject and the light source, you will need four times as much light to illuminate a surface with the same intensity. If you triple the distance, you need nine times as much light.

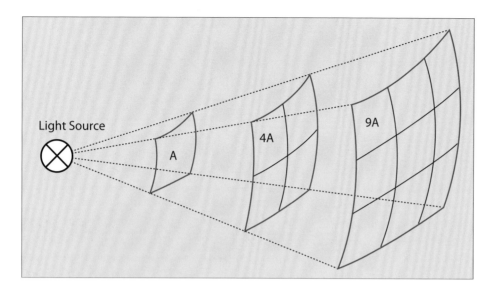

◀ *The inverse square law: If you double the distance between the subject and the light source, you will need four times as much light to illuminate a surface with the same intensity. If you triple the distance, you need nine times as much light.*

The inverse square law assumes that you are using a light source that radiates symmetrically. In the figure above you can see that only one-fourth of the light from the source is available to illuminate each of the four squares of the subject at double the distance. That is, the amount of light that reaches the subject decreases proportionally to the square of its distance from the light source. The inverse square law is especially important in flash photography, and we will revisit this concept many times throughout this book. Appendix A explains how to calculate with the inverse square law in real-world situations.

Continuous Light

Why is there a section about continuous light in a book about flash? The main reason is that the advantages and disadvantages of flash become even more obvious when flash light is compared with other light sources. The sun is the most widely used source of continuous light. It provides cheap, bright light with a useful spectrum and it's available everywhere. But to tame sunlight you need to use reflectors, diffusers, shades, and other light-shaping tools. These tools transform hard, direct sunlight into a soft, diffuse source of photographic illumination. Unfortunately, the opposite is impossible; you can't produce hard sunlight on a cloudy day.

The color temperature of ambient light varies during the day from warm gold to pure white to cool blue tones. If you need consistent light indoors or outdoors during the evening, you need to use either a continuous artificial light source or a flash. The major advantages of continuous light over flash are that it allows you to immediately see how your image will look, and you can use it to capture moving images. But the disadvantages outweigh the advantages. The light yield is relatively low, and many conventional sources of continuous light—halogen, neon, and light-emitting diode (LED) lamps, for example—produce illumination that is either too warm or too cool, or it simply has too many gaps in

▲ *Some continuous light sources have problematic gaps in their spectrums. This figure shows the spectrum produced by sunlight or flash (top) compared to a typical energy-saving lamp (bottom).*

its spectrum. All continuous light sources require long exposure times, high ISO values, or both, which inevitably leads to increased image noise. Images taken with a flash usually look cleaner.

The Nature of Flash

Photographers have used flash since the very beginning of the photographic age. The first flash experiments used magnesium powder that was ignited by hand during the exposure. Nowadays, we use sealed glass tubes filled with xenon. One of the major reasons flash has become so popular is that it provides an extremely bright source of light for a very short period of time (see a comparison of continuous light and flash light on page 266 in appendix A). Xenon produces a visible spectrum with a color temperature that is similar to the midday sun, which makes it well suited to photographic applications. In contrast to neon or LED light, xenon has very few gaps in its spectrum. Flash light and sunlight produce great results when they are combined, and battery-powered flash units are small and easy to carry. They can allow the photographer to freeze action in an image, and their point-shaped light source is perfect for use with accessories such as umbrellas and softboxes. The following sections list the terms and units that are used to describe the light produced by a flash unit.

Flash Output | The energy released when a flash unit is fired is measured in joules (J) or watt-seconds (Ws). If you know the size of the capacitor in your flash unit and its charge voltage, you can calculate the energy stored in the capacitor using the following formula:

$$W = \frac{1}{2}CU^2$$

The output of most studio flash units is expressed in Ws (400 Ws is a typical value), but an accessory flash unit is often described in terms of its guide number (see the "Guide Numbers" section on page 8). Converting joules directly to guide numbers doesn't work because guide numbers depend on additional factors, such as the light beam's angle of reflection and the zoom setting of the flash reflector. If you need to compare accessory and studio flash units, you can generally assume that the most common models (SB-900, 580EX II, YN-560, etc.) have output values of around 60–70 Ws. The relationship between flash output and exposure value (EV) numbers is linear (see appendix A on page 266). If you double the flash output, the EV for the shot is also doubled.

Flash Duration | People often assume that flash durations are so short they are negligible when it comes to calculating exposures. However, when you use high-speed flash or another technically advanced technique, such as Supersync (also sometimes called pseudo-HSS or *tail-sync hack*), the duration is highly relevant. As the curve in the figure shows, flash duration is logarithmic rather than linear, and it is stated in terms of the two constants $t_{0.5}$ and $t_{0.1}$ which represent the time it takes for the flash output to subside to 0.5x and 0.1x of the full output. The following formula delivers a good approximation of the relationship between the two:

$$t_{0.1} \approx 3 \times t_{0.5}$$

When you use an accessory flash, assume that the flash duration is approximately proportional to the output setting you use. For example, a Nikon SB-900 unit produces flash light for 1/20,000 second at $t_{0.1}$ (minimum output) and 1/500 second at full output. If you want to freeze the movement of liquids or splashes, you need to select a low output setting and use additional flash units in parallel if one unit doesn't provide enough light. Studio flash units often cannot be set to such low output power and therefore are generally slower.

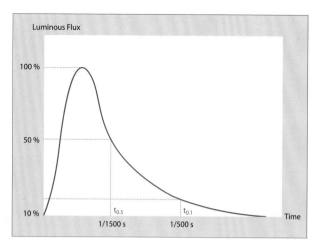

▲ *The flash durations $t_{0.5}$ and $t_{0.1}$ in relation to the curve of flash output over time*

The relationship of *flash output ~ flash duration* doesn't always apply. Studio flash units often use multiple capacitors, depending on the current output setting. The best way to find the right setting for the shortest possible flash duration is to refer to the user's manual or ask the manufacturer.

Guide numbers | A guide number (GN) is used to indicate how much light a flash unit can produce. The GN is defined as the product of the maximum distance at which the flash can illuminate a subject (A) and the aperture (B):

$$GN = A \times B$$

Guide numbers can be quoted for specific angles of view and ISO settings. For example, for the Canon Speedlite 580EX II, the GN is given as 58 meters at ISO 100 and a zoom setting of 105mm. Because large numbers are more impressive, flash manufacturers usually quote guide numbers at the maximum (i.e., narrowest) available zoom setting. You can use the maximum subject distance or a known aperture setting to calculate the required guide number setting. If the ISO value changes, you can calculate the maximum flash range using the following formula:

$$A = \frac{GN}{B} \sqrt{\frac{E_F}{100}}$$

Here, the maximum distance or range, A, and the guide number, GN, are given in meters; B is the aperture setting; and E_F represents the current ISO setting, which is usually assumed to be 100.

Examples of how to calculate using guide numbers are provided in appendix A on page 266.

Shaping and Directing Light

In addition to its spectral distribution and energy, light is also described in terms of its directionality and diffuseness, such as harsh direct sunlight, the soft light found in shade, or the light that enters through a north-facing window. Sunlight is a direct, point-shaped light source and creates well-defined, hard-edged shadows, whereas the light from a north-facing window is diffuse and forms soft-edged shadows. If neither sunlight nor light from the north is available, you can still produce various degrees of diffused light using flash and light shapers.

Diffusers function like clouds; they enlarge the light source and soften its overall effect. Reflectors—such as a white wall or a piece of Styrofoam—have a similar effect and also enlarge the light source. Because light that enters a north-facing window does not come directly from the sun and is scattered by the surroundings, this type of light is diffuse, even on cloudless days. The distance between the subject and the light source also plays a role; the closer the subject is to the light source, the larger and softer it will appear. The sun is an extremely large light source, but it's very far away, so sunlight acts like a hard point of light.

Direct and Diffuse Reflection | If you point a small light source at a mirror, the reflected light will look nearly the same as the source light because the light

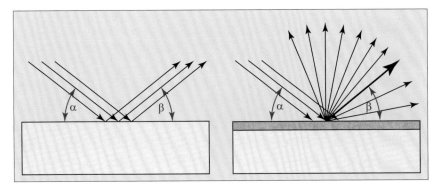

◄ Just like in a game of pool, the angle of incidence of light rays is the same as the angle of reflection. The left side of the illustration shows the behavior of light rays hitting a smooth surface, such as a mirror. On the right, it shows how a textured matte surface partly diffuses the incoming light rays. This results in a mix of direct and diffuse reflection.

is directly reflected. A mirror is therefore no use as a reflector unless you simply want to redirect the light. If you want to soften the reflected light, you need to use a textured matte surface to diffuse the reflection.

Playing off the Cushions | Just like the balls in a game of pool, reflected light and diffused-reflected rays follow the equation *angle of incidence = angle of reflection*. If you bounce light off a reflector, you have to keep this rule in mind when you position your lights.

Standard Light-Shaping Tools | In addition to reflectors, you can also use partially transparent diffusers to shape the light from a flash unit. Frosted and sand-blasted glass make great diffusers, as do translucent foils, light-colored textiles, and paper. Diffused light allows you to produce more subtle lighting effects. The most widely used type of light shapers are 5-in-1 or 7-in-1 reflectors, which have a diffuser at their core and can be used with white, silver, or gold coverings. You can also use these reflectors with a black cover to reduce the amount of light that reaches the subject.

A translucent umbrella is a type of collapsible diffuser, and a reflective umbrella can serve as a simple foldable reflector.

Umbrellas produce soft light too, but because they are open at the back they can allow unwanted stray light to reach the subject. The idea of a closed umbrella led to the invention of the softbox—a kind of box-shaped diffuser with a rear covering that does not allow light

to enter the box. The inside surface of the rear covering is lined with reflective silver material, which helps to increase the light yield. Softboxes can be square, octagonal, rectangular, or long and thin like a strip light. In contrast to diffusers and reflectors, which soften light, other types of light shapers can concentrate and shape light. Typical light shapers include snoots and honeycomb grids, which form and reduce light into narrow beams; barn doors allow you to precisely adjust the vertical or horizontal dispersion of light. You can also mount dark-colored flags close to the light source to darken specific areas of the scene.

The illustrations on pages 12–14 show various professional studio lighting products and the effects they produce. All these tools are available in versions

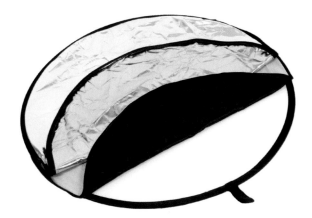

▲ A 5-in-1 reflector set. The base can also be used as a diffuser. (Photo courtesy of EnjoyYourCamera)

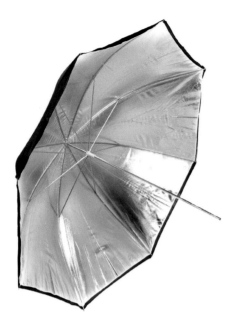

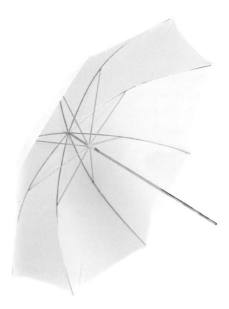

◄ With a reflective umbrella (left), the flash is directed into the reflector and the light is reflected toward the subject. Conversely, the light from the flash shines through a diffuser umbrella (right). Both types of umbrella enlarge the light source and produce softer light. (Photos courtesy of EnjoyYourCamera)

designed to be used with a camera's hot shoe, also referred to as *system flash*. It is important to remember that system flash units produce much less output than their studio equivalents, so they are not suitable for use with oversized reflectors or softboxes. Additionally, because these products have built-in reflectors, the light they produce is more direct. They can be effectively used with umbrellas, but they are less suitable for use with specialized accessories such as parabolic tele reflectors, which are designed to be used with omnidirectional light sources (e.g., sunlight that comes from all directions). There are two ways to work around this restriction:

▸ Attach a clip-on diffuser to your flash. This produces a more omnidirectional light but reduces the flash output.

▸ Modify your flash unit to work in bare-bulb mode. For details about how to do this, search the Internet for "bare-bulb flash."

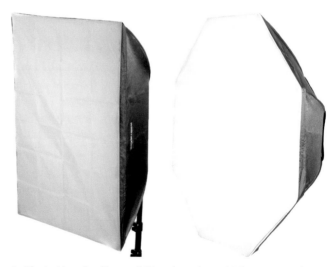

▲ The insides of softboxes (left) and octaboxes (right) are coated with a silver material to increase the light yield. The effect they produce is similar to that of a diffuser umbrella, but without the risk of stray light escaping from the device. (Photos courtesy of EnjoyYourCamera)

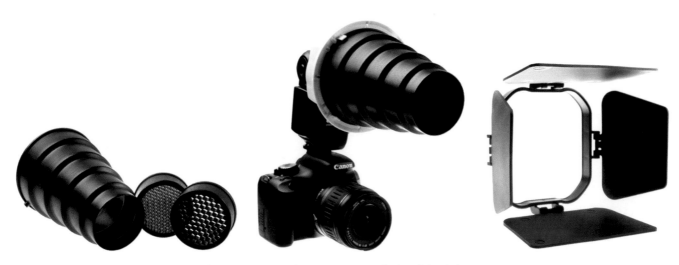

▲ *A snoot with honeycomb grids (left), a snoot mounted on an on-camera flash unit (center), and barn doors (right). These light shapers are used to reduce and direct the light to small spots or stripes. (Photos courtesy of EnjoyYourCamera)*

Exposure Metering

Exposure metering for flash requires a different approach than metering in continuous light. The following sections provide detail about the available options and discuss which approach is best in certain situations. Also covered is how to mix flash and ambient light.

Using Tried-and-True Settings | The EV of a photo is an absolute value, so you can use standard values in situations with known conditions. The accompanying table lists a few sample situations and the values you can expect to use. Zero EV is assumed to be the result of shooting with an aperture of f/1 and an exposure time of 1 second (see also "Setting Exposure Using Known Values" on page 270). In real-world situations you will rarely use this method of adjusting your exposure, but it will help you develop a feel for what happens when you alter the exposure time or ISO value. For example, when you shoot indoors in artificial light,

you need to use a relatively wide aperture, such as f/2.8, and an ISO value of 800 or more. In contrast, the *sunny 16 rule* states that in sunlight, if you set the aperture to f/16 and the exposure time to the inverse of the ISO value (e.g., 1/100 second at ISO 100, 1/200 second at ISO 200, etc.), you will probably produce a correctly exposed image. At ISO 100 and 1/200 second, you would need to set the aperture to f/11.

Scenario	Exposure value (EV)
Evening skyline just before sundown	12–14
Brightly lit shop windows at night	7–8
Art gallery	8–11
Cloudy landscape at mid-day	12
Indoors in the evening under artificial light	5–7

◀ *Type S 9″ parabolic reflector,*
Expert Pro Plus 500, 88 Ws.
Metered apertures:
1. *f/8*
2. *f/4 + 8/10*
3. *f/4 + 6/10*

Images by Michael Quack/Visual Pursuit

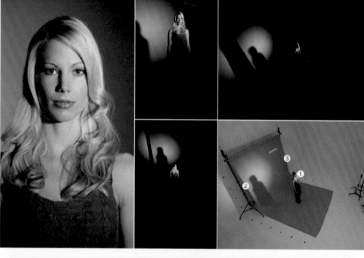

◀ *Type S 9″ parabolic reflector*
with #1 honeycomb grid, Expert
Pro Plus 500, 189 Ws.
Metered apertures:
1. *f/8*
2. *f/2.8 + 8/10*
3. *f/1 + 3/10*

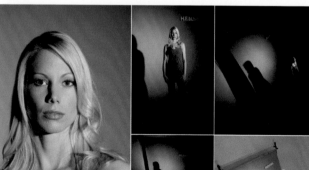

◀ *Hensel Accent Tube snoot*
and Expert Pro Plus 1000,
812 Ws.
Metered apertures:
1. *f/8*
2. *f/4*
3. *f/1.4*

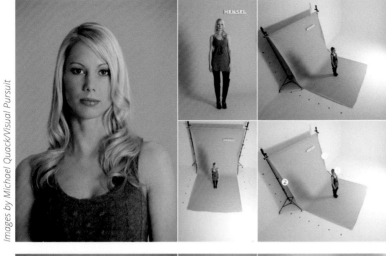

◀ *Hensel Softstar 42 in diffusion umbrella, Expert Pro Plus 500, 330 Ws.*
Metered apertures:
1. *f/8*
2. *f/5.6 + 2/10*
3. *f/5.6 + 8/10*

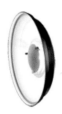

◀ *Hensel Master 42 in silver umbrella, Expert Pro Plus 500, 379 Ws.*
Metered apertures:
1. *f/8*
2. *f/5.6 + 2/10*
3. *f/5.6 + 5/10*

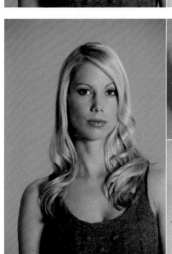

◀ *White Hensel beauty dish, Expert Pro Plus 1000, 616 Ws.*
Metered apertures:
1. *f/8*
2. *f/5.6*
3. *f/5.6 + 5/10*

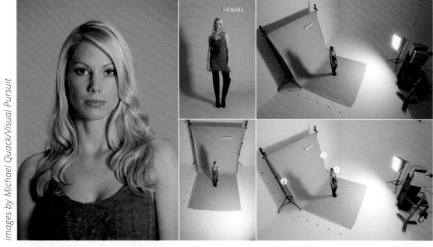
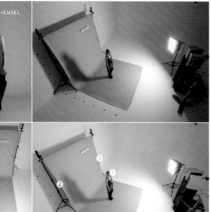

◀ *Hensel softbox 18 x 26 in, Hensel Tria 3000-AS with EH Pro Mini head, 462 Ws.*
Metered apertures:
1. *f/8*
2. *f/4 + 8/10*
3. *f/5.6 + 1/10*

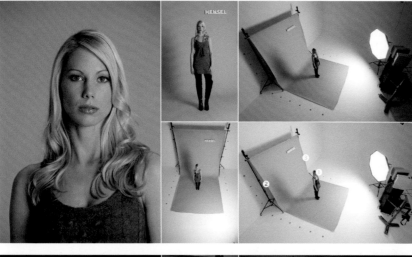

◀ *Hensel Octaform 60 in octabox, Hensel Tria 3000-AS with EH Pro Mini head, 350 Ws.*
Metered apertures:
1. *f/8*
2. *f/4 + 7/10*
3. *f/5.6 + 2/10*

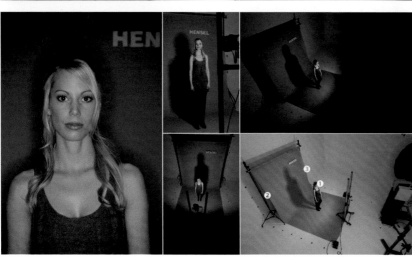

◀ *Hensel 3000-AS Ringflash with EH Pro Mini head, 462 Ws.*
Metered apertures:
1. *f/8*
2. *f/4 + 8/10*
3. *f/5.6 + 1/10*

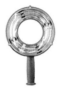

Images by Michael Quack/Visual Pursuit

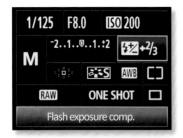

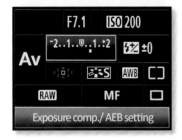

▲ *Flash exposure compensation (top). In auto exposure mode (bottom), exposure compensation can be used to influence your results.*

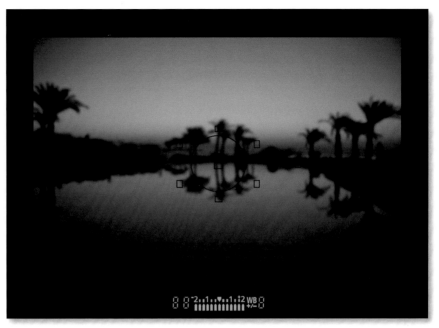

▲ *The exposure meter display works in manual mode too*

Because 1/200 second is the standard flash sync value for many cameras, it's an important base value if you want to use additional flash (see "Flash Synchronization" on page 25). Although the formula works only for available light, you can still use it as a jumping-off point to calculate settings for flash shots that also include ambient light.

Using the Camera's Built-in Light Meter | If you use your camera's automatic exposure mode, you are sure to use the built-in light meter often. In this mode the camera uses readings from the built-in exposure meter to automatically set the exposure time, aperture, and ISO value. You can adjust the exposure by using the camera's exposure compensation function.

If you then mount a through-the-lens (TTL) flash unit from the same manufacturer as your camera, the camera will automatically adjust the exposure. Again, you can influence the exposure by adjusting the exposure compensation. I find that automatic exposure metering produces slightly inconsistent results from shot to shot, so I use it only if I'm in a hurry. You will get more stable and predictable results if you shoot in manual (M) mode and take your time to carefully meter each shot. Keep an eye on the viewfinder meter display to help you judge the ambient light while you shoot. If you use the built-in meter as the basis for your calculations, it is important to remember that the readings assume the subject has a reflectivity of 18%. If you base your measurements on a reading from a standard gray card, everything will be fine. If, however, you take meter readings from pale skin or white textiles, you will have to deliberately overexpose your shot (e.g., between 2/3 and 1 1/3 stops) to prevent the image from turning out too dark. A useful way to set up your camera for a portrait shot using ambient light is to turn off auto-

focus and switch to center-weighted metering before you switch to manual (M) mode, then zoom in so the subject's face fills the frame. Adjust the exposure so the meter reading in the viewfinder is at 0, and then add 2/3 stop of overexposure.

If you are able to operate your camera controls without looking, you can use this method to set a correct exposure without taking your eye away from the viewfinder. This procedure can also work in spot and matrix metering modes. I often use spot metering in tricky situations, and I use center-weighted metering for general shooting.

This approach to metering will also help you practice non-TTL flash metering. If you want to block out the ambient light in a scene, you can keep an eye on the appropriate level of underexposure in the viewfinder display, and if you want to include ambient light in your shot, you can also adjust the exposure on ambient light in this way.

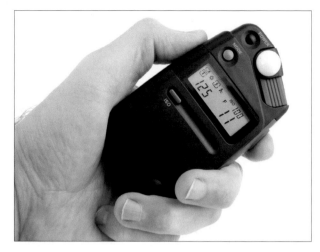

▲ *The photographer has preset ISO 100 and 1/125 second, and the meter has calculated an aperture value of f/11 (Photo courtesy of Arturko, Fotolia.de)*

Using a Separate Light Meter | Apart from the special case of TTL flash metering, built-in exposure meters can measure only continuous light sources. To work around this limitation, you can use a separate handheld exposure meter that calculates the exposure value or aperture (if you preset the ISO value and exposure time).

Most studio photographers meter the light that comes from their lamps, even though this increases the risk of dark objects turning out too dark and light

◀ *High-end light meters allow you to meter the light coming directly from the source or the light reflected by the subject*

◀ *A screen loupe enlarges the monitor image and makes it much easier to judge the quality and sharpness of your images, regardless of how bright the ambient light is*

objects turning out too bright. Metering reflected light allows you to better judge the correct exposure for complex subjects.

Many of today's light meters can also be used to meter flash light, either by using a built-in sensor to measure the peak flash intensity or by RF-triggering these devices parallel to the flash unit itself. To use a flash meter, begin by setting reasonable base values, such as ISO 100 and 1/125 second, before you turn on the meter and fire the flash. If the meter indicates an aperture of f/11 for a correct exposure, but your planned shot requires a larger aperture, simply dial in the appropriate value on your flash. Remember that each full f-stop doubles (or halves) the flash output. If your flash unit supports smaller increments between full f-stops, each increment usually represents 1/3 stop or 1/10 stop.

Metering Using the Camera Monitor and Histogram | This metering method involves taking a test shot and checking it visually (with the help of the overexposure warning) on the camera monitor. This is a fast

and reliable way to judge your exposure. Camera monitors are small, but they display adequate image quality and show precisely how the light is distributed in the image. You can quickly judge if the main and accent lights are placed correctly and if you have struck a good balance of flash and ambient light. If the image in the camera monitor is too bright or too dark, you can turn off the auto brightness function. I always do this and set a static medium brightness value. In bright light, a dedicated screen loupe is a great tool to help you accu-

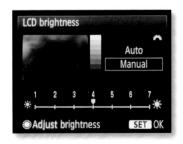

▲ *If you use your camera monitor to evaluate the exposure, always switch off the automatic brightness control, and if possible, use a screen loupe*

rately see the preview image. I also use the highlight overexposure warning function (the blinking overexposed areas) to help me identify any clipped highlights.

The histogram is also a useful exposure aid. A well-exposed photo will have a histogram curve that approaches, but doesn't touch, the right side of the graph. With a little practice, you will learn to identify which parts of an image are represented in the histogram by the peaks and valleys. In the sample image in the accompanying figure, for example, you might decide that the sky is of less importance than other areas of the image. The blown-out highlights might not matter, and you may decide that retaining the shadow detail on the fronts of the buildings is worth the overexposure.

On the other hand, you can expose backlit subjects to retain background detail while the subject appears as a silhouette. The histogram for the image of a mannequin makes it easy to tell if the image is correctly exposed. For example, in the backlit shot of Kimi on the next page, the background plays a secondary role and the blinking warning areas do not matter.

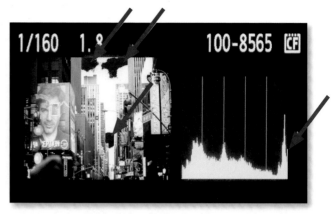

▲ *The arrows pointing to the blinking areas in the image (left) are reflected in the histogram (right). Note that the peak on the right side of the histogram shows the overexposure: these areas of the image are blown out (i.e., they contain no usable data).*

▼ *The histogram indicates a perfect silhouette with deep, saturated blacks and no blown-out areas in the background*

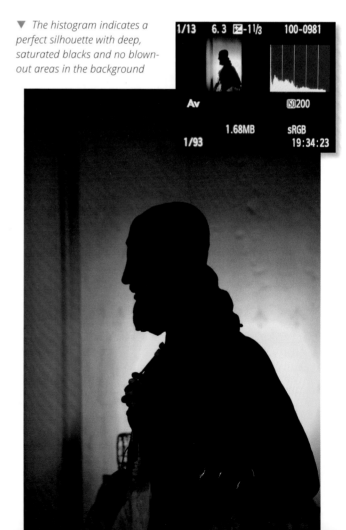

◄ *The histogram warning function is enabled so you can see if you need to adjust the exposure*

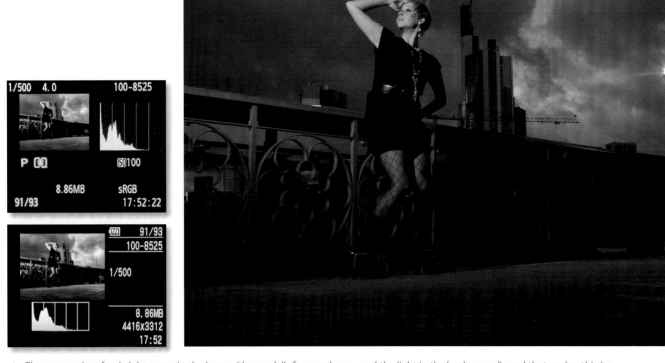

▲ *There are only a few bright areas in the image (the model's face and arm, and the light in the background), and that makes this image appear underexposed in the histogram, but it is correctly exposed. The screenshots are from a Canon EOS Rebel T1i (EOS 500D) (top) and a Canon PowerShot G10 (bottom). (Model: Layka)*

I shot the above photo with a Canon PowerShot G10. This combination of camera and subject required a lot of care when it came to identifying the few relevant peaks at the right side of the histogram. Be careful when you shoot subjects that don't fill much of the frame. Depending on the scene and the camera, it can be extremely difficult to correctly identify the parts of the histogram that relate to the subject, which makes it hard to evaluate the exposure. In this case, it was preferable to using the camera's display or checking the blinking histogram warning.

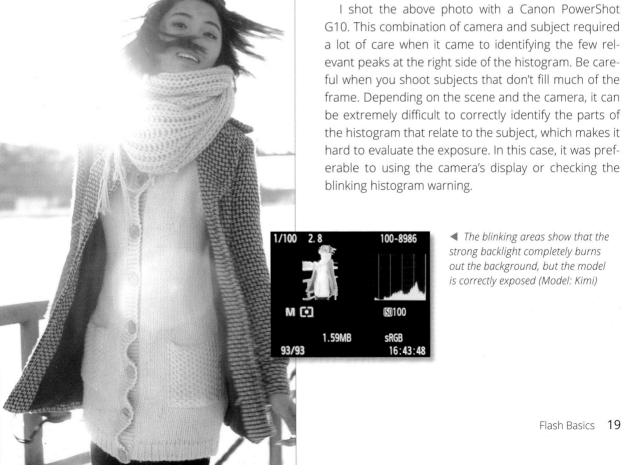

◀ *The blinking areas show that the strong backlight completely burns out the background, but the model is correctly exposed (Model: Kimi)*

You need to know your camera monitor well if you want to use the histogram and the blinking warnings to evaluate your exposures. If you change camera systems (for example, from Canon to Nikon), you will need to get used to the behavior of the new camera. Different cameras indicate overexposure at different thresholds, and the monitor brightness varies from camera to camera. As previously mentioned, using consistent monitor brightness and a screen loupe will greatly help you to evaluate your exposure correctly. With a little practice you will be able to judge the exposure by eye almost as well as if you used a light meter. If you master this approach, you will be in the company of an illustrious group of pro photographers that includes David Ziser, Neil van Niekerk, David Hobby, Joel Grimes, and Kevin Kubota, all of whom rarely use light meters.

Manual Flash Settings

There are various ways to manually set up non-TTL flash units. The simplest approach is to suppress the effects of ambient light and illuminate the subject using flash only. Things get more complex when you want to mix natural light and flash.

Flash without Ambient Light | This is the easiest type of shot to set up. Begin by using settings such as ISO 100 (for low noise), f/5.6 (for sufficient depth of field), and 1/125 second to ensure that there are no conflicts with your camera's sync speed capabilities (discussed later). Place your flash as close to the subject as possible but far enough away to ensure that the entire scene is sufficiently lit, and then set the flash output to 1/4. You can fine-tune the output setting after you take one or two test shots, but remember to make your first test shot without flash to check that you have suppressed the ambient light. Because the flash duration is much shorter than the time the shutter is open, only the aperture, subject distance, and flash output determine the look of the image—the length of exposure has no effect. The only exception is when you use high-speed sync (HSS) techniques (see page 25).

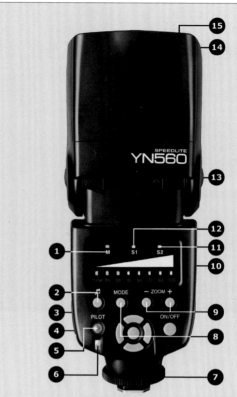

▲ *The generic YN-560 strobist flash has no built-in TTL functionality and must be controlled manually*

1	Standard manual mode
2	Flash ready sound on/off switch
3	Battery pack connector
4	PC sync socket
5	Charge indicator lamp/test flash button
6	Power save indicator
7	Locking ring
8	Mode switch (M, S1, S2)
9	Zoom +/–
10	On the front: optical sensor for slave firing
11	Slave mode with preflash suppression
12	Slave mode
13	Articulated tilt/swivel joint
14	Reflector
15	Wide-angle diffusor

This strobist-style manual flash setup requires more effort, but you won't need to use a flash with any kind of smart features or built-in electronic trickery. In fact, you can use the cheapest flash units you can find. The accompanying figure shows the Yongnuo YN-560 model, which is a widely used, low-cost flash unit. Each LED represents a full stop (i.e., each increment halves or doubles the flash output). The YN-560 provides just as much flash output as the Canon Speedlite 580EX II at about an eighth of the cost. Canon's Speedlite, on the other hand, offers advanced features such as TTL auto mode, high-speed sync, wireless flash control, and stroboscopic mode—and, of course, you can also use it in manual mode as an expensive alternative to a strobist flash.

Combining Ambient Light and Flash | In the right situation, ambient light and flash light can be mixed to produce interesting results. Try capturing the mood at dusk by combining the artificial lights in a scene with a flash-lit subject. In such cases, the exposure time determines the proportions of flash light and natural light in the image. Longer exposure times allow more ambient light to reach the sensor. You don't need to change the amount of flash light you use, but you do have to slightly underexpose the main subject. If the subject is correctly lit by the ambient light, adding flash will overexpose it.

Begin by selecting camera settings that expose the scene correctly without flash, and then underexpose the background by 1 or 2 stops to make sure it looks good. Check the meter readings and the results on the camera monitor before you add flash to light the subject.

Manually Controlled Off-Camera Flash Units | Using manually controlled off-camera flash units provides a number of advantages. You can choose the flash-to-subject distance and the direction the flash is facing, and you can use light modifiers to fine-tune the flash effect. You can remotely fire off-camera flash in non-TTL mode by using a cable or an infrared release. Flash cables come in a variety of shapes and sizes, and all TTL cables can be used to fire flashes that are set to manual mode. The top-left figure on page 22 shows the Yongnuo OC-E3 cable. It has hot shoes at both ends so you can use it with flash units that don't have a PC socket.

Most flashes can be fired remotely using the built-in optical sensor. If the direct light from the master flash unit on the camera spoils the lighting, you can cover the reflector with an infrared filter (for example, the Nikon SG-3IR IR Panel for built-in flash).

The most elegant and robust way to fire a flash unit remotely is with a radio control. This high-end technology has now reached the mass market, and modules from Asian manufacturers, such as the Yongnuo RF-602, are highly recommended. PocketWizard is another manufacturer of flash accessories that offers additional features, such as TTL functionality and a slightly better build quality than Yongnuo products.

Some cameras have built-in wireless flash control functionality and therefore require no additional accessories if you use flash units made by the same manufacturer. Cable, optical, and slave release systems generally work with any make of camera and flash. Exceptions to this rule are cameras made by Sony because they use a proprietary flash shoe. However, adapters are available.

▲ *Connecting an off-camera flash unit with a cable. This is the simplest, cheapest, and most reliable way to remotely fire a flash, though it comes with the risk of stepping on the cable. The Yongnuo OC-E3 cable shown here is suitable for manual or TTL use with Canon flashes. Similar cables are also available for flashes made by Nikon and other manufacturers.*

▲ *An off-camera flash unit (here, the YN-560) fired using its built-in optical sensor. This is a cheap way to fire off-camera flashes, but it only works at short distances. An articulated shoe-mounted flash used as a master unit would offer more power and hence more control than the popup flash shown here.*

▲ *An off-camera flash unit fired with an accessory optical slave unit from Kaiser. The figure shows a Canon flash (that has no built-in optical slave cell of its own) mounted atop the Kaiser unit. This is a cheap solution that works best over short distances, but only if the master and slave devices have clear visual contact.*

▲ *The Yongnuo RF-602 is a non-TTL radio trigger (the transmitter is mounted on the hot shoe and the receiver sits under the off-camera flash). This simple, cheap solution works over relatively long distances. It requires no direct visual contact with the slave and even works through concrete walls. The drawbacks are that this model does not offer TTL (auto) flash and does not support high-speed and second-curtain sync.*

TTL Technology

TTL technology is the successor to an earlier flash technology that used a built-in sensor to calculate the necessary flash output, independent of the camera's own circuitry. As the name suggests, TTL (through-the-lens) technology meters flash directly through the camera's lens and ensures that the light emitted by the flash unit corresponds perfectly to the scene and the angle of view of the lens. A TTL system fires a preflash that the camera circuitry uses to calculate the correct exposure and transmit the corresponding data to the flash. The flash unit then uses the data to calculate the correct flash output setting. This complex data transmis-

sion requires high-end technology in the camera and the flash unit, as well as a high-tech interface between the two. TTL-capable flash units are easily recognizable by their multiple hot shoe contacts. TTL software and hardware is generally proprietary to the manufacturer, although third-party manufacturers—such as Nissin and Metz—make flash units that are compatible with Nikon, Canon, Sony, Pentax, or Olympus systems, but still you have to choose the right type for your flash. The figure on the next page shows the popular Canon Speedlite 430EX II.

▲ *A non-TTL hot shoe (top) has two contacts: ground and fire. A TTL hot shoe, like the one from Canon (bottom), has multiple contacts that transmit complex control signals and exposure data between the camera and the flash unit.*

Metering Modes | In TTL mode, the camera controls the exposure by using techniques that are very similar to the familiar spot, center-weighted, and matrix metering methods used in continuous light situations. Canon's TTL technology offers center-weighted and matrix modes, and other manufacturers offer similar options. Canon and Nikon offer spot flash metering—called Flash Exposure Lock (FE Lock) by Canon, and Flash Value Lock (FV Lock) by Nikon. FE Lock and FV Lock save spot-metered exposure values that you can then use to light a reframed image; this technique is often called *meter and recompose.* Spot metering/FE Lock is used in the first workshop, allowing the preflash to be decoupled from the main flash. With this trick, it's possible to even use slave flashes without preflash suppression.

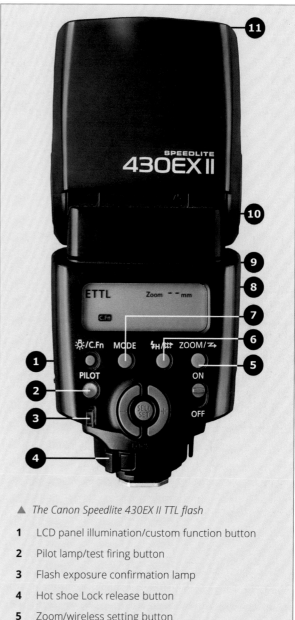

▲ *The Canon Speedlite 430EX II TTL flash*

1 LCD panel illumination/custom function button
2 Pilot lamp/test firing button
3 Flash exposure confirmation lamp
4 Hot shoe Lock release button
5 Zoom/wireless setting button
6 High-speed sync/2nd curtain button
7 Mode setting button (TTL/manual mode)
8 On the front: wireless TTL sensor
9 On the front: AF-assist beam emitter
10 Tilt/swivel flash head and locking button
11 Wide-angle diffusor

Combining Flash and Ambient Light in TTL Mode | TTL technology makes it easy to mix flash and ambient light. Just meter the scene (without flash) using one of your camera's auto modes, reduce the overall exposure value using exposure compensation (EC), turn on your flash unit, and shoot. The flash will automatically illuminate the main subject with the correct output. In a situation like this, for the flash, the Canon system ignores any EC settings you make and always meters the flash for the main subject, whereas the Nikon system automatically incorporates the compensation value in its flash calculations. To work around this, you have to use the flash exposure compensation (FEC) function on the flash unit to balance out the camera-based EC setting. For example, if you set an EC value of –1 EV, you have to set an FEC value of +1 EV to compensate. The Canon and Nikon systems function almost identically in manual mode. You can meter for the ambient light and let the flash automatically calculate the correct lighting for the main foreground subject. The only difference is that Nikon's EC values also influence the exposure in manual mode. This may seem a bit strange, but at least it's consistent with the behavior in aperture-priority (AV) and shutter-priority (TV) modes, and it enables the user to bias the exposure metering display in manual (M) mode.

If you are shooting in a tricky situation, such as in low natural light, it's better to set the camera to manual mode and draw on your experience to select the best camera settings (the ISO-setting that is tolerable with the camera regarding noise, the shutter speed that can be used handheld, and the aperture that is tolerable regarding DOF) instead of relying on the camera's automatic exposure meter. This way you will control the amount of ambient light that is included in your exposure, and the TTL flash will control the illumination of the main subject. By now, you have probably realized that TTL technology is a somewhat elusive science. If you want to get the most out of your TTL equipment, it is essential to thoroughly study your camera and flash manuals and take plenty of test shots under a wide range of conditions.

▲ *TTL off-camera flash control using a Yongnuo ST-E2 as the master and a Canon Speedlite 430EX II as a slave. This is a relatively inexpensive and reliable solution, but it requires a direct line of sight between the units. A Canon flash, such as the Speedlite 580EX II, could also be used as a master in this setup (a second 430EX II would not work, because it doesn't have built-in master functionality).*

Off-Camera TTL Flash | TTL flash can be used off-camera, most easily and cheaply with a manufacturer-specific flash cable, but there are better solutions. The major manufacturers have developed their own optical flash control systems based on either infrared technology (Canon) or pulsed flash (Nikon Creative Lighting System, or CLS). Some Canon cameras (such as the EOS 7D) have built-in master functionality, and others require a proprietary or third-party shoe-mounted infrared transmitter, such as the ST-E2 module (available from Canon and, in a clone version, from Yongnuo).

Radio control is a reliable (but more expensive) way to control flash, and it does not require a direct line of sight between the transmitter and the receiver. Canon offers the Speedlite 600EX-RT radio-controlled flash system, and the MiniTT1 from third-party manufacturer PocketWizard is compatible with Canon and Nikon flashes.

Flash Synchronization

A flash unit normally must fire while the shutter is open. The following sections describe how the simultaneous interaction of flash and focal plane shutter can be achieved.

Focal Plane Shutter | Most current digital single-lens reflex cameras (DSLRs) have a two-curtain focal plane shutter that works in standard mode, as shown in the figure below-left. When the shutter is released (t_0), the first shutter curtain descends until the sensor is completely uncovered (t_1). The sensor is exposed to light from the start of the process (t_0) and is fully revealed between t_1 and t_2. The second shutter curtain then descends to cover the sensor, and the shutter movement is complete at t_3. If the condition for successful flash synchronization isn't upheld—that is, the exposure time is shorter than the camera's flash sync speed (1/200 second for Canon and 1/250 second for Nikon)—the sensor is never completely uncovered,

resulting in a stripe that appears at the bottom of the frame, as shown in the photograph on page 26.

To avoid having a black stripe across the frame, you can use high-speed synchronization (HSS). The alternative, SuperSync (also called pseudo-HSS or tail-sync hack), is not supported directly by the major camera manufacturers, but I explain how to use it in workshop 4.

In practice, if you use RF-triggered off-camera flash, you will need a little headroom in your exposure times to compensate for the slight lag due to the RF transmission. A shutter speed of 1/125 second is a good choice in most situations.

High-Speed Synchronization | In high-speed sync mode, the flash unit not only emits a preflash and then a main flash, as in standard mode, but it pulses like a strobe light for the entire duration of the exposure. The multiple flashes have the same effect as a continuous light source, which eliminates the problem of a black stripe in the image. In HSS mode, you have to calculate

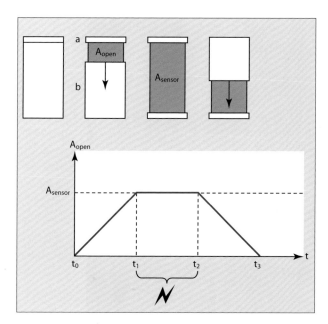
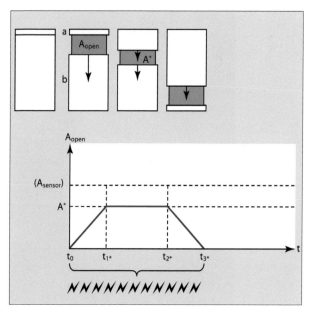

▲ *The figure on the left depicts successful synchronization. The figure on the right shows an exposure time that is too short; the flash will work only in high-speed sync (HSS) mode, which uses multiple weak flashes to simulate continuous light.*

▲ *If you use flash with an exposure time that is shorter than your camera's sync speed, the photo will usually have a black bar along the frame. This shot was taken with a Canon EOS 5D Mark II (with a sync speed of 1/200 second) set to 1/250 second. (Model: Romashka).*

▲ *Left to right:* **1.** *Canon PowerShot G10 in Av mode (no flash);*
2. *same as previous but underexposed by 2 stops;*
3. *with a YN-460 non-TTL flash attached with a spiral cable*
Picture #3 f/4.5 | 1/2000 second | ISO 100 (Models: Cherryberry and Chris)

the exposure values as if you were shooting in continuous light. For example, if you halve the exposure time, you will have only half as much light to play with (see the sample exposure calculations on page 266). Note that with most flash units you can set this HSS mode even while in manual mode, thereby eliminating the metering preflash.

You may wonder why such short exposure times are needed. Various situations require this approach. For example, if you shoot with flash in direct sunlight, you usually have to set an exposure time longer than 1/200 second, and therefore, in return, you have to close the aperture down. However, this approach uses a lot of flash power, and you can't use a wide aperture. One way around this problem is to use a neutral density (ND) filter, although it will adversely affect the image quality (see page 64).

The described HSS option can be a solution, but there are also drawbacks. The main disadvantage of HSS is that the overall amount of light is reduced by about two stops (with a Canon camera, the loss is –1.66 EV). Furthermore, for a long time HSS was feasible only in off-camera flash that is used along with the more expensive infrared or radio-controlled systems from your camera manufacturer, or the MiniTT1 and FlexTT5 models from PocketWizard. Cheaper radio trigger solutions now come from companies like Yongnuo (YN-622C/N) and Phottix (Odin TTL Flash Trigger) (see appendix A "Calculating HSS Exposure" on page 274).

Another possibility is to use a camera such as the Nikon D70 and the Canon EOS-1D, which have hybrid electromechanical shutters that make it possible to use extremely short flash sync speeds. Electronic leaf-type shutters are more widespread in compact cameras,

such as the Canon PowerShot G9 and G10 models, which are capable of shooting at flash sync speeds as short as 1/4,000 second.

SuperSync or Pseudo-HSS (see page 54) is another way to produce similar effects. It involves using studio or portable flash heads set to high output (i.e., long flash duration) and setting the flash duration to be at least as long as the exposure time. In other words, the light from the flash unit shines the whole time the shutter is open. This technique requires a very responsive triggering system that is based on a dedicated system flash, as well as an optical servo slave trigger. The system flash has to be set to manual mode (to suppress the preflash) and HSS. It then triggers the optical servo, which then triggers a standard radio transmitter like the Yongnuo RF-602 (actually even a bit earlier). If the flash is set to a sufficiently high output setting, the flash duration will be longer than the exposure.

Interestingly, this technique can also be applied with low-cost accessory flash units without any TTL or HSS functionality. A Yongnuo YN-560 can, for example, be used at speeds shorter than the camera's sync speed. However, the flash must be set to full output (to keep the flash duration as long as possible) and you will probably have to use several flashes in parallel to provide enough light. One disadvantage of this approach is the uneven brightness during the flash burning-off. Such imperfections can be repaired in Photoshop, but the problem can be serious enough to ruin an image—

the trick is in the timing. This relatively new approach is gaining followers, so you can learn more by searching the Internet for "SuperSync," "HyperSync," "tail-sync hack," and "strobist."

First- and Second-Curtain Sync | If you take another look at the lower-left figure on page 25, you will see that there are various moments during the exposure when the flash can be fired. First-curtain sync fires the flash at t_1 whereas second-curtain sync fires the flash at approximately t_2 minus the flash duration. Using second-curtain sync in combination with longer exposure times alters the look of the image, and the results are usually more in harmony with the viewer's visual perception.

Most proprietary system flashes allow you to set first- or second-curtain sync in the menus of the camera or the flash unit, but it's tricky when you use third-party gear. You can work around any restrictions by using an accessory flash to remotely trigger a second flash with its slave sensor. This allows you to shoot second-curtain (and SuperSync/pseudo-HSS) effects using studio flash. If you take this route, remember to switch the trigger flash to manual mode to suppress the preflash. Last but not least, if you aren't convinced of the reliability of a slave sensor, place the slave trigger close to your flash and use it to trigger a radio transmitter. There is no end to the combinations you can use!

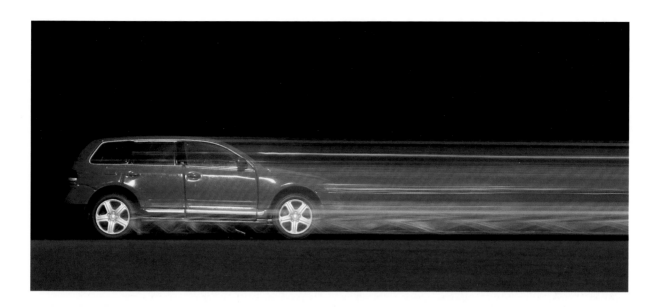

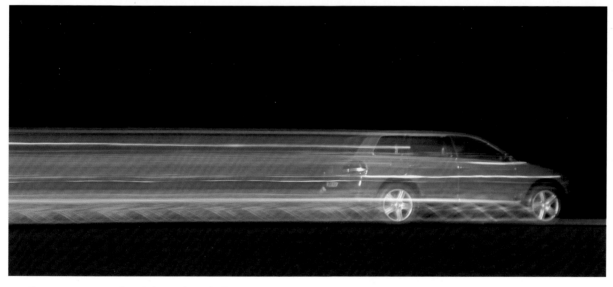

▲ *The car was moving from left to right in both photos. The top image demonstrates the sometimes implausible results of using first-curtain sync. The bottom image shows that second-curtain sync produces results that are more in line with our expectations.*

Choosing Your Equipment: What's in the Bag?

▸ *How to select the right gear and avoid purchasing the wrong things*
▸ *Packing for a location shoot*
▸ *Using studio light modifiers with on-camera flash*

Unlike hobbies such as golf and paragliding, photography is relatively cheap, especially now that the costs of film and developing have disappeared. However, today's photographers often collect large amounts of gear in hopes of gaining flexibility and capturing better images—I am no exception. But do you really need all those accessories? Sometimes a homemade solution is not only cheaper, but may also be better than a commercially produced gadget. A good example is the Spin-

▲ *A common hose clamp simply and reliably attaches an umbrella to a tripod. It may not be the prettiest solution, but it's far cheaper than anything else.*

Light 360 EXTREME, which is nothing more than a commercial version of Neil van Niekerk's *black foamie thing* (http://neilvn.com/tangents/the-black-foamie-thing/), which takes five minutes to build, costs two or three dollars, and fits in any photo bag. The 360 EXTREME is heavy, clunky, conspicuous, and costs 50 times as much (www.spinlight360.com/shop/spinlight-360-extreme).

In this chapter and in the 40 workshops that follow, I mention only the gear I have found to be genuinely useful. Wherever possible, I will suggest inexpensive alternatives to the commercial products.

Starting Out on the Cheap

Perhaps surprisingly, flagship flash units, such as the Nikon SB-910, the Canon Speedlite 600EX-RT, or the Metz mecablitz 58 AF-2 digital, can easily cost more than a basic studio flash setup. However, if you are just starting out, I recommend that you start with a low-cost non-TTL flash. It will save you money and force you to learn manual flash settings, which will accelerate your learning. If you always set your camera to programmed auto mode using TTL flash, you'll miss out on lots of creative opportunities.

Non-TTL flashes from Asian manufacturers cost as little as $35 on eBay. A full starter kit can include two flashes (the Yongnuo YN-460, for example, has an optical slave cell built in), a couple of sheets of Styrofoam, two umbrella diffusers, and two stands (old camera tripods will do). The simplest way to fix your umbrellas to stands is to use hose clamps from a hardware store.

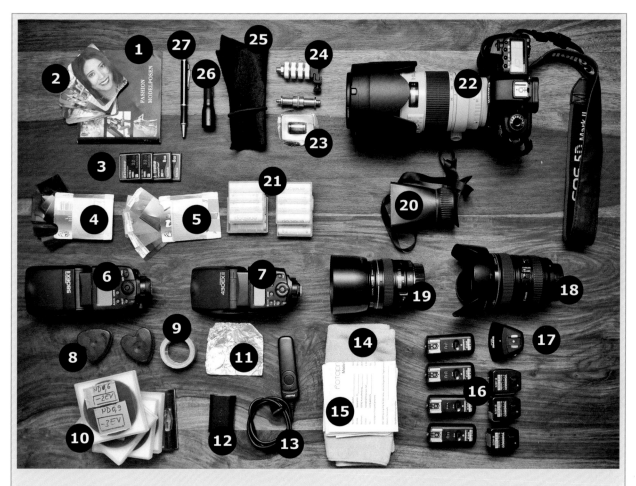

1	Little posing guide (homemade)	**9**	Tape	**20**	LCDVF display loupe	
2	Business cards	**10**	Various ND filters (B+W, Hoya)	**21**	Eneloop AA and AAA rechargeable batteries	
3	SanDisk CompactFlash (CF) memory cards	**11**	Aluminum foil	**22**	Canon EOS 5D Mark II with EF 70–200mm f/2.8 IS II	
4	LEE color filters	**12**	Extra Canon camera battery			
5	LEE color temperature orange (CTO) and other special-purpose filters	**13**	Phottix camera cable release	**23**	Spare battery for flash trigger	
		14	Microfiber lens cleaning cloth	**24**	Camera screws (1/4″), cold shoe, spigot	
6	Canon Speedlite 580EX II flash	**15**	Model release forms	**25**	Black foamie thing (felt)	
7	Canon Speedlite 430EX II flash	**16**	Yongnuo RF-602 radio trigger	**26**	LED LENSER P3 flashlight	
8	LED flashing hearts (useful as focusing aid)	**17**	SUNPAK DSU-01 optical trigger	**27**	Pen	
		18	Canon EF 24–105mm f/4L lens			
		19	Canon EF 85mm f/1.8 lens			

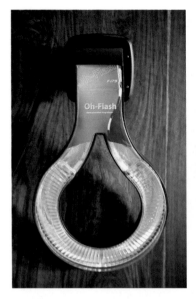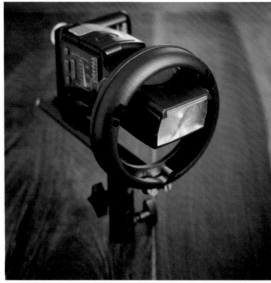

◀◀ *Oh-Flash ring flash adapter by Phottix. Though this accessory is not the highest quality and is sometimes a bit shaky, at least it's inexpensive.*

◀ *The Aurora Bracket[1] for Walimex, Bowens, and Jinbei light shapers makes a good alternative to the more complex flash2softbox system*

This basic kit is sufficient for shooting food, products, and portraits at home. Location shoots can be more of a challenge because optical flash triggers aren't as reliable outside, and cheap tripods might not be stable enough. But even these challenges can be solved at relatively little cost. The most important things to acquire are a radio receiver (such as the Yongnuo RF-602), two or three 8–10 ft light stands (Walimex is a good value brand), and a couple of good umbrella adapters (Manfrotto 026, for example). You will also need a softbox (flash2softbox, Lastolite Ezybox, Aurora Firefly XL, etc.). You will quickly find out what types of subjects you like to shoot and then you can invest in the gear you really need. I use beauty dishes, clamps, adapters, ball heads, snoots, honeycombs, and other light modifiers from Manfrotto, Novoflex, and Lastolite.

If you want to shoot at weddings and other public events, sooner or later you'll need to use TTL equipment. It takes too long to adjust manual settings, and it distracts you from capturing important moments. The downside of using TTL gear is its price. A TTL flash can easily cost six or eight times as much as a non-TTL model, and reliable radio controllers cost extra too (for example PocketWizard TT1/TT5 or the Canon 600EX-RT system). However, depending on how you use your equipment, it can quickly pay for itself. Other specialized macro or high-speed gear can be expensive too. In the workshops later in this book you will find the gear I used listed in each individual workshop.

My Everyday Backpack

I use a Lowepro SlingShot 302 AW backpack, which easily holds a full-frame DSLR with a 70–200mm lens attached. I fill the rest of my pack with other equipment that is fairly standard, although the lenses I take with me vary from shoot to shoot. I usually end up using 70–200mm and 24–105mm zooms and a 50mm or 85mm prime (or a Lensbaby).

Tripods and Stands

I use a travel or sports bag to carry my tripods and stands. Some of my stands are too long to fit in the bag, but it offers plenty of extra space for my flashes and other accessories. Dedicated tripod bags from Calumet

[1] *Though the Aurora Bracket is no longer manufactured, it is a very good product that may be found on eBay. An alternative is the Phottix HS Speed Mount II.*

offer good value if you don't want to improvise. I carry larger accessories, like my Duke Nukem (see workshops 5 and 6 later in the book) and my beauty dish, separately.

Other Accessories

In workshop 2, I used the Sambesi flash2softbox system. The system components are solid and flexible. A bayonet mount is available separately; I use it to mount my homemade Chinatown Special beauty dish (http://vimeo.com/9577963). The system also includes an adapter for Bowens and Walimex VC accessories.

Various adapters are available for mounting light shapers on system flashes—for example, the Aurora Bracket can be used to mount Bowens accessories, and the Hedler FlashEule can be used to mount Hedler products. And be careful: there are lots of different mounts on the market, so ask your supplier for details if you are not sure which accessories fit your system.

Various companies (Ray Flash, enlight photo, and others) manufacture value-priced ring light adapters

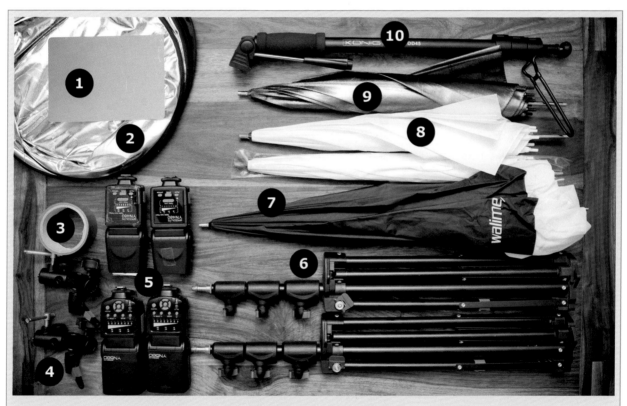

▲ *The contents of my stands bag (my Walimex light stands are not included in the figure)*

1 Novoflex gray card

2 Delamax 5-in-1 reflector

3 Tape (as usual, nearly all used!)

4 Manfrotto 026 umbrella adapters

5 Four Yongnuo flashes

6 Two Manfrotto 1052BAC mini light stands

7 Walimex brolly box

8 Two Walimex white shoot-through umbrellas

9 Walimex silver reflector umbrella

10 Koenig boom stick/monopod

◀ *The flash2softbox system:*
1. *Softbox mounted on a Canon flash*
2. *Softbox mounted on a Yongnuo flash with an adapter*
3. *With my homemade Chinatown Special beauty dish*
4. *The front of the Chinatown Special beauty dish*

for system flashes. Although these units produce much less output than proprietary ring flashes and neon ring lights, they are fun to experiment with. I sometimes use the low-end Oh-Flash from Phottix. It is a good value for the money, but it won't stay on my flash unit unless I use a lot of tape!

Over the years I have collected a lot of clamps, goosenecks, tabletop tripods, and I found Manfrotto and Novoflex accessories to be the best.

Additional Equipment

Some pieces of equipment require special knowledge for them to be useful. Here are a few tips:

▸ The cheapest Yongnuo flashes like the YN-462 are adjusted with a rotating knob that has no click stops. This is not a reliable way to shoot, so you should avoid them. Make sure your flash unit has clear click stops at whole EV increments (i.e., 1/1, 1/2, 1/4 output).

▸ If you use the Manfrotto 026 umbrella adapter, make sure the umbrella stem is at an angle and the flash points toward the center of the umbrella—otherwise

you'll be labeled as a newbie. At least, that's what happened to me.

▶ Many experienced strobists prefer Eneloop batteries. They have a high charge capacity and a very low discharge rate when they're not in use. In spite of their lower nominal voltage, they provide just as much power as conventional batteries (see the test results published at www.flickr.com/photos/galllo/7883565718/). Make sure you use a charger that supports single-cell charging. Always use Eneloop batteries in complete sets and store them in the provided plastic box. Don't mix batteries from differ-

ent sets; label them, along with the purchase date, to be sure. If you are shooting at an event where you need to take lot of flash shots at short intervals, try using an external battery pack. The Yongnuo YN-560 and the Canon Speedlite 580EX II have connectors for attaching external power sources.

▶ If you want to prevent your umbrellas from falling over and breaking when you are out and about, try weighing down your stands by taping a gallon water jug to the base, or use tent pegs to fasten them down. If it's simply too windy, then shoot without light modifiers. Hard light can look cool too.

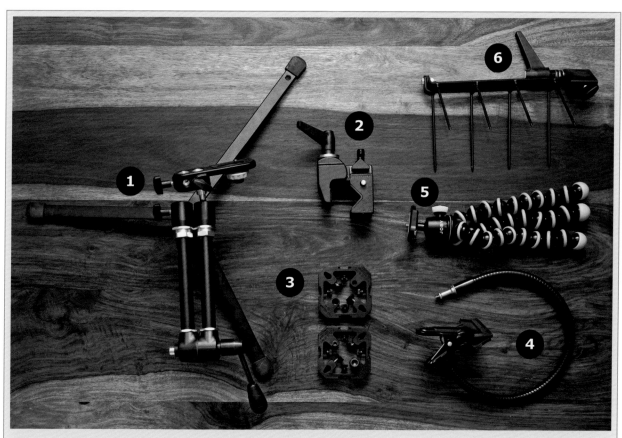

▲ *Various clamp and holder systems*

1 Manfrotto Magic Arm (available separately or in the set shown here with a stand and a Super Clamp)

2 Manfrotto Super Clamp 035

3 Two FourSquare flash adapters, each for four flashes

4 Walimex gooseneck with table clamp

5 Joby SLR-Zoom GorillaPod

6 Double Styrofoam fork from proxistar

- If you are shooting using optical slave triggers or Nikon CLS system flashes, make sure you have a clear line of sight between your master and slave flashes. Different flash models (sometimes even from the same manufacturer) have optical receivers in different places, so make sure you know where you are aiming. In tricky situations, you can use aluminum foil to deflect the trigger signals to the right place.
- If you are shooting in a group, clearly label your equipment with colored tape so you'll know which components are yours when everybody is packing up.
- When you're shooting outdoors and in the rain, protect your flashes with freezer bags.
- Flashes and radio receivers often come with their own carrying bags, ministands, and other bits and pieces. I prefer to premount my lights (a stand with an umbrella swivel, a receiver, a flash, and an umbrella) and carry them in my tripod bag, ready to shoot, with the umbrella folded down. That way, I am ready to go when I reach the location. Most gear is stable enough to be transported this way.
- If you read about them online, Walimex and Yongnuo products don't have very good reputations. I have found, however, that they offer great value for the money. Plus they're not expensive to replace if they get lost or damaged, and they can often be repaired quite easily (see example instructions for the YN-460: www.flickr.com/photos/galllo/4732637702/ [scroll down for English text]).

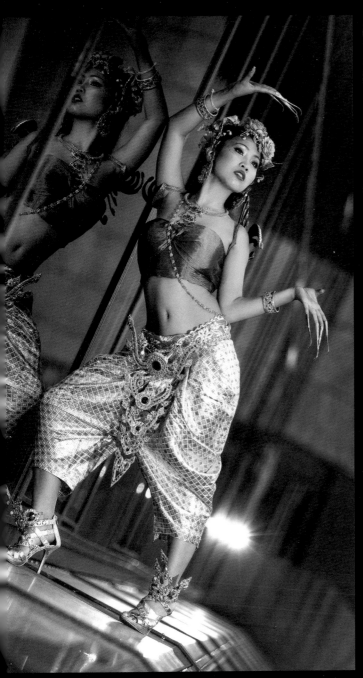
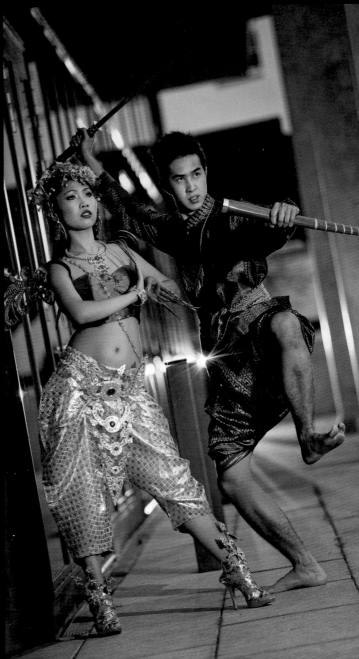

▲ Many scenes seem ordinary at first, but they really begin to shine with flash. For this shot I used multiple off-camera flashes and color filters. The setup is similar to the one described in workshop 7. (Models: Tiney and "Mr. M")

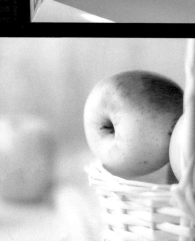
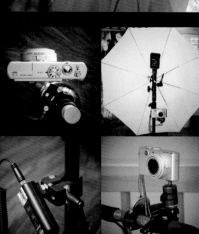

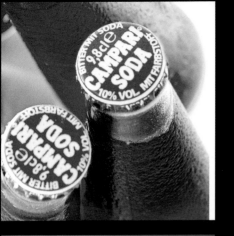

The Fun Starts Here!
40 Lighting Workshops

- **Portraits and Fashion**
- **Macro with Flash**
- **Still Life and Product Shots**
- **Food Photos**
- **High-Speed Flash**

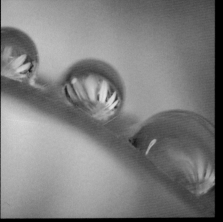

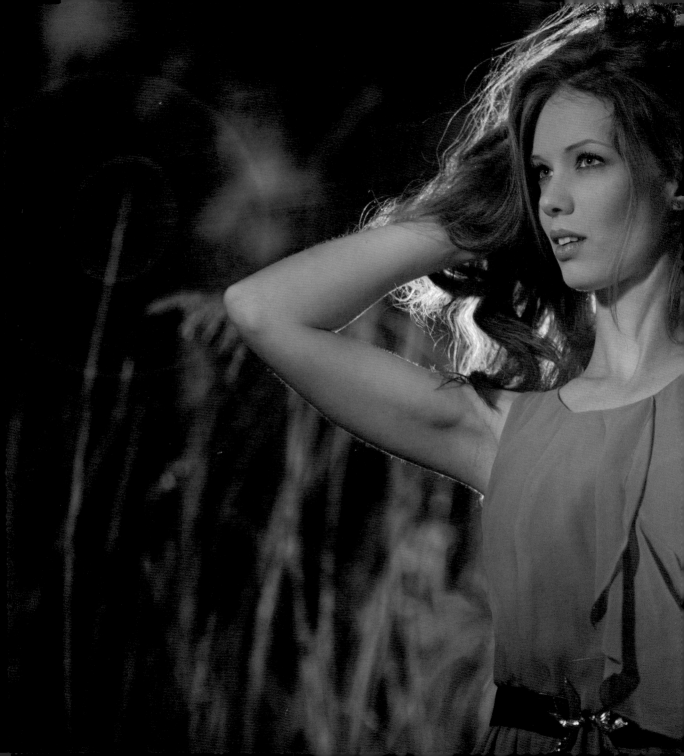

Workshops 1–13
Portrait and Fashion

Portraiture and photography of people in general are probably the most important applications for creative flash techniques. You can't dictate the weather, and it is hard to capture a flattering look in the rain or when the sun is high in the sky. Continuous light is fine for this type of work in a studio, but a battery-powered flash—with its low weight, compact size, and high output—is the way to go on location. The workshops on the following pages start by describing a simple setup for shooting portraits for business professionals and then move on to more complex techniques, such as key shifting and Super-Sync/pseudo-HSS.

Workshop 1
Portraits for Business Professionals

‣ *How to shoot portraits for business professionals using a simple setup with on-camera TTL flash*

‣ *How to trigger a non-TTL accent flash using the main TTL-flash*

Sometimes business people ask me to shoot a photo for their website, résumé, or a job application. I prefer to carry as little gear as possible for jobs like this, and so I usually just take my backpack, a reflector, two flashes, and a lightweight tripod with me. This workshop introduces my setup.

Before we continue, I should point out that portraits always look better if they are shot with soft light. It's easiest to produce soft light with large light sources, which are usually too unwieldy for the type of shoot described here. A collapsible 7-in-1 reflector is the best choice. It can be used to shape sunlight and flash, and to create a large and flattering light source. Another way to reduce the bulk of your kit is to use lightweight camera tripods instead of light stands, one of which also serve as an emergency tripod if you need it. My Velbon Ultra LUXi L is a great little tool that folds down really small, and it can be extended a long way without losing stability. Its quarter-inch thread is perfect for mounting a range of flashes and accessories. A Yongnuo RF-602 radio trigger and a Kaiser slave trigger (or an alternative model like the one mentioned on page 56) complete the kit.

The Setup

For this portrait, the main light was a Canon Speedlite 430EX II TTL flash mounted on-camera and rotated sideways toward a reflector that I placed on a chair. Diffuse light from a window opposite the reflector provided fill light; a second reflector or a white wall would do just as well. The model sat on a chair in front of a blue partition that was lit with a second background effect flash. The second flash can also be rotated for use as a sidelight or to light a subject's hair. A cheap non-TTL flash is fine for this part of the setup.

This setup includes three cool technical tricks. The first involves firing the background flash. My Yongnuo YN-460 has its own built-in slave trigger and can be used without preflash, but it's too far from the main

▼ *Schematic of the portrait setup. An on-camera TTL flash is bounced off a reflector, and a non-TTL accent flash illuminates the background.*

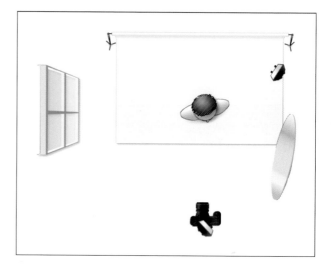

flash to be triggered effectively. My solution is to use a trigger sandwich that consists of a slave trigger and a RF-602 radio trigger taped to the reflector along with a radio receiver attached to the accent flash.

The second trick is to suppress the preflash while using the on-camera TTL flash in TTL mode. A preflash would trigger the slave flash too early, so instead of switching to manual (M) mode, which would mean shooting without TTL functionality, the work-around is to use the Flash Exposure Lock feature (FE Lock), which decouples the preflash from the main flash and gives the slave (the accent flash) time to recharge. On Canon cameras, you can fire the preflash by pressing the * button near the thumb grip on the rear of the camera.

The third trick is to use a flag, to prevent flash light from reaching the subject directly. You can use a snoot, a honeycomb grid, or, if you want to go the cheap and simple route, a black foamie thing (invented by Neil van Niekerk). Without such a tool, it's difficult to prevent hard flash light from hitting the subject. If the model can see any part of the front of the flash unit, it means the light will directly reach the subject.

Camera Settings and Shooting

For this shot I used a Canon 24–105mm standard zoom lens and a full-frame camera. The lens isn't perfect for portraits, but it's great for shooting upper-body shots in small spaces. The lens has a good built-in stabilizer, which allowed me to shoot handheld down to

▲ This shot was taken without a background flash and it isn't quite right. The model needs to be separated more effectively from the background. The angle of the reflector isn't right either, so the subject's right eye is too dark and has no catch light.

◄ This trigger sandwich, made of a slave cell and a radio trigger, can reliably trigger non-TTL slave flash using a TTL main flash

to subject—for example, setting +0.7 EV FEC works well when you shoot light skin with a Canon camera.

The TTL flash ensures that the main subject is correctly lit. This setup is relatively simple and is quick to master.

Post-Processing in Photoshop

The sample image is cropped, but otherwise it is only slightly processed. If necessary, you can increase or reduce the fill light using Photoshop's Image > Adjustments > Shadows/Highlights tool. If you wish, you can also add a vignette and increase the contrast and vibrance. When you are done processing, sharpen the finished image for output.

▲ *Neil van Niekerk's black foamie thing in action. It's simply a mouse pad that was cut into shape and held by a rubber band, but it works well.*

1/20 second, although this worked only because the model kept perfectly still. It allowed me to use ISO 200 and include more of the ambient light as fill light.

To set up this shot, position your flashes as shown in the diagram, switch your camera to manual (M) mode, and meter for the background. I usually use center-weighted metering. Adjust the exposure until about –1 EV, or slightly less, is metered for the ambient light. Now make a test shot without flash.

If the background looks right, add flash. Switch your flash to TTL mode and add FEC between 0 and +1/3 EV. These values vary from camera to camera and subject

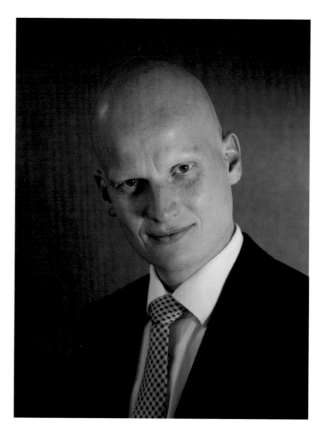

▲ *The unprocessed shot*

Tips, Tricks, and Notes

I have had plenty of practice with this setup, so by now it works well for me. The things to look out for the first few times you use it are as follows:

▸ **Preflash issues:** If you have problems triggering the accent flash, you can try using a normal slave trigger and suppressing the preflash instead of using FE Lock. Slave triggers are generally available in three categories:
 - Cheap and not capable of suppressing preflash (Walimex and Kaiser are good value brands)
 - Midrange with a dedicated preflash off switch (again, from Walimex or Kaiser)
 - More expensive but with different modes, including multiple preflash; for example, a SUNPAK digital slave unit (DSU-01) can be used to trigger studio flash, even with a consumer-grade camera with built-in flash but without a hotshoe.

▸ **Reflector:** I used a 42-inch reflector that packs down to 16 inches. Don't use a reflector with a diameter of less than 32 inches because the effect will not be as good. A white wall or a flip chart makes a good impromptu reflector; you can even use a white shirt.

▸ **Black foamie thing (BFT):** My BFT is made from a mouse pad with the fabric covering removed, and it's trimmed to 6 x 7 in. I attach it to my flash with a hair tie. It may sound like a toy, but the effect is professional. I never leave home without it. If you find yourself without your BFT, you can always use a black card or black paper, or even your hand, or simply tip the flash head back as far as it will go.

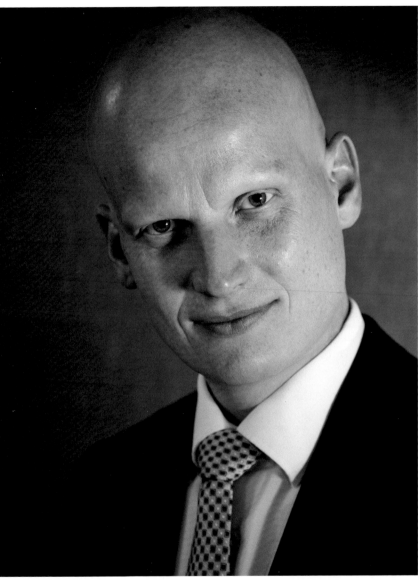

▲ *The final image after cropping and a little post-processing*

Workshop 2
That Sunny Feeling

- ▸ *Using off-camera TTL flash with a TTL flash cable*
- ▸ *How to use a softbox with flash*
- ▸ *All about dragging the shutter*

If you need a classy-looking location on a dull day, try renting a room in a boutique hotel. Some hotels even allow you to shoot in the lobby if you don't use too much equipment or take up too much space. The friendly management at The Pure in Frankfurt, Germany, allowed me to do just that, and you can check out the results on the next few pages. I created the sunny look of the photos entirely with flash and slight alterations to the white balance. This workshop shows that flash doesn't have to look cold and hard.

I wanted to use as little gear as possible so I could try a lot of setups without having to rebuild the scene every time. I used a small, dedicated softbox called the flash2softbox, which was developed to be used with Speedlights. (Note: This item is no longer available in the U.S., but I can recommend the Firefly Beauty Box FBO50 made by Aurora, which I also often use.)

I used a Canon Speedlite 430EX II TTL flash attached to the camera with a 33 ft spiral cable from Yongnuo. There is a quarter-inch thread built into the softbox handle so the softbox can be easily mounted on a tripod.

The Setup

Even in dreary weather, the subtle halogen lighting in the lobby of The Pure produces a pleasant atmosphere, and the frosted glass windows let in plenty of soft, diffuse light.

I wanted to utilize both types of light for these photos. I used the softbox mounted on a low stand to light

◀ *My flash2softbox that I used with a Canon Speedlite 430EX II TTL flash, a Yongnuo Canon-compatible TTL spiral cable, a flash2softbox adapter, and a 16 x 16 in softbox. The handle has a built-in quarter-inch thread that you can use to mount it on a tripod or light stand.*

▶ *Shot in the lobby of The Pure, a hotel in Frankfurt, Germany, using a TTL flash-mounted softbox placed to the right of the subject (Model: Judith)*

Canon EOS Rebel T1i (EOS 500D) | 50mm f/1.4 lens set to f/2 | M mode | 1/50 second | ISO 100 | RAW | white balance set to auto | TTL Canon Speedlite 430EX II flash connected to the camera with a 33 ft cable | spot metering with FE Lock

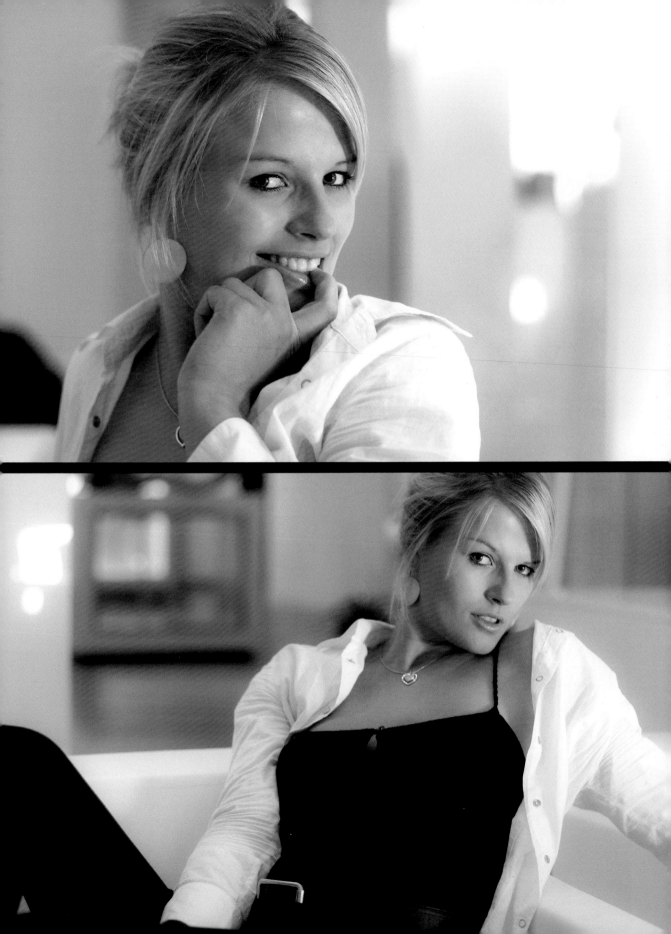

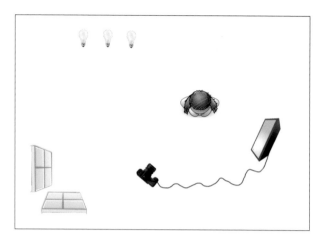

▲ *Schematic of the setup showing diffuse window light from the left, halogen light from behind, and a cable-bound softbox on the right*

the model from the right, and I made sure it remained above the line of her eyes. In shots like this you should always ensure that you get nice catch lights in the model's eyes and that you avoid an unflattering nose shadow (for example, a shadow below the nose that reaches the lips).

Camera Settings and Shooting

Use manual (M) mode and adjust your settings to correctly capture the ambient light. On this shoot I knew I could capture handheld images at 1/50 second, and from experience I know that my camera produces little or no noise at ISO 100. I realized that f/1.4 would be a little too wide, so I stopped down to f/2. In situations like this I set up my camera to capture as much ambient light as possible. In darker situations you can increase the ISO value and lengthen your exposure time. This process is known as "dragging the shutter."

▼ *Begin by setting the camera up to capture the background correctly without flash before you add flash to illuminate the subject. Light skin usually requires between 0 and +1.3 EV FEC, although these values vary from camera to camera and among skin colors.*

Using the camera in TTL auto mode would yield a different result: the camera would try to expose the subject correctly, but the background would be too dark.

When you have found the correct settings for the background, the TTL flash takes care of everything else and automatically sets the exposure for the main subject. Always make some test shots and fine-tune the flash exposure compensation (FEC) setting if necessary.

Exposure metering is important. I usually switch between spot and center-weighted metering, and I seldom use the other modes. For this shoot I used spot flash metering, which is called Flash Exposure Lock (FEL) by Canon and Flash Value Lock (FV Lock) by Nikon. This technique involves metering for a particular spot within the scene and saving the metered value in the camera's memory before you finalize the composition. Pressing the * button on the rear panel of Canon DSLRs meters and saves flash exposure values.

If you know your camera well enough to find its controls while you look through the viewfinder, you can use the camera's built-in light meter (usually indicated by a numeric scale at the bottom of the viewfinder frame) to help you find the right settings for the background. This saves time and test shots.

Tips, Tricks, and Notes

▶ I have been asked if I used a colored gel to take these photos. The simple answer is no. The camera's automatic white balance circuitry produced the warm look without any interference from me. If necessary, I could have adjusted the white balance with a virtually lossless shift in a RAW converter. I don't use automatic white balance very often. I usually set the white balance to daylight or flash to ensure consistent colors throughout a shoot. This approach also makes batch processing simpler.

▶ An umbrella is a more compact alternative to a softbox for a quick setup like this, but a diffusing

▲ *The flash2softbox system works with Yongnuo and other third-party flashes, although I had to build my own little bracket adapter to mount my Yongnuo flash/radio receiver combo*

umbrella produces unwanted light spill at its rear, and the light from a reflecting umbrella is more difficult to aim precisely. I like the light that reflecting umbrellas produce, but a drawback is that the stem can get in the way.

▶ You can use this setup with non-TTL flashes too, but you will have to make all the settings manually. Furthermore, to get my Yongnuo flash/radio receiver combo to work with the flash2softbox I had to make my own little aluminum bracket to hold it.

Workshop 3
Gobo Projections Using Flash

▸ *Build your own gobo projector*
▸ *How to create projected backgrounds in the studio*

Stores sometimes use gobos to project advertisements onto flat surfaces. A gobo projector works like a slide projector, but instead of projecting a photographic slide a gobo uses a pattern (much like a stencil) that is usually made of metal or etched glass to project a pattern. This gives the projection higher contrast, and the material is more heat resistant than a slide. Gobo projectors are usually much simpler than slide projectors because they don't require complex mechanisms to change slides between shots. Gobo projectors usually

use a halogen light source, but in this workshop we use flash to project interesting backgrounds in the studio.

Note that in the context of theater and event management, the term *gobo* is used to describe patterned slides, but in a photo studio it describes a shade that is placed in front of a flash to selectively block the light it produces. In both cases, the gobo is placed between the light source and the scene, which can be a projector lens or a photographic subject. I use the terms *flag* or *shade* to describe the latter tool.

The Setup

There are various ways you can use flash to project patterns. The simplest (and most expensive) approach is to equip a studio flash head with a custom gobo projector, such as from Walimex or Richter. You could also hack a gobo projector and replace the halogen light source with a speedlight, which is less expensive. Another simple and cheap method is to use an old analog single-lens reflex (SLR) camera body with a lens attached. As shown in the figure on the left, the gobo replaces the film in the modified SLR, and the flash is mounted where the back of the camera used to be, with a custom

▲ *A selection of 27mm and 53.3mm metal gobos*

▸ *A gobo projector can be used to produce magical studio backgrounds (Model: Mauzz; studio courtesy of my co-photographer, Ray Sjoeberg)*

Canon EOS 5D Mark II | EF 85mm f/1.8 set to f/2.5 | M mode | 1/100 second | ISO 100 | RAW | white balance set to flash

i'm blue
da ba dee
da ba die

Eiffel 65, 1998

▲ *A homemade gobo projector. The flash and the radio trigger are mounted on the aluminum bracket, and the gobo (a skyline) replaces the film*

Homemade Gobo Projector	
Broken SLR body	$20 on eBay
Old-school 35–70mm SLR zoom lens	$25 on eBay
Canon Speedlite 430EX II flash (already owned)	$0
Two knurled metal tripod screws with quarter-inch male and female threads	$5
Aluminum blank (for the bracket) from a home improvement store	$5
Gobo from Rosco (www.rosco.com)	$10

bracket that also serves as a tripod mount. You can cut the gobo to fit if it is too large, or you can mount it on aluminum foil or a piece of card stock if it is too small. I used wire cutters to remove the shutter from the SLR, and I used tape to fix the gobo in place.

You can mount the aluminum bracket in a vice while you bend it to shape and drill the mounting hole. I mounted my projector on a Manfrotto MA026 umbrella adapter so I can use it in portrait or landscape orientation. The parts I used are listed in the accompanying table.

Camera Settings and Shooting

Because this setup uses the light path of the SLR as a projector and the gobo is located on the film plane, the projected image is guaranteed to be sharp, and it can be zoomed and focused with the focus scale on the lens, just like when you take a photo. The aperture can be adjusted, too, although you will probably leave it at the widest setting.

To optimize the light yield, set your flash to 1/2 or full output. Set the reflector to its wide-angle setting and position it as close to the gobo as possible. If you are using a gobo that is a slide or is made of plastic or an additional colored gel, make sure the flash won't melt it. It's best to mount gels between the gobo and

▶ *The complete setup in the studio. The gobo projector is aimed at the gray background, and two narrow softboxes produce a cross lighting setup to illuminate the model.*

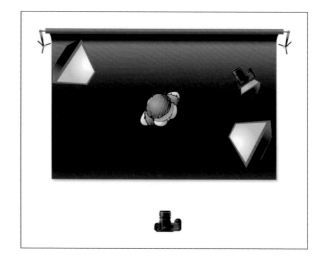

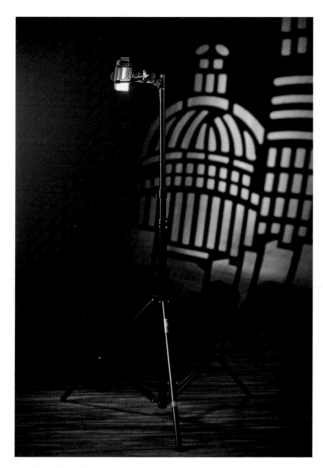

▲ *Our gobo projector in action*

Post-Processing in Photoshop

I didn't have to change much in the final image; I did only the usual straightening, cropping, color and contrast adjustments, and sharpening in Photoshop, but you could perform all these same steps in Elements, Lightroom, or Adobe Camera Raw.

Tips, Tricks, and Notes

If this workshop whets your appetite, do an Internet search for "DIY gobo projector" or "homemade gobo projector." The Internet is a great source of inspiration for all sorts of homemade projects.

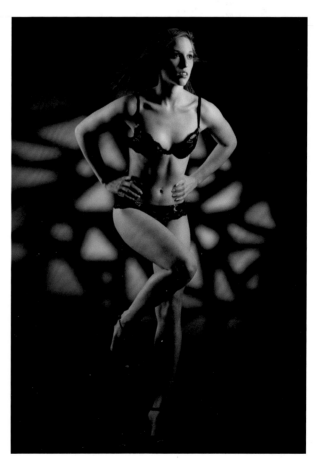

▲ *An example of an abstract gobo background pattern backgrounds (Model: Mauzz; studio courtesy of my co-photographer, Ray Sjoeberg)*

the camera, or cover the projector lens with the gel. In this setup, the flash is connected to a RF-602 radio trigger, although a cable or slave cell should work just as well. If your flash unit has a modeling flash function, you can use it to assist zooming and focus. Modeling flash emits a series of weak flashes that appear as continuous light to the human eye. The Canon Speedlite 430EX II we used allows you to assign modeling flash to the Pilot/Test button.

This type of gobo projector is effective, but not very powerful, so you may need to dim the studio flashes a bit and increase the ISO. The accompanying illustrations show a possible setup and the results. Gobos come in a wide range of prices, so compare before you buy.

Workshop 4
Wide-Aperture Look in Daylight

▸ *How to outsmart physics and shoot wide open at 1/8000 second without an ND filter using standard studio flash*

▸ *Pseudo-HSS and second-curtain sync on location and in the studio*

The limitations due to the sync speed make shooting with flash in bright sunshine a tricky operation. Remember that a conventional DSLR shutter is not completely open at any point during the exposure at speeds of faster than 1/200 second, and the exposure is made by a strip of light that moves across the surface of the sensor (see page 25). Using flash under such circumstances produces either a dark bar at the edge of the frame or a completely black photo. For this workshop, with standard flash usage, the frame would be completely dark at shutter speeds of 1/640 second and faster.

If your flash has a sufficiently long duration, the most elegant way to circumvent this problem is to use it as a kind of pseudo-continuous light source. The tricky part of this approach is ensuring that the flash is triggered before the shutter opens—a technical necessity that a conventionally triggered flash cannot fulfill. The standard work-around is to use high-speed sync (HSS), but with the drawback of loosing two stops. This workshop shows you another way to achieve a similar effect without the drawbacks using SuperSync/Pseudo HSS

▲ *An HSS-capable flash is mounted on the camera. The slave trigger and radio transmitter sandwich is attached to the flash. It triggers a studio flash unit that is fitted with a beauty dish.*

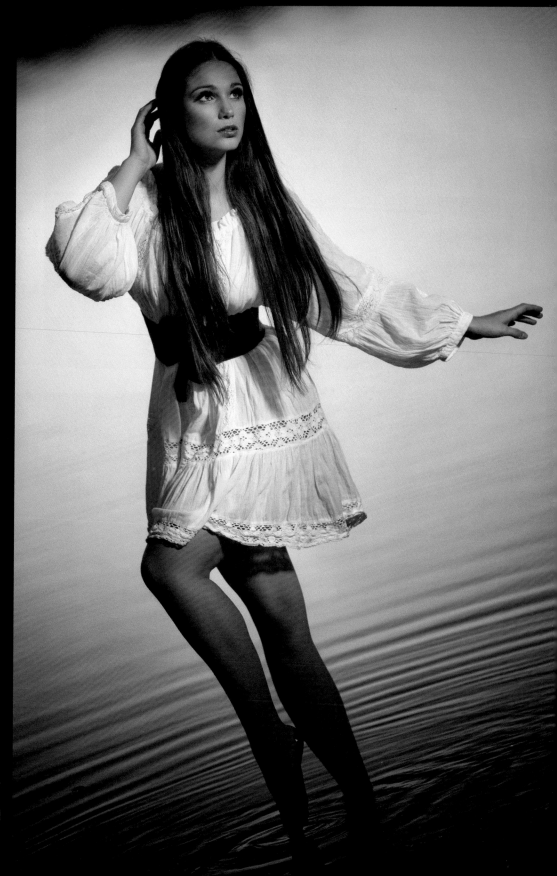

▶ *A photo that we captured during our SuperSync shoot (Model: Neleta)*

Canon EOS 5D Mark II | 70–200mm f/2.8L IS II set to 200mm and f/4.0 | M mode | 1/500 second | ISO 160 | RAW

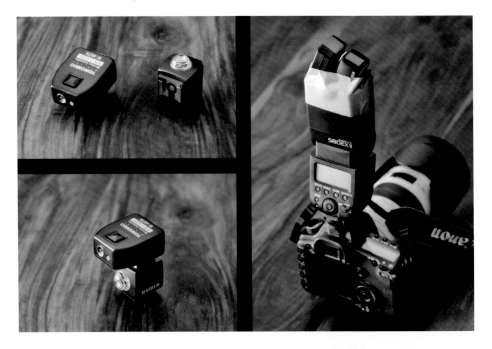

◄ *The slave trigger/radio transmitter sandwich. Attaching this combo to the flash with tape isn't pretty, but it does the job and is easy to remove afterwards. The sandwich can also be attached in a clip-on diffusor.*

The Setup

The following sections describe a relatively cheap, Canon-based way to use pseudo-HSS. The following steps can also be applied for setups that use flashes made by Nikon and other manufacturers:

▶ I used a Canon EOS 5D Mark II fitted with a Canon Speedlite 580EX II, although a cheaper HSS-capable flash, such as the Speedlite 270EX II, would work too. I set the flash to HSS mode and low output, and I pointed it upward. I also selected manual (M) mode to prevent it from emitting a preflash.

▶ I mounted the flash on a Sonia slave trigger cell I bought from colinsfoto on eBay (be sure to buy the green one), but there are other brands that are just as good. Instead of firing a second flash, I used the slave trigger to trigger a Yongnuo RF-602 radio transmitter. I fixed this little trigger sandwich to the front of my flash with tape.

▶ I used a relatively cheap 400 Ws Walimex studio flash/beauty dish combo powered by a Walimex Pro Power Station battery and triggered by a RF-602 radio receiver.

▲ *How the setup looks during the shoot (Model: Dominique, co-photographer: Niko/NN-Foto)*

Camera Settings and Shooting

When everything is set up, the shoot itself is easy. You will usually set up a shot like this with the sun behind the model so it acts like a rim light that emphasizes her silhouette and the shine of her hair. Switch your camera to manual (M) mode, select ISO 50 or 100, and set the aperture and exposure time to capture the surroundings without flash (this will probably result in a slight underexposure).

The scenery is now well lit, but the model is underexposed by 1 or 2 stops. Make some test shots to check the flash output and distance, and use the histogram and look at the blinking warning areas to double check your settings. This mixture of underexposed surroundings and flash for the main subject creates a special look. If you push this effect so the color of the sky shifts from bright blue to dark blue, the effect will resemble the *American night* look that is popular in movies (see workshop 9).

Post-Processing in Photoshop

I used my standard white balance, color, and contrast settings during RAW import and added only a little beauty retouching in Photoshop before I applied the final round of sharpening.

Alternative Methods

An Internet search for "overpowering the sun" will yield all kinds of information about the latest trends in flash photography. There are various ways to counteract the effects of a slow focal plane shutter:

▸ The best-known approach is to use an ND filter to reduce the exposure time and shoot in bright sunlight with the aperture wide open (see workshop 6 and our sample EV calculations on page 266). However, very dark ND filters reduce the overall image quality and can cause autofocus to fail.

▸ Use a camera with a faster sync speed or one with a leaf or digital shutter. Compact cameras like the Canon PowerShot G10 have a built-in hot shoe and can be used to shoot with flash at speeds up to 1/4000 second. You can see a sample of this type

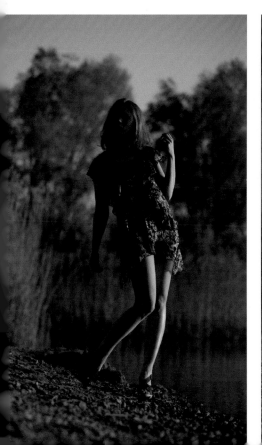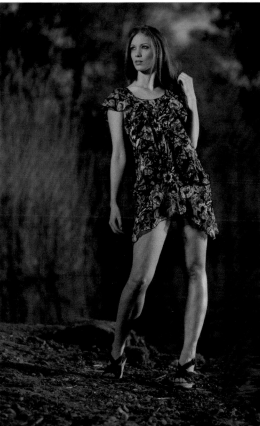

◀ *Begin by setting your exposure for the ambient light without flash. Here, the sun is behind the model, resulting in an underexposure that is canceled out by the flash. Both of these images are straight out of the camera.*

of shot at my blog http://fotopraxis.net/2011/10/20/workshop-american-night/. I used the G10 for the shoot. (Note that the blog is in German but you will get the idea by looking at the photos.)

▶ In this workshop, I used HSS mode on the flash to circumvent the limitations of the normal sync speed, and I used studio flash to create the lighting effect. You can, of course, use the on-camera flash to illuminate the subject in situations like this, but remember that using HSS reduces the light yield by at least 2 stops. Another popular technique for this type of situation is to use *gang light*. You use a whole gang of flashes (e.g., with PocketWizard triggers) to provide sufficient light in spite of the low yield in HSS mode. The downside of this approach is cost. For additional information and sample HSS exposure calculations, see the "Calculating Flash Exposure in HSS Mode" section on page 274.

Tips, Tricks, and Notes

▶ The SuperSync trick (aka pseudo-HSS) works well even with extremely short exposure times of as little as 1/8000 second. But keep in mind that the flash now works similar to a continuous light source. This results in a very low light output at very fast exposure times.

▶ The trigger technique we used in this workshop can also be useful in studio situations. For example, if you need second-curtain sync in the studio, you can simply mount a TTL flash on the camera, switch it to M mode, and use second-curtain sync to trigger a studio flash as described in this workshop. At close distances you can use the on-camera flash to directly trigger your studio flash without an additional radio trigger.

▶ I have had mixed success with optical slave triggers. Sometimes they work perfectly, and other times they cause problems. The great thing about slave triggers is they are cheap, so you can always purchase a bunch of models from different manufacturers and try them to see which works best.

▶ Instead of the Walimex studio flash that we used, a portable unit like the Hensel Porty is just as good. The most important feature is a relatively long flash duration, which requires a fairly high flash energy of 400 to 1,200 Ws.

▶ You can apply this technique with a second accessory flash instead of a studio flash—if it is powerful enough and is set to full output. My experiments often produced a thin black stripe within the frame that was caused by the insufficient output of an accessory flash coupled with very short exposure times.

▶ If you have problems with this technique, make sure the preflash and, if available, the red-eye reduction assist lamp in your trigger flash are switched off. You can also try other triggers or replace the radio trigger with a TTL flash cable. You will soon discover which part of the system is causing trouble.

The photo on page 55 was also captured during our SuperSync shoot. The sun was already quite low, so it wasn't as bright as earlier in the session. We took this shot at 1/500 second, which would have plunged the subject into almost complete darkness had we not used the SuperSync/pseudo-HSS trick.

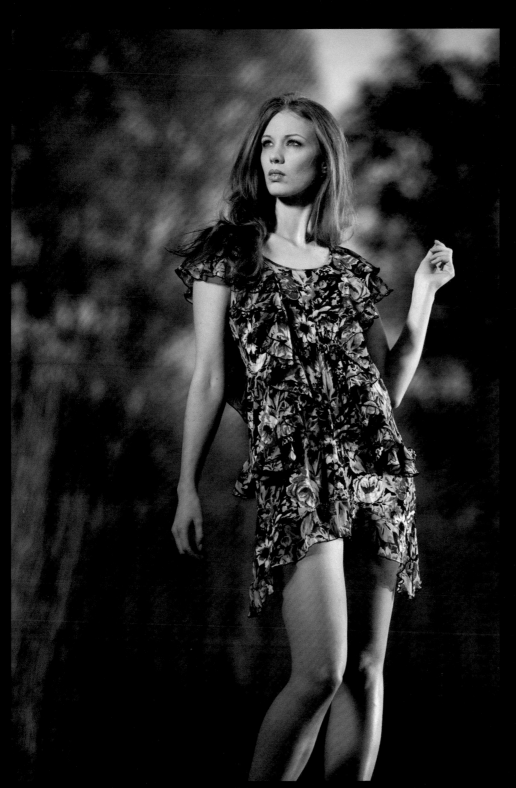

◀ *Shooting with flash on a sunny after-noon with the aperture wide open is pos-sible only with a clever trick or two (Model: Dominique)*

Canon EOS 5D Mark II | 70–200mm set to 145mm and f/3.2 | M mode | 1/640 second | ISO 100 | RAW

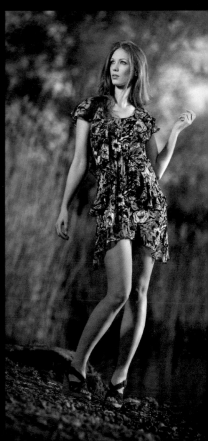

Workshop 5
Duke, Nuke Them 1

▸ *How to produce lots of light using multiple small flashes*
▸ *Using five flashes simultaneously*
▸ *Shooting with flash in the midday sun*

Shooting in the midday sun is usually not a good idea. The light comes from directly above, which gives subjects dark, shaded eyes and produces short, ugly shadows. A low sun is much better for backlit shots, too. At midday you can shoot in the shade with flash, but even there the ambient light is often still very bright.

Flash usually limits the exposure times you can use and often restricts you to shutter speeds of 1/200 or 1/250 second (see workshop 4 for tips on how to work around this limitation). In such cases, you often can expose correctly for the ambient light only by using a small aperture or an ND filter, which itself requires a lot of flash power to sufficiently illuminate the subject. A single on-camera flash is seldom powerful enough, so if your budget doesn't allow for a portable studio flash, multiple Speedlites are the way to go. The advantages and disadvantages of this approach are as follows:

Advantages:

▸ If you already own a number of flashes, acquiring a couple more non-TTL units won't stretch your budget too far.
▸ They are easy to transport, are easily scalable, and don't take up too much space when traveling.

▸ If you can afford additional TTL flashes, your setup will also be capable of HSS.
▸ Multiple flashes set to low output are faster than a single flash set to high output, making it easier to freeze high-speed action, such as water splashes.

Disadvantages:

▸ A setup with five flashes can produce up to 300 Ws of flash output. Battery-powered studio flash often has up to four times as much output, giving you the potential to further underexpose your subject's surroundings and make the sky and the surroundings look more dramatic.
▸ Recycle times are longer than if you use a professional-grade portable flash solution.
▸ Speedlights are not designed for this type of use. Shooting long sequences can lead to overheating and flash failure, although they usually recover (eventually).
▸ The relatively low capacity of the batteries and thermal overheating protection make long sessions impossible.
▸ Costs can quickly increase if you want to use a complex setup that is capable of HSS.

However you look at it, I love using this kind of setup, not only because of the advantages, but just because it is cool!

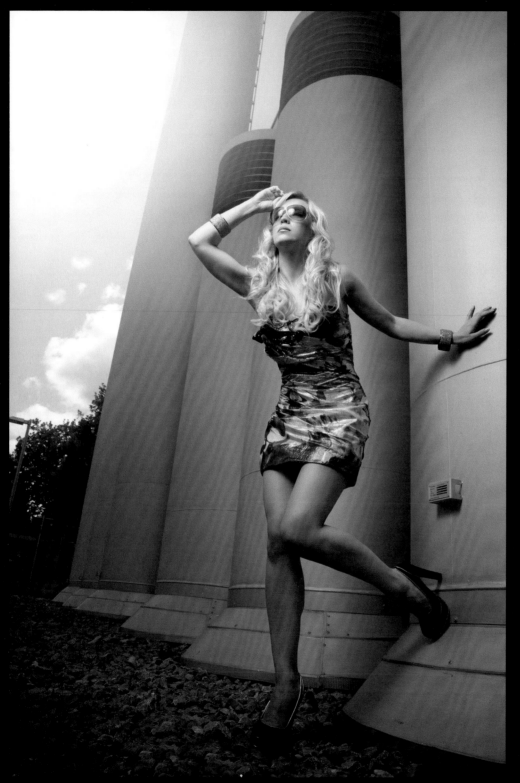

◄ *Flash portraits in the mid-day sun aren't easy to shoot, but they are possible (Model: Solnyshko)*

Canon EOS 5D Mark II | 24–105mm f/4 set to f/10 and 28mm | M mode | 1/125 second | ISO 100 | JPEG | white balance set to flash | five off-camera flashes fired simultane-ously through a white umbrella

The Setup

The accompanying photo shows the first prototype of the Duke Nukem setup with five non-TTL flashes from various manufacturers set up to fire through a white diffuser umbrella. The top three flashes are secured on a Lastolite TriFlash bracket, and the other two are affixed with homemade brackets that consist of a Walimex universal flash shoe, a Novoflex 19P ball head, and a Manfrotto Nano Clamp. To ensure that nothing came loose, I used a screw-thread locking adhesive from Loctite on the fastening screws. I then mounted the complete flash head on a conventional stand weighted with a one-gallon water jug. The umbrella swallows about 2 stops of light, but it softens the edges of the shadows and combines the five separate shadows from the flashes into one. It is possible to use this type of setup

▲ *Duke Nukem version 1. Five flashes are fired simultaneously through a shoot-through umbrella.*

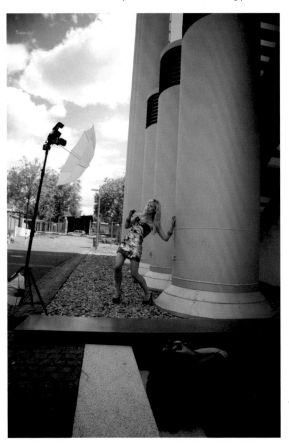

▲ *The model is positioned in the shade, but the midday sun is still very bright (co-photographer: Michele)*

without an umbrella, but the individual shadows would be more visible in the images. All five flashes are fired in manual mode using RF-602 radio triggers. You can also fire just one flash with a radio control and the others with an optical signal, but this approach is not as reliable.

Camera Settings and Shooting

The sequence of photos shows how we built up the scene to capture the final image. I began by shooting a couple test shots of the surroundings in auto mode to check out the most interesting details and angles of view. I then switched to manual mode and set the camera to expose correctly for the ambient light while taking the camera's sync speed of about 1/160 second into account (sync speeds vary from camera to camera). After I found the settings that made the background and sky look right, I added the flash trigger to the setup. It is best to position an umbrella so its stem points directly toward the subject's nose from above to prevent unflattering nose shadows. I then positioned the camera about 30 degrees to the light source so the light would look good even when the subject looked straight into the camera (which produces a loop lighting effect). In situations like this, you need to position the light as close

▲ **1.** Checking the location for interesting details and angles; **2.** setting the exposure for the surroundings in M mode without flash; **3.** adding the Duke Nukem, made up of five flashes set to high (almost full) output. This is the original unprocessed photo.

to the subject as possible while providing enough light to illuminate the entire upper body. The flash output has to be set to maximum (or almost maximum) to be effective.

Post-Processing in Photoshop

The processing steps I performed were relatively simple:

▸ Aligned, cropped, and repaired missing areas using the Clone Stamp
▸ Optimized the skin tones
▸ Warmed up the overall colors
▸ Increased saturation in the shadows and the subject's dress with the Sponge tool
▸ Applied some subtle dodging and burning
▸ Sharpened the image

▸ *The Photoshop layer stack showing the processing steps I performed*

Tips, Tricks, and Notes

This approach can be extended to encompass even more flashes. The FourSquare flash bracket (www.lightwaredirect.com) is a great piece of equipment that can be mounted at 45 degrees to a second unit so you can create a stable holder for eight flashes! These brackets are not inexpensive, but they are rock solid. Check out how to put them to use in Dave Black's surfing shoot at www.tiny.cc/eu6wlw.

Using multiple flashes gets even more interesting if you use TTL units that have a built-in HSS mode. Multiple flash setups are often referred to as gang light, and a quick Internet search for that term in combination with the term strobist will show you some great examples of how to use it. You don't have to use costly PocketWizard triggers for all the flashes in a multiple flash setup; you can just as easily trigger a single main flash with a TTL cable and trigger the others with simple optical slave cells.

Workshop 6
Duke, Nuke Them 2

- ▸ *How to produce lots of light using small flashes*
- ▸ *Using five flashes simultaneously*
- ▸ *Shooting with a wide aperture in the midday sun with an ND filter*

The previous workshop showed how to simultaneously use five flashes, but you may want less depth of field and more bokeh. The setup demands a small aperture that retains sharpness throughout the frame. Using an ND filter is one way to bring wider apertures and therefore less depth of field into play in a daytime shoot.

Neutral Density Filters

ND filters reduce the strength of the incident light and help make it possible to use wide apertures at speeds greater than the camera's sync speed. ND filters are labeled as shown in the accompanying table

Density	Exposure Time Increase Factor	EV
0.3x	ND2	–1
0.6x	ND4	–2
0.9x	ND8	–3
1.2x	ND16	–4
1.5x	ND32	–5
1.8x	ND64	–6
2.1x	ND128	–7
2.4x	ND256	–8
2.7x	ND512	–9
3.0x	ND1024	–10

▲ *ND filter labeling convention*

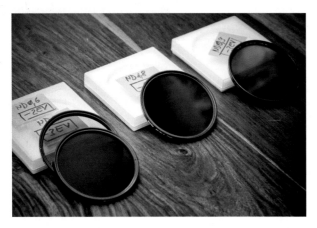

▲ *A selection of ND filters*

▸ *A flash-lit portrait with background bokeh captured in the midday sun—an ND filter made it possible (Model: Solnyshko)*

Canon EOS 5D Mark II | EF 85mm f/1.8 set to f/2.5 with a 5 stop ND filter | M mode | 1/200 second | ISO 100 | RAW | white balance set to flash | five off-camera flashes fired simultaneously through a white shoot-through umbrella

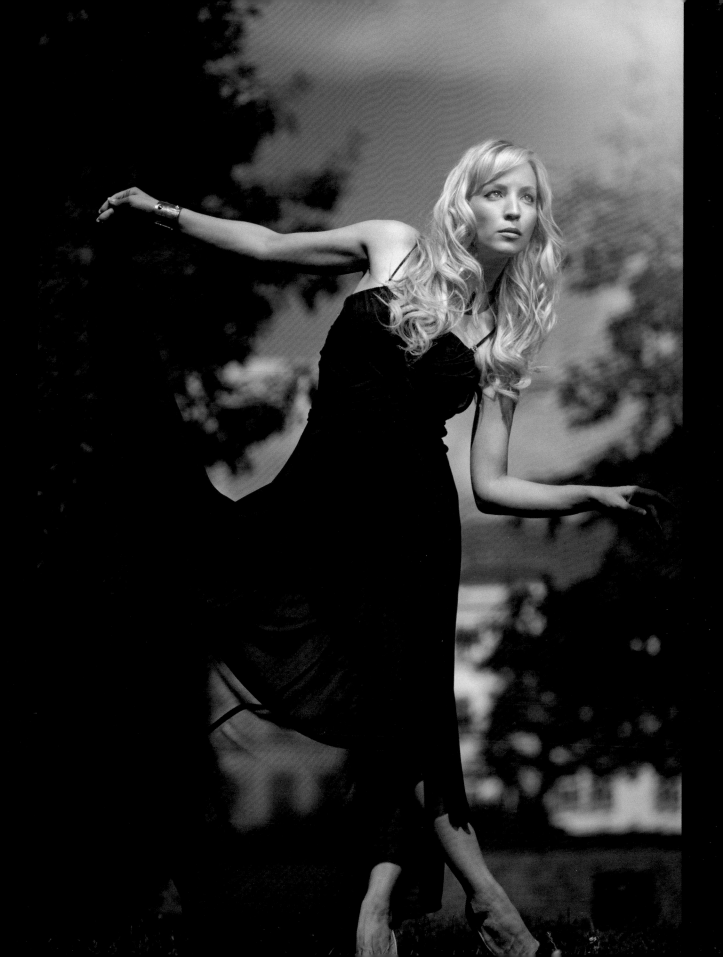

The Setup

We set up the scene shown in the photo on page 65 so the interesting background was visible but blurred when it was captured with a moderately wide aperture.

Camera Settings and Shooting

For this shot I switched to a short telephoto EF 85mm f/1.8 lens set to f/2.5. I then had to work out which ND filter to use; the previous aperture setting was f/14, and the new one was f/2.5, which covers 5 stops (f/2.8, f/4, f/5.6, f/8, f/11, f/16), if you use the nearest full stops. This means that an ND32 filter was required (see the previous table). An ND64 filter would also work with a slightly wider aperture. I captured this shot in RAW format to make it easier to correct the exposure and adjust the slight color cast caused by the filter, without losing data.

Post-Processing in Photoshop

In addition to the steps described in the previous workshop, I also used a Hue/Saturation adjustment layer to correct the slight color cast that the ND filter produced.

Tips, Tricks, and Notes

Following are some tips to keep in mind when you use ND filters:

▶ ND filters are available from various manufacturers in a wide range of prices. I have found that the color shifts produced by ND filters correspond almost directly to price. If you want to produce authentic-looking results, purchase filters from a manufacturer with a good reputation, such as B+W or Hoya, even though they are more expensive.
▶ Be careful when you stack ND filters to achieve the correct strength. That's what I did for this shot because I couldn't find my ND32 filter. Image quality and color fidelity are reduced with each additional layer of glass. Not all ND filters can be stacked—the slim filters made by Hoya, for example, cannot.

▶ Like other filters, ND filters are available in various sizes. All of mine are 77mm. If I am using a smaller lens, I simply handhold the filter in front of it.
▶ Variable-strength ND filters are available. I have found that cheaper filters are detrimental to image quality, and high-end filters from companies like Singh-Ray are too expensive. It costs less to purchase a complete set of single-strength filters that are as good as, or even better than, the most expensive variable filters.
▶ Don't use combinations of polarizer, ultraviolet (UV), and skylight filters. A high-quality sunshade for each of your lenses is a better investment. It also protects the front element of your lens and improves image quality.

▼ *An overview of our setup*

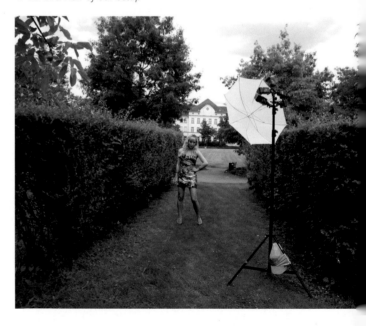

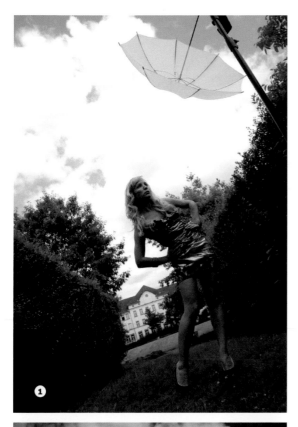

◀ **1.** *This is how the scene looked when it was captured by a wide-angle lens without flash or an ND filter.*

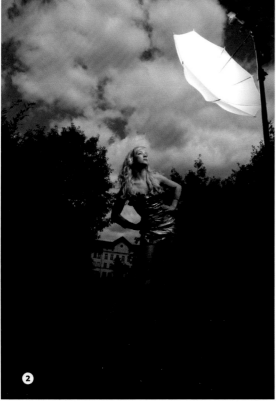

◀ **2.** *The same wide-angle shot was taken with flash, and the exposure was dialed down to suit the ambient light.*

Canon EOS 5D Mark II | 24–105mm f/4 set to f/14 and 24mm | M mode | 1/160 second | ISO 100 | JPEG | white balance set to flash | five off-camera flashes fired through a white shoot-through umbrella

Workshop 7
Colored Gels Rock!

▸ *Using filters to produce color accents*
▸ *How to mix colors*

The "Spectra and Tricks with Color Filters" tutorial on page 72 explains how to use filters and alter white balance settings to change the color temperature or artificially color the background in your images. But filters can be used for more artistic purposes too. I have two sets of filters: the serious ones, such as CTO and green, for making selective color shifts (they are carefully sorted and labeled); and my fun filters, which include a random mix of bright colors including yellow, pink, green, purple, and all the others you can find in a LEE swatch book—the more colorful, the better. Any time a scene seems too dull, I can brighten it up with a color filter or two.

I don't usually use color filters on my main lights, but they are great for side lights or background accent lights. Reflective surfaces like windows or puddles are perfect for amplifying the filter effects and creating multicolored reflections.

The Setup

For this shot, we used four off-camera YN-460 non-TTL, non-zoom flashes without additional light modifiers. The two background flashes were fitted with colored gels and arranged so one pointed straight into the camera and the other pointed at the window on the right. The light from these accent flashes was reflected and intensified by the ground and the window. We used the other two flashes as rim and main lights for the model. We used RF-602 radio receivers on all four flashes.

▲ *Four off-camera flashes without light modifiers, two of which are fitted with colored gels*

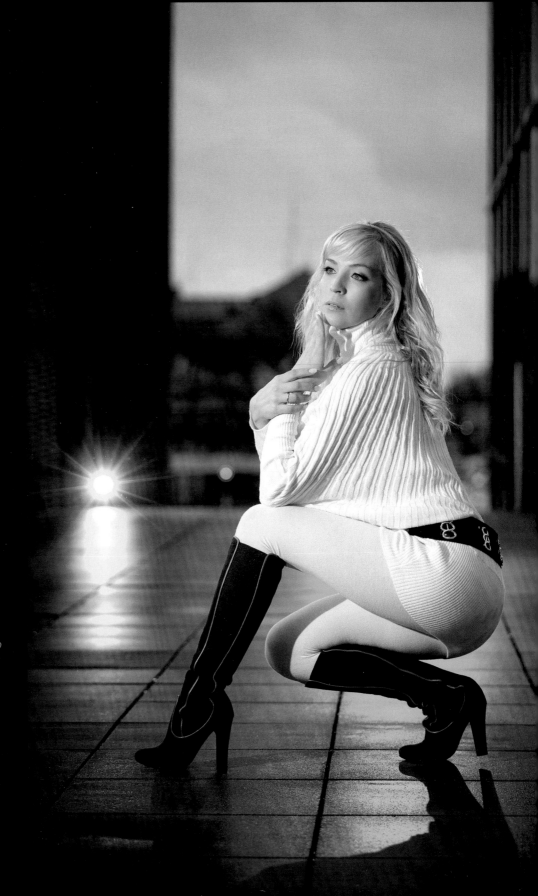

▶ *Accent flashes with color filters can add real sparkle to an otherwise ordinary image (Model: Solnyshko)*

Canon EOS 5D Mark II | EF 70–200mm f/2.8 set to f/3.2 and 90mm | M mode | 1/160 second | ISO 100 | RAW | white balance set to flash | four off-camera flashes, two with colored gels, no light shapers

The turquoise and yellow filters we used are about 120 degrees apart on the color wheel (complementary colors are 180 degrees apart). In this case, the choice was random, but personally, I have found that colors separated by 120 degrees often work quite well together.

Camera Settings and Shooting

The ambient light was fairly dull, so our flashes were really effective right from the start. Here too, the best way to begin is using manual (M) mode to expose for the background and the detail in the sky without the flash trigger mounted. These settings will leave the subject underexposed, but that is where the flashes come in. Set up your main light first, followed by the rim light then the accent lights. Make some test shots starting at 1/8 output and work up slowly to the correct settings. Because they were farther away, the colored background flashes required quite a bit of power (recall the inverse square law from chapter 1). We will talk about how to affix the gels to the flashes in the tutorial on page 72.

Post-Processing in Photoshop

As usual, the initial post-processing steps involve straightening the image and selecting a slightly tighter crop, followed by adjustments to contrast and color, and finally some subtle beauty retouching to optimize the subject's skin tones. You can always add a logo or some text like "Fashion" and then perform your final sharpening for output.

▲ *The location seen from the viewpoint of a passerby. This photo shows us setting up the main lights (Model: Solnyshko; co-photographer, Ray Sjoeberg)*

▲ *The finished, processed image and the corresponding layer stack*

Tips, Tricks, and Notes

Mixing colors the way we did opens up a whole new world of possibilities. The other examples reproduced here show just two of the countless variations. The setup was similar, but we used different colored gels. We used a 50mm Lensbaby Composer with a Double Glass Optic for the shot on this page.

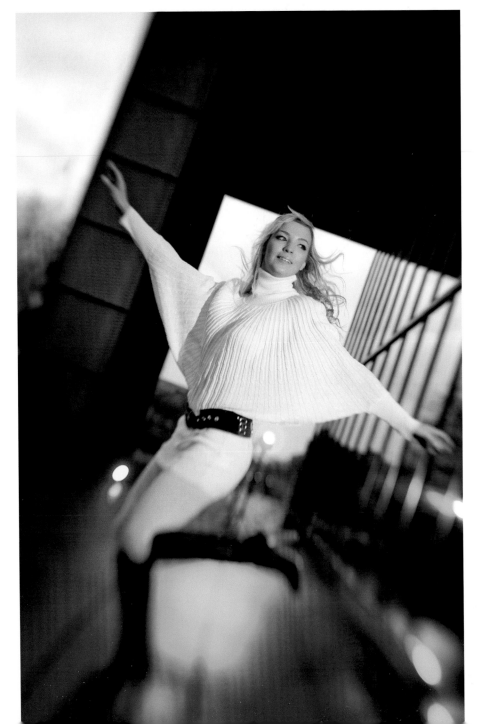

◀ *I admit this shot is a little over the top, but at least it isn't boring! (Model: Solnyshko)*

Canon EOS 5D Mark II | Lensbaby 50mm set to f/4 | M mode | 1/200 second | ISO 400 | RAW | white balance set to flash

In Depth:
Spectra and Tricks with Color Filters

Have you ever photographed in fluorescent light and found that, despite having made the appropriate white balance setting (in your camera or during RAW import), your photos don't look natural? The human eye is especially sensitive when it comes to perceiving colors in skin tones and and in food, and it picks up on even the tiniest discrepancies. Fluorescent lamps come in many shapes and sizes with various color temperatures, and the spectra they produce often contain gaps (the spectra of LEDs have the same characteristics).

White Balance | Setting white balance using a white card, a SpyderCUBE, or some other tool sometimes works very well, but tools often fail in fluorescent light.

▼ *Left to right: These graphs show the relative intensities of the visible spectra produced by sunlight, xenon flash, a conventional light bulb, and fluorescent (neon) light. The graphs are based on data found at www.tiny.cc/p18wlw.*

The spectrum produced by fluorescent light is made up of a few isolated green and purple peaks, which is very different from the continuous spectrum provided by daylight.

A calibration chart like the DC Pro target can help to set things straight, but if you have to shoot under mixed light sources, automatic white balance (AWB) is often a good choice; it will usually select a setting that is close to the desired result. If you shoot in RAW format, you can adjust the white balance later, with no loss of image quality. You can see how altering the white balance reduces image quality by checking the adjustment against the exposure meter readout; the difference can be as much as ±1 EV. If possible, always use RAW format in tricky lighting. Successfully adjusting the white balance at the post-processing stage is virtually impossible for JPEG images.

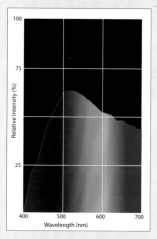
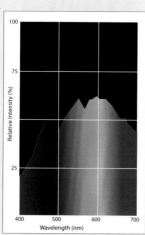

Gel Filters | Although they are now made of plastic, color filters used to be made of gelatin, which is where the word gel comes from. Gels are indispensable for flash photography and are most commonly used to help match the temperatures of ambient and artificial light. I keep my effects filters unsorted in one wallet, and I keep specific white balance filters, such as my LEE 204 CTO and my LEE 244 Plus Green, carefully labeled in a separate wallet.

Orange filters are perfect for mixing flash with tungsten or halogen light. These filters are called 1/4, 1/2, 3/4, or 1/1 (full) color temperature orange (CTO). Color temperature straw (CTS) filters are yellow and create a sunny effect. The accompanying table lists the most commonly used filters and the differences they make to daylight, which is 6500 K.

Fluorescent (neon) light is trickier to deal with. Some photographers recommend that you use a LEE 244 Plus Green (or similar) filter on your flash and set your white balance to fluorescent. This approach can work, but shooting in fluorescent light is always frustrating and should be avoided if possible.

Instead of using a filter to alter the color of the background light, you can work the other way around and use a filter to alter the color of the main flash and shift the colors for the subject and the background later in the camera or on a computer. This saves you from having to use a background flash and can produce a better overall effect. There are two ways to approach this kind of lighting.

Color	LEE filter number	Color temperature conversion
1/8 CTO	LEE 223	6500 to 5550 K
1/4 CTO	LEE 206	6500 to 4600 K
1/2 CTO	LEE 205	6500 to 3800 K
3/4 CTO	LEE 285	6500 to 3600 K
1/1 CTO (full)	LEE 204	6500 to 3200 K
1/8 CTS	LEE 444	6500 to 5700 K
1/4 CTS	LEE 443	6500 to 5100 K
1/2 CTS	LEE 442	6500 to 4300 K
1/1 CTS (full)	LEE 441	6500 to 3200 K

▲ *The values assigned to a selection of commonly used LEE filters*

▲ *The simplest way to affix colored gels to your flash is to use homemade plastic tabs cut from spare gels that you can insert into the diffuser slot on the flash head. The filters stay put, and you don't need to use tape or Velcro.*

▶ *A LEE Filters swatch book contains everything a strobist's heart desires. Empty gum packages are great for storing filters when they are not in use.*

▲ *A full CTO filter on the flash along with a flash or day-light white balance setting produce orange skin tones and a normal-looking background*

Color Shift Based on a Known Color Temperature | If you use a full CTO filter, you know in advance that your flash will produce light with the same color temperature as a traditional light bulb, and you can set your white balance to tungsten.

Color Shift Based on an Unknown Color Temperature | If you aren't sure of the color temperature shift produced by your filter, you have to calibrate your camera accordingly. To do this, hold the filter in front of the lens, shoot a test image of a white or gray surface, and set your white balance manually using the reading you just made. This is called Custom WB (Canon) or PRE (Preset manual; Nikon).

You can use the same approach and a blue filter to turn the background red. You can also attach a filter to your flash and shoot a flash-lit photo of a white or gray surface to find the appropriate white balance setting. The process is explained in detail in Gary Fong's YouTube video at www.tiny.cc/128wlw. A complete list of LEE filters and the effects they produce, as well as a downloadable version of the LEE Swatchball filter comparison program, can be found at www.leefilters.com/lighting/colour-list.html.

When you use it with color filters and flash, your camera's manual white balance setting opens up a new world of creative possibilities.

▲ *A full CTO LEE 204 gel on the flash and a tungsten in-camera white balance setting produce natural-looking skin tones and an artificially colored blue background. For this shot we fired an additional flash with a purple gel from the right.*

▲ *When you use it with color filters and flash, your camera's manual white balance setting opens up a new world of creative possibilities*

◄ Evelyn, my most patient model, photographed in front of a white background. Left: With CTO and blue filters mounted one above the other on the flash. Right: With orange and purple filters on the flash and manual white balance set as described in the text.

▼ The result of using the color filter trick along with some subtle retouching and a color shift in Photoshop CS6 using Adjustment Layer and Color Lookup > Late Sunset (Model: LondonQueen)

Canon EOS 5D Mark II | EF 24–105mm f/4.0L set to 50mm and f/4 | M mode | 1/125 second | ISO 400 | RAW | off-camera flash with a CTO filter fired through a white shoot-through umbrella from the front, flash with a purple gel from the back (right side), white balance set to tungsten

Workshop 8
Creating a Fire Effect with an Orange Filter

> ▸ *Using an orange filter to set the scene on fire*
> ▸ *How to create smoke effects*

If you are shooting on location in the evening or at night, your flash won't have to compete with the sun, but you run the risk of your backgrounds looking dark and uninteresting. In an urban environment you can simply use the bokeh of any background lights for a livelier background, but in a rural area you have to produce your own background lighting. We shot this workshop at a nearby lake where the reeds provided an interesting counterpoint to the subject. We used one flash on a stand to light the reeds and another fired through a white shoot-through umbrella to illuminate the model.

The Setup

We fitted the effect flash in the reeds with a full CTO gel to create a fire-like effect. See the "Spectra and Tricks with Color Filters" tutorial on page 72 for details on mounting and using gel filters. This effect flash shines toward the camera and is partially obscured by the model. To enhance the fire effect, we set off a smoke tablet in front of the flash.

We lit the main subject with a second flash mounted on a stand behind a white shoot-through umbrella. We used two non-TTL YN-460 flashes triggered by RF-602 modules.

Camera Settings and Shooting

First I set up the camera to capture some background detail without flash. Because it was quite dark, I increased the ISO to 500, which allowed me to shoot handheld at 1/80 second at a focal length of about 100mm. I used f/4, rather than the maximum aperture of f/2.8, to ensure the model's eyes were in perfect focus. Because I had already increased the ISO sensitivity, I starting testing the flashes at 1/8 output and fine-tuned them from there.

◀ *Schematic of our setup showing our main flash fired through a white umbrella and our background flash with its full CTO filter (without light modifiers) in the background*

▶ *Using a flash with an orange filter is preferable to setting the reeds on fire! (Model: Neleta; co-photographer: Niko/NN-Foto)*

Canon EOS 5D Mark II | 70–200mm f/2.8L IS II set to f/4 and 95mm | M mode | 1/80 second | ISO 500 | RAW | white balance set to flash | two off-camera flashes: one from behind with a full CTO filter, and the other from in front fired through a white shoot-through umbrella

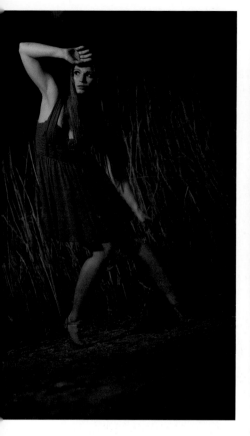

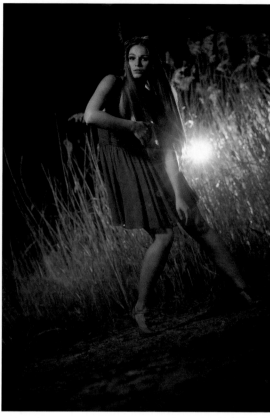

◄ *Two of our test shots: one without an effect flash, and one with an effect flash. The second image shows a nice starburst effect (we added the smoke effect later).*

Post-Processing in Photoshop

In addition to my standard processing steps, I concentrated on emphasizing the flash light. I also added more smoke, a vignette, and a color adjustment. You can create realistic-looking light rays in Photoshop as follows:

▶ Create a duplicate layer (Ctrl+J) using the Lighter Color blending mode.
▶ Add Filter > Blur > Radial Blur with an Amount setting of 100 and Blur Method set to Zoom. Use your mouse to select the center of the effect.

The original image is shown on the bottom left on page 79, and the post-processed version, with its relatively complex layer stack, is shown on the bottom right. This may seem complicated, but even simple processing steps can produce a lot of layers. Always process an image carefully and build the look you want one step at a time.

Tips, Tricks, and Notes

The images on these pages include some with lens flare and some with starburst effects. You can deliberately produce them as follows:

▶ Lens flares occur when you shoot directly into the light. You can emphasize the effect by shooting without a sunshade, opening the aperture, and using a skylight or UV filter. To reduce the strength of the effect, make sure the light source is almost completely obscured by the subject.
▶ Starbursts occur when you shoot with a small aperture. The number of rays a starburst has depends on the number of aperture blades, and its strength depends on the internal construction of the lens. You can enhance the effect by stopping down or using a dedicated effect filter, like the Cokin starburst filter.

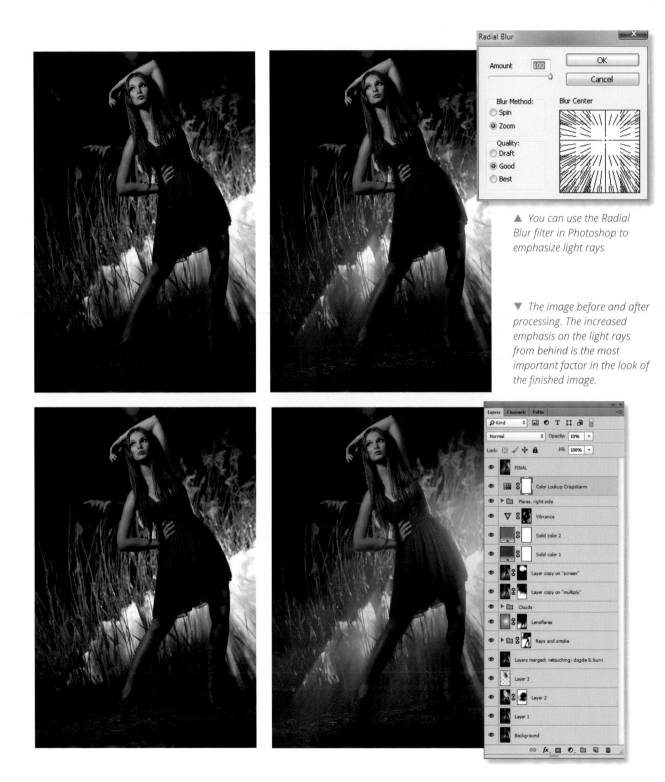

▲ You can use the Radial Blur filter in Photoshop to emphasize light rays

▼ The image before and after processing. The increased emphasis on the light rays from behind is the most important factor in the look of the finished image.

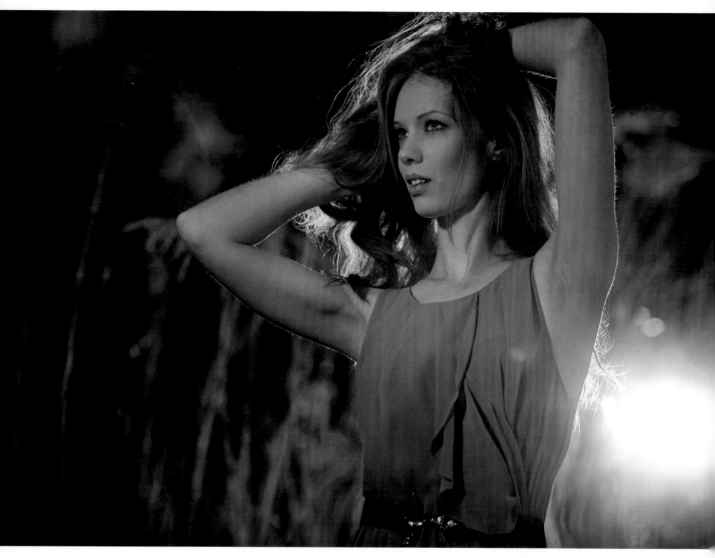

▲ *Another image from our fire shoot, this time with pronounced lens flare*

Canon EOS 5D Mark II | EF 70–200mm f/2.8L IS II set to f/2.8 and 200mm | M mode | 1/80 second | ISO 200 | RAW | white balance set to flash | two off-camera flashes: one from behind with a full CTO filter, the other in front fired through a white umbrella (Model: Dominique)

In Depth:
Don't Shake It Up

Flash can be used to freeze the movement of a subject, but if you include ambient light in your flash shots and don't hold the camera completely still, you will see ghosting effects in your photos. The old rule of thumb that says 1/50 second is the slowest you can effectively shoot handheld is a useful point of reference, but today's technology has fundamentally changed the way we shoot. The 1/50 rule was formulated for 35mm film cameras with a 24mm x 36mm frame and a standard 50mm lens. Using a longer lens required a new calculation to compensate for the increased risk of camera shake.

Therefore, it is generally accepted that you can take handheld images free of camera shake with an exposure time of *1/focal length* for a full-frame camera.

If your camera has a smaller sensor, you need to include the crop factor in your calculations. For example, a 50mm full-frame lens behaves like an 80mm lens if it is on an APS-C camera with a crop factor of 1.6. The focal length remains the same, but the results are quite different.

For non-full-frame cameras, the modified formula says an exposure time of *[(1/focal length)/ crop factor]* can generally be used to shoot handheld images with no camera shake.

This is closer to reality, but it's not always true because of modern image stabilization systems. Image stabilization (IS) and vibration compensation (VC) systems allow us to shoot with much longer exposure times than before. Camera manufacturers claim improvements of between 2 and 4 EV, which equates to a factor of 4 to 16 when applied to exposure times.

In other words, the old formula can now be expressed as *[(1/focal length)/crop factor] x a factor of 4 to 16 with image stabilization*, or written as a formula:

$$t_{max} = \frac{1}{f \cdot c_{crop}} \cdot c_{Stabi}$$

In this case, f = focal length, c_{crop} = crop factor (e.g., 1.6 for APS-C or DX), and c_{stabi} = factor of 4–16 with active image stabilization. In real-world situations, you won't have time to work this out precisely, so you will have to make a quick mental calculation that goes something like this: "I'm using a full-frame camera with a stabilized zoom set to 100mm. A conservative stabilizer factor of about 4 means I can reasonably expect to shoot without camera shake at 1/25 second."

The same thought process should result in about 1/40 second for an APS-C or DX camera. Whichever numbers you come up with, always hold your camera as still as possible, press it tight to your eye, make sure you are standing firmly, and hold your breath while you press the shutter release. Burst shooting is also a useful tool for combating camera shake. Shooting three or four images in quick succession increases the probability of at least one frame being sharp.

Workshop 9
Key Shifting

▸ *All about key shifting*
▸ *How to create a punchy lighting setup*

Usually photographers can shoot for free in public spaces. Although some parks in Frankfurt, Germany now charge a special-use fee of 50 euros (about $70), one of my favorite locations, the Bolongaro Park, in the Hoechst area of Frankfurt, still allows you to shoot for free if you request permission first. This wonderful place is full of sculptures and has a fountain, a giant outdoor chessboard, and two stone staircases, one of which you can see in the photos here. The whole place is perfect for fashion shoots. We used the *key shifting* flash technique to turn day into night, and the following sections explain how.

The Setup

This was a relatively complex shoot. We used a battery-powered studio flash with a beauty dish as our main light, and we placed an additional flash (a speedlight) without modifiers at the top of the staircase to act as a rim/effect light that is visible in the final image. A third flash (also a speedlight) was located to the right of the railing to create the shadow you can see in the finished image. We set up a California Sunbounce reflector to the left of the stairs to provide some fill light. As you can see in the schematic, we placed the beauty dish a long way from the subject so it lit the scene adequately without appearing in the frame. The extra distance meant we had to dial the main light up to 1/4 output. Alternative setups for use with only accessory flashes are listed at the end of this workshop.

▲ *A battery-powered studio flash with a beauty dish at the left, two off-camera flashes at the right and from behind and above, and a large reflector opposite the second flash*

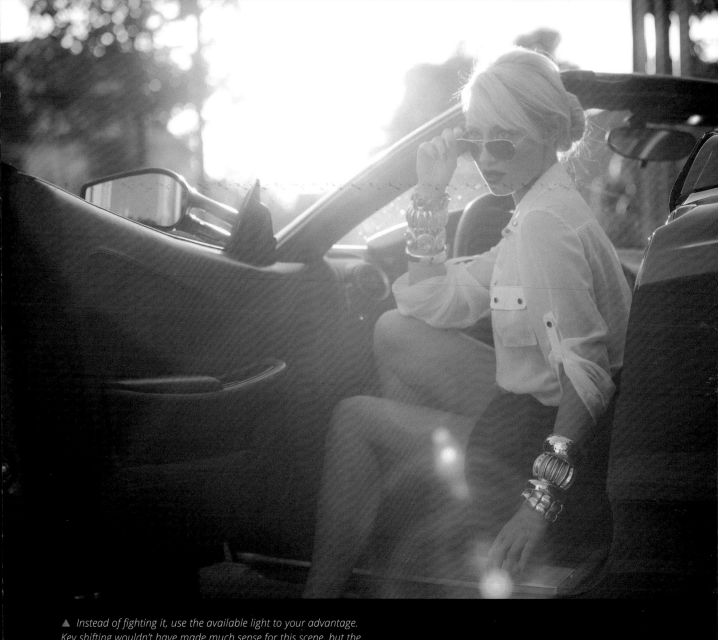

▲ Instead of fighting it, use the available light to your advantage. Key shifting wouldn't have made much sense for this scene, but the backlit flares make for a really punchy image. This is one of the few images in this book that was taken without flash. (Model: Diana)

Camera Settings and Shooting

What makes this scene particularly interesting are the camera settings and the use of key shifting (see the text box below). To demonstrate the effect, look at the two images on page 85. You can see the first shot taken in diffuse ambient light without flash. Technically speaking, the image is okay, but it isn't very interesting. Adding flash wouldn't help because the subject is correctly lit—additional light would only cause it to be overexposed.

If, as shown in the second example, we key shift the shot (i.e., we deliberately underexpose the surroundings by about 2 stops), we end up with a shot that appears to have been captured in the evening, and the flash provides effective accents. For shots like this you can check the amount of underexposure on the metering scale in your viewfinder. We started with our flashes set to 1/8 output and the main light to 1/4 output, and we worked up to the correct settings from there. In multiflash setups, it is usually best to add each flash separately in sequence.

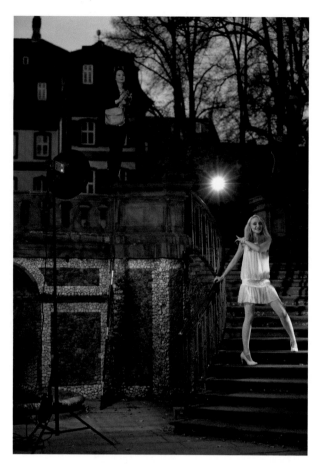

▲ *The setup showing our makeup artist (with leaves), the beauty dish, the large reflector on the left, and the effect light at the top of the stairs. The flash on the right that produced the shadow of the railing is not visible in this shot. (Model: Ann-Catrin)*

Key Shifting, Dragging the Shutter, and American Night

Key shifting describes a technique that is often referred to as *dragging the shutter*, which alters the interplay of ambient light and flash light in a photo. This is typically—but not always—achieved by changing the exposure time, which alters the effect of ambient light but not flash light.

To drag the shutter, you typically increase the exposure time to allow more ambient light to reach the sensor. But you can also reduce the exposure time to allow less ambient light. The term *key* describes which part of the tonal scale makes up the majority of the image. Most of the tones in a *low-key* (i.e., darker) image are located toward the left side of the histogram, whereas a *high-key* image is bright and contains tones that are mostly located toward the right side of the histogram. By adjusting the exposure time to alter the relationship between the ambient light and the flash light, you alter the key—and therefore the look and feel of the image. Reducing the exposure time allows less ambient light to reach the sensor; increasing it has the opposite effect. In this workshop I reduced the exposure time to darken the surroundings and the sky to create a darker mood. This effect, with its deep blue sky, is also known as *American night,* named after a François Truffaut film called *La nuit américaine* that used this effect to excess. It is also sometimes called *day for night.*

Post-Processing in Photoshop

The flash light provided plenty of contrast, and the colors were nice and punchy straight out of the camera. The additional processing steps we applied were as follows:

▸ Straightened the horizon and cropped the image a little tighter
▸ Added a vignette with the P.O.S. Lens filter in the RadLab plug-in
▸ Performed a little standard beauty retouching and subtly applied the Liquify filter
▸ Slightly dodged and burned
▸ Retouched the model's skin tone with the Dynamic Skin Softener filter in Nik Color Efex
▸ Slightly whitened the subject's teeth
▸ Applied a second vignette
▸ Merged the layers and applied Smart Sharpening to the result (see the layer stack reproduced on the next page)

▼ *Underexposing the surroundings by 2 stops and adding flash produces an exciting, high-contrast image with a darker feel. The histogram shows the change to the distribution in tonal values (i.e., the change in key) with this approach—hence the name of the effect is key shifting.*

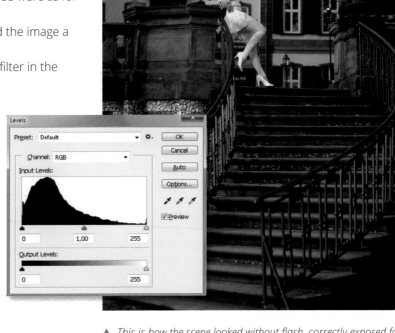

▲ *This is how the scene looked without flash, correctly exposed for the ambient light, but simply boring. Compare the histogram with the one below.*

Canon EOS 5D Mark II | EF 70–200mm f/2.8L IS II set to 70mm and f/2.8 | M mode | 1/125 second | ISO 100 | RAW

▲ *Before and after images and the corresponding Photoshop layer stack. The most obvious effect is produced by the vignette.*

Tips, Tricks, and Notes

This is one of the few workshops in which we used a powerful battery-powered studio flash along with Speedlites. We could have set up this scene with just Speedlites if we had used the Duke Nukem (see workshop 5). The problem with using the Duke Nukem instead of a studio flash is that you can't use it with a beauty dish. A white umbrella would have produced similar results, but if you rely on consistently reproducible results, a studio flash powered by rechargeable batteries is a better option. Such a flash unit can produce usable light even when the sun is high in the sky (see workshop 6).

If, however, you prefer to work with ambient light, you need to make the best of the conditions. If the sun is too bright, you can work without flash, use backlight, or work in the shade with a reflector. If diffuse daylight is still too bright to perform key shifting with Speedlites, try to find another location in different light while you wait for the blue hour.

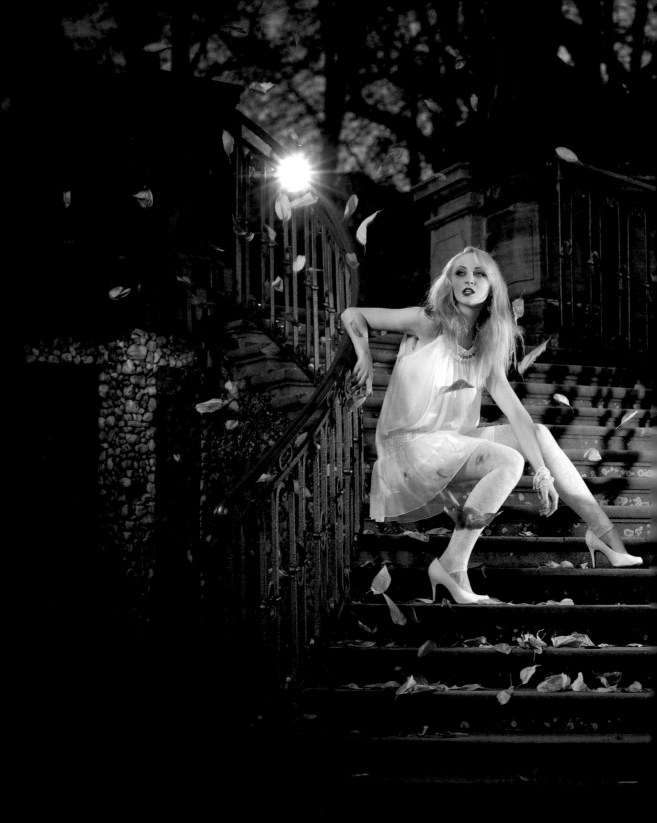

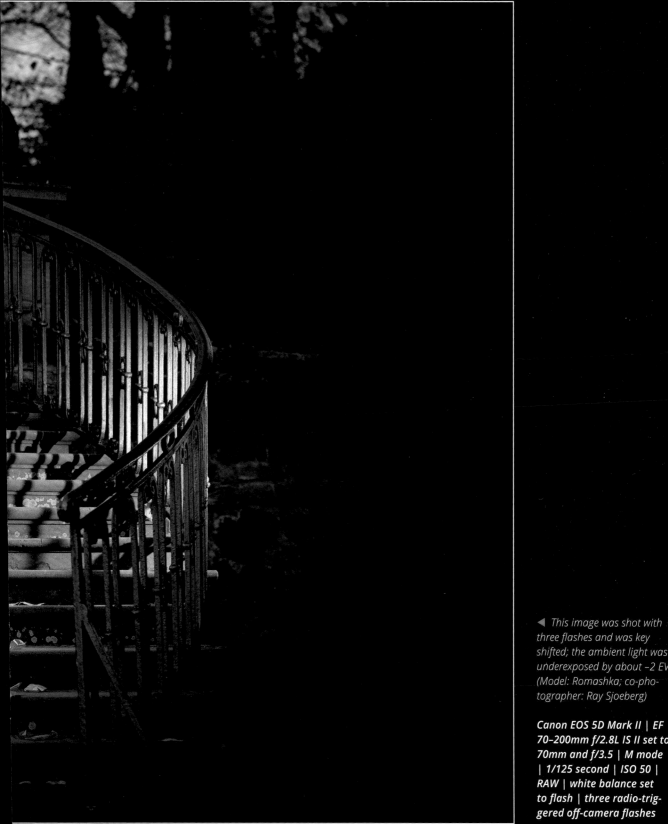

◀ This image was shot with three flashes and was key shifted; the ambient light was underexposed by about −2 EV (Model: Romashka; co-photographer: Ray Sjoeberg)

Canon EOS 5D Mark II | EF 70–200mm f/2.8L IS II set to 70mm and f/3.5 | M mode | 1/125 second | ISO 50 | RAW | white balance set to flash | three radio-triggered off-camera flashes

Workshop 10
Fashion Shoot in Hard Light

The leaves in this image may look like an artificial studio background, but they are real. We really did take a leather chair into the woods, and guess who had to carry it! It was worth the effort, and the leather and wood of the chair perfectly suited the autumn leaves and the model's outfit. In contrast to our main prop, our lighting rig was easy to transport. It consisted of two small stands with umbrella swivels, two radio triggers, and two flashes. This setup does not require light modifiers, and you can decide later how soft you want the shadows to be.

The Setup

We used two cheap Yongnuo YN-460 non-TTL flashes, which have internal reflectors fixed at a 35-degree angle of spread, and the modest output was perfectly adequate for a simple setup like this. The effect is similar to a cross lighting setup, but the lights are arranged on one side instead of opposite each other. This prevents the accent light stand from appearing within the

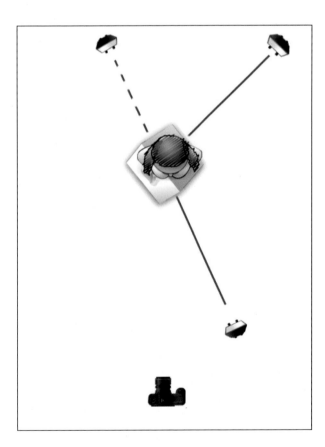

◀ *We used two off-camera non-TTL flashes, one at the front right and the other at the back right. The effect is similar to that of a conventional cross lighting setup (represented by the dashed line), but the accent light is on the right instead of the left.*

▶ *A fashion photo shot in the woods using two off-camera flashes and no light modifiers (Model: Lu)*

Canon EOS 5D Mark II | EF 70–200mm f/2.8L IS II set to f/3.2 and 125mm | M mode | 1/200 second | ISO 160 | RAW | white balance set to flash | two off-camera flashes without light modifiers

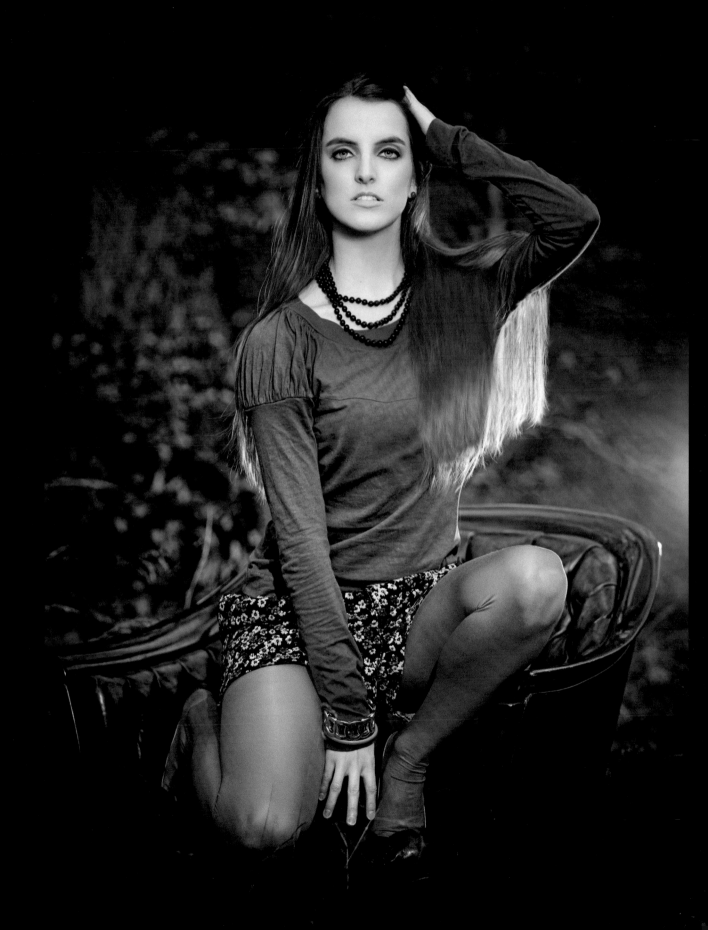

◀ *The original photo (left), and the post-processed version (right)*

frame, but the flash can still function as a rim light that accentuates the subject against the background, just as it would in a cross lighting setup. The main light is set up at about 30 degrees to the subject to prevent the shadow around her nose from being too obvious. Both flashes were located about 10 ft from the subject.

Camera Settings and Shooting

As usual, take a couple test shots without flash to get the right look for the background before you add the flashes. You can add the flashes in one step for this setup.

I began my test shots at 1/4 output and ISO 100. The histogram revealed a slight overall underexposure, so I just dialed in ISO 160 to correct this. Any other change—such as in aperture, shutter speed, flash output, or flash-to-subject distance—would have altered the look of the image too much.

I then set the white balance to flash and I stopped the lens down slightly to f/3.2 to keep everything nice and sharp.

Post-Processing in Photoshop

It took almost two hours to process this image, mainly because of the alterations we made to the model's hair and the creases in her shirt. The before and after versions are shown above and the steps we used are as follows:

▶ Straightened and cropped the image
▶ Balanced the contrast and color with the Tonal Contrast filter in Nik Color Efex 4.0
▶ Retouched the model's skin tones with the Dynamic Skin Softener filter in Nik Color Efex 4.0
▶ Slightly liquefied the image at the model's waist and neck
▶ Made eye enhancements
▶ Softened the chin and nose shadows (see "Tips, Tricks, and Notes" in this workshop)
▶ Repaired the model's hair and the creases in her shirt
▶ Added a vignette with the P.O.S. Lens filter in the RadLab plug-in
▶ Applied Smart Sharpening

In addition to my usual retouching steps, I also used the Patch tool to soften the shadows. Even though a white umbrella or a small softbox on the main light would have had the same effect, using hard light teaches you how to position and aim your lights—at least in my eyes, that influences the look of an image more than changing the light modifiers.

Tips, Tricks, and Notes

The Yongnuo YN-460 is so cheap it won't cause any real heartache if it breaks. However, even if its flash capability is still going strong, its buttons are sure to fall apart. You can see a useful how-to guide that explains how to repair them and other rubber buttons at www.tiny.cc/uv6wlw.

The image for this workshop would not have been possible without Photoshop, and the alterations we made to the model's hair play a significant role in the quality of the final result. You can capture natural-looking portraits without additional processing, but nowadays fashion and beauty shots made without digital help are rare. If you want to work in the fashion or beauty industries, I wholeheartedly recommend the retouching DVDs by Gry Garness and Natalia Taffarel, which offer high-end tips that will help any aspiring fashion photographer come to grips with the demands of the business.

▲ *Three clicks is all it takes to soften shadows with Photoshop's Patch tool*

Workshop 11
Nighttime Bokeh

▸ *How to capture wonderful background bokeh in urban settings*
▸ *Setting up your lights*

Bokeh (those lovely out-of-focus areas in an image) is addictive, and lenses that produce beautiful bokeh are usually expensive! Bokeh can be captured in daylight (see the "Depth of Field and Bokeh" tutorial on page 98), but it really comes into its own at night when the circles of confusion produced by the lens form beautiful bokeh bubbles. I love shooting in the evening and at night when the light is at its most tantalizing. The downside of this time of day is it increases the risk of camera shake and image noise, and focusing at wide apertures is tricky. This workshop explains some ways to capture great nighttime shots. The image on the next page was captured in the rain at the famous Theaterplatz in Darmstadt, Germany. The wet conditions didn't make the shoot easy, but the water did produce some great reflections.

▲ *Schematic showing the artificial light from the theater, the main light at the front, the edge light at the back right, and a second edge light with a green filter at the left. No other light shapers were used.*

▲ *Our location in the rain, exposed with settings for the ambient light*

▶ *The Theaterplatz in Darmstadt, Germany, is a great location for a bokeh-laden nighttime fashion shoot (Models: Tiney and "Mr. M"; co-photographer: Ray Sjoeberg)*

Canon EOS 5D Mark II | 70–200mm f/2.8 set to f/3.2 and 168mm | M mode | 1/50 second | ISO 640 | RAW | white balance set to flash | multiple non-TTL speedlights

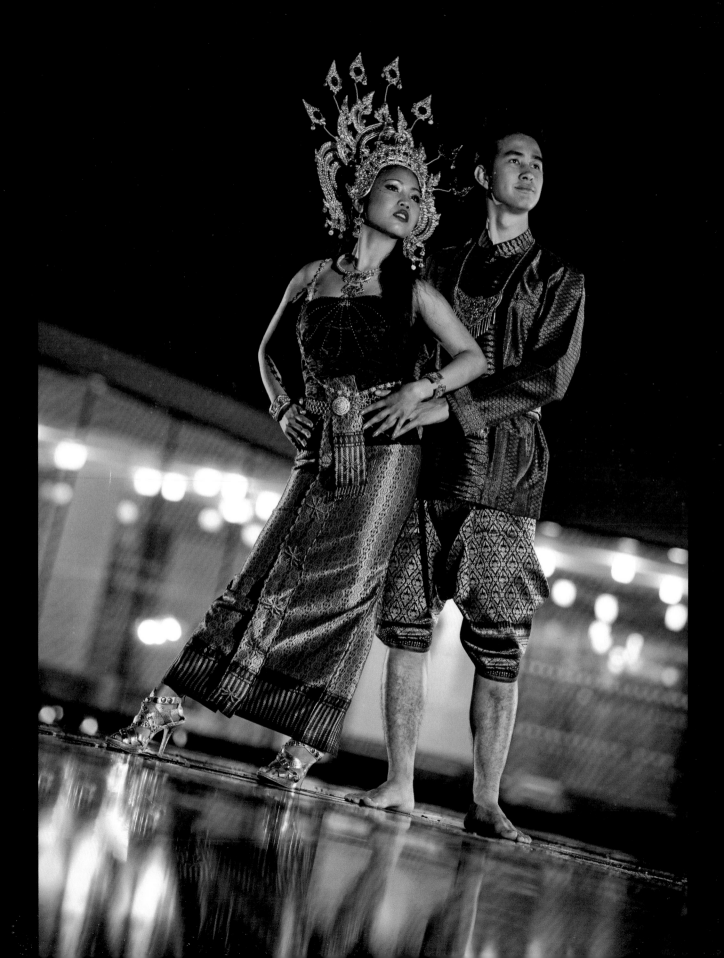

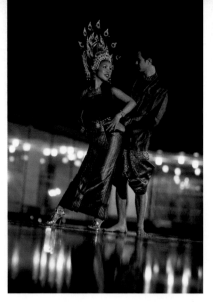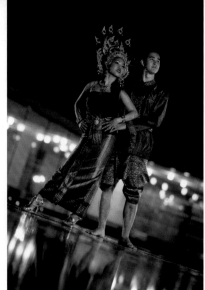

▲ *Left to right: Shots with no flash, the main light alone, and the complete lighting setup*

The Setup

This is another relatively complex setup, but since we didn't use light shapers, it went quickly. If you use flash without additional light-shaping tools, you can get away with using the smallest and lightest stands you can find. For this shoot we used Manfrotto 1052BACs, which would fall over easily if they were used with umbrellas or softboxes.

As usual, I added the flashes one by one, starting at 1/4 or 1/8 output, and then I fine-tuned their positions based on two or three test shots.

Camera Settings and Shooting

For my base exposure using only ambient light, I used ISO 640 and 1/50 second to capture the lights from the theater, although this was risky at a focal length of 170 mm. The lens I used has a great built-in stabilizer, but I would have ended up with fewer throwaway images if I had shot at ISO 1000 and 1/80 second. Stopping down slightly to f/3.2 provided adequate sharpness and retained great background bokeh.

How to Focus at Night

Due to the lack of contrast in the subject at dusk and after dark, autofocus cannot detect the edges of a subject and does not function properly. You can work around this issue by employing the following techniques:

▸ Illuminate the subject with a pocket flashlight, or hold a cell phone beside the subject's face so the autofocus sensors can detect it. A flashing LED button pinned to the subject's clothing also works.

▸ Use a fast lens (f/1.4 or f/1.8). Even if you stop down, a larger maximum aperture will make the focus more accurate.

▸ Use a dedicated laser focus aid, like the DeluxGear PinPoint. Take care to not point laser-based equipment at the subject's eyes.

▸ Use the focus-assist lamp in a YN-622 transmitter.

▸ If you use a tripod, you can switch your camera to manual focus and use the live view monitor to focus on the subject's face, with the help of an additional flashlight and a display loupe if necessary. This procedure may seem a bit awkward, but it really should deliver perfectly sharp results.

◀ *Small blinking LED buttons are cheap focusing aids and double as nice little gifts for models and other team members*

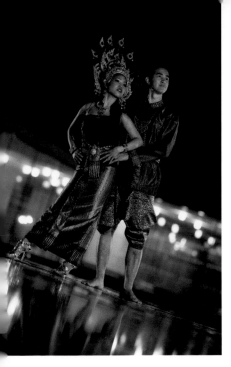 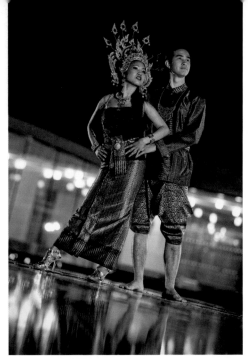

▲ *Left to right: The original image, and the final image after post-processing in Photoshop*

As the before and after images show, I didn't have to make many adjustments to these images. Thanks to the full-frame camera, the noise remained in check at ISO 640. The steps I made were as follows:

▶ Straightened and cropped the image
▶ Slightly brightened the center of the frame and the faces
▶ Balanced the color and contrast, and did final sharpening

▲ *Schematic of my Diaz-style setup*

Tips, Tricks, and Notes

If you decide to further investigate nighttime bokeh, sooner or later you will come across Dustin Diaz. Dustin's *Project 365* won him Flickr's Best Photographer of the Year award in 2009. His photo stream (www.flickr.com/photos/polvero) includes plenty of nighttime shots with all kinds of bokeh. Note that many of Dustin's shots are based on complex setups that are in a class of their own, and that he often uses a 200mm f/2 Nikkor lens that might be too expensive for many photographers.

The photo on page 101 shows my co-photographer, Alexander Kasper, reading the book *Snow Crash*. The main light was a flash with a 3/4 CTO filter fired through a white umbrella on the left. The edge light was behind Alex, and I added a third flash with a green filter and no light shaper to illuminate the ground behind him. All three flashes were non-TTL Yongnuo YN-460s with RF-602 radio triggers. In keeping with Dustin's style, I added text on the image using the Trajan Pro font with wide spacing.

In Depth:
Depth of Field and Bokeh

By now you have probably noticed that I use a shallow depth of field as a design element in a lot of my photos. This section explains how to produce a shallow depth of field and the pitfalls to avoid.

Most cameras can produce only two-dimensional representations of the three-dimensional world, but there are ways to photographically emphasize the depth and details in a scene. Along with differences in brightness and contrast, varying the sharpness in an image is the most obvious way to differentiate important and less important elements. In photography, the Japanese word *bokeh* (which means *blur* or *haze*) is widely used to describe the quality of background blur. The fact that lens manufacturers cannot quantify the bokeh that lenses produce underscores that good bokeh is a matter of taste. Here is what we can say with certainty about bokeh:

▸ Good bokeh is usually a function of extensive blur. If the blur is not extreme enough,, it often seems accidental.

▸ The number of aperture blades and their shape determine the shape of the bokeh bubbles, and it impacts the roundness of the blurred points of light. It is generally accepted that circular and oval circles of confusion produce pleasing bokeh, and geometric patterns are not as good. In a DSLR, the shape of the camera's mirror box can also cause clipping along the edges of the circles; this effect is also considered less aesthetically pleasing.

▸ The smoothness of bokeh plays a role in its perceived quality. The onion ring style of bokeh that some lenses produce is considered suboptimal. Bokeh perfectionists also look for circles of confusion with sharp edges and no halos.

Note that an image that doesn't contain obvious circles of confusion can still have either high- or low-quality bokeh, but the circles make it more easy to recognize and categorize the bokeh. How can you create pleasing bokeh? As previously mentioned, the primary consideration is a shallow depth of field, which depends on the focal length of the lens (longer is better), the aperture (larger is better), the camera-to-subject distance (closer is better), and the distance to the background (farther is better). For technically minded readers, I recommend the article "Depth of Field and Bokeh" by Dr. H. Nasse at

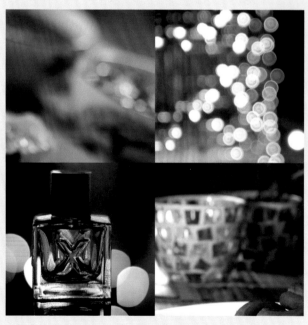

▲ *Examples of bokeh. Clockwise from top left: Pentagonal, onion ring, clipped, and indistinct bokeh. All these bokeh styles are considered less than ideal.*

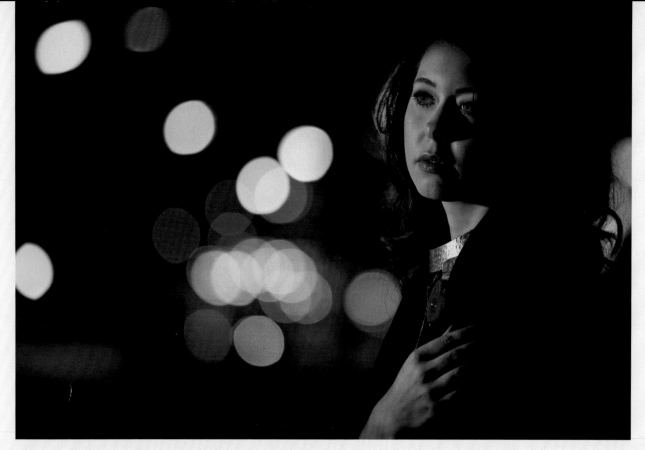

▲ *An extensive bokeh effect is achieved by bright lights in the background combined with a long focal length, using a wide aperture, and focusing at a short distance (Model: Anne)*

Canon EOS 5D Mark II | EF 70–200mm | f/2.8L IS II USM set to 200mm and f/3.2 | M Mode | 1/60 s | ISO 1000 | RAW | with RF-602 shoe mount flash used within an umbrella light stand positioned at top left

Zeiss, which you can download from http://tinyurl.com/md476kq.

The size of your camera sensor plays an indirect role in creating bokeh. To produce images with conventional angles of view, the small sensors built into consumer-grade cameras are used with very short focal-length lenses. The result is images that are in sharp focus from the close foreground to the far background. You have to use macro mode to photograph subjects at extremely close distances and produce somewhat blurred backgrounds. Most lenses produce nicely rounded circles of confusion at maximum aperture, but more expensive lenses with specially shaped aperture blades produce smooth circles even at smaller apertures. Prime lenses generally produce smoother bokeh than zoom lenses, and lenses that are designed for extreme sharpness usually aren't the best choice for producing great bokeh.

In Depth:
All About the Sync Speed

I took the photo on page 91 with a Canon EOS 5D Mark II set to 1/200 second, which is the shortest flash exposure time the camera is designed to use. Nikon (and a few other manufacturers) stretch this to 1/250 second, but 1/400 second is as fast as you will find in cameras with focal plane shutters.

You need to be careful even if you stick to the manufacturer's quoted sync speed because radio triggers often increase the exposure time required for flash sync. Make some test shots with your camera to find out at what exposure time the ominous black stripe appears within the frame. Even with radio triggers I can expose accurately at up to 1/200 second, but faster speeds produce dark stripes in the images. Aside from the HSS and SuperSync/pseudo-HSS techniques we have already described, there are other ways to use short flash exposure times:

▶ At 1/320 second, half of an image taken with an EOS 5D Mark II will be correctly exposed, which might be sufficient if you crop the image tightly enough. If you know this in advance, you can frame the subject accordingly and simply crop out the dark areas during post-processing. In landscape format the dark stripes produced by my Canon cameras appear at the bottom of the frame. If you are shooting bright skies, it can help to turn the camera upside down when you shoot.

▶ If you include more daylight in your flash shots, the dark stripes will be less obtrusive (see David Ziser's great explanation of this technique at http://vimeo.com/31405365).

▶ If all else fails, you can lighten any remaining dark stripes in Photoshop.

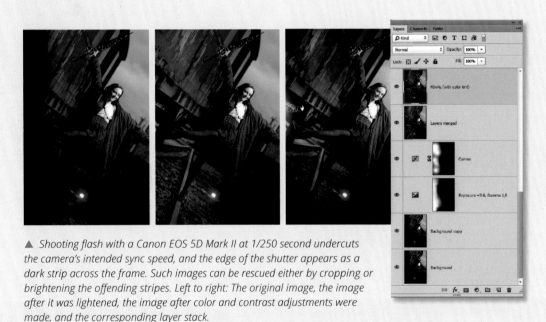

▲ Shooting flash with a Canon EOS 5D Mark II at 1/250 second undercuts the camera's intended sync speed, and the edge of the shutter appears as a dark strip across the frame. Such images can be rescued either by cropping or brightening the offending stripes. Left to right: The original image, the image after it was lightened, the image after color and contrast adjustments were made, and the corresponding layer stack.

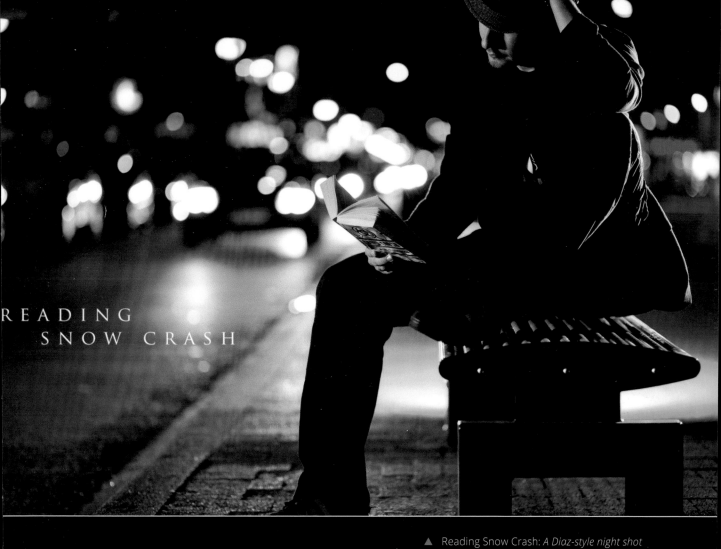

READING
SNOW CRASH

▲ Reading Snow Crash: *A Diaz-style night shot*

Canon EOS 5D Mark II | 85mm f/1.8 set to f/1.8 | M

Workshop 12
Dancer in a Flurry of Flash

> ‣ *How to create stroboscopic effects without a dedicated stroboscopic mode*
> ‣ *Creating a complex setup with seven flashes, stroboscopic effects, and two sets of radio triggers*

The idea for this project came from Joe McNally, who produced cool results using Nikon flashes in his "Repeating Flash" video (www.youtube.com/watch?v=g4fK3yvJLZM). Reproducing Joe's setup could get expensive—I counted 10 Nikon SB-900 Speedlights. After mulling the idea over for a day or two and doing a couple experiments, I found that I could produce similar results using cheap non-TTL flashes. Actually, I only needed one flash with a built-in stroboscope mode—all the others were fired as conventional slaves.

I positioned two additional flashes that I mounted in umbrellas at each end of the stage to capture the start and finish positions; I triggered the first one with the main stroboscopic flash using a radio transmitter on the camera, and I triggered the final flash with a hand held radio transmitter at the end of the long exposure. It's a complex scene, so after you're done with initial preparations, plan on at least two hours of setup and testing time.

All the other workshops in this book use a maximum of five flashes, but for this shoot I used seven flashes, and even that was almost not enough. This might seem like flash overkill, but anyway, it was a lot of fun!

The Setup

The final image on the next page shows the dancer's movements captured in a stroboscopic sequence of ghostlike images that start and finish with well-lit shots of her entire figure. To set up a shot like this, you need a darkened studio, you have to mount the camera on a tripod, and you need to set up your flashes to completely surround the model. We could have produced a similar effect by merging a series of individual images in Photoshop, but we took the purist route and captured the scene in a single long exposure. Here is how we did it:

1. The subject began by standing at the left and looking directly into umbrella **1** I released the shutter in bulb (B) mode with a cable release. This fired the radio release for the flash in umbrella 1on channel A and the stroboscopic Canon Speedlite 580EX II **4** (the only smart TTL flash in the whole setup). Flash **1** and flash **4** were mounted on RF-602 receivers, both set to channel A.

2. Following the initial shutter release, the subject danced along between flashes **2**. and **6.**, which were set up to flash simultaneously with the 580EX II (see the "Camera Settings and Shooting" section later in this workshop).

3. The subject ended her movement in front of umbrella **7.** and remained still in that position while I manually released the flash mounted in that umbrella with a second radio trigger set to channel B.

4. Finally, I let go of the cable release to close the shutter.

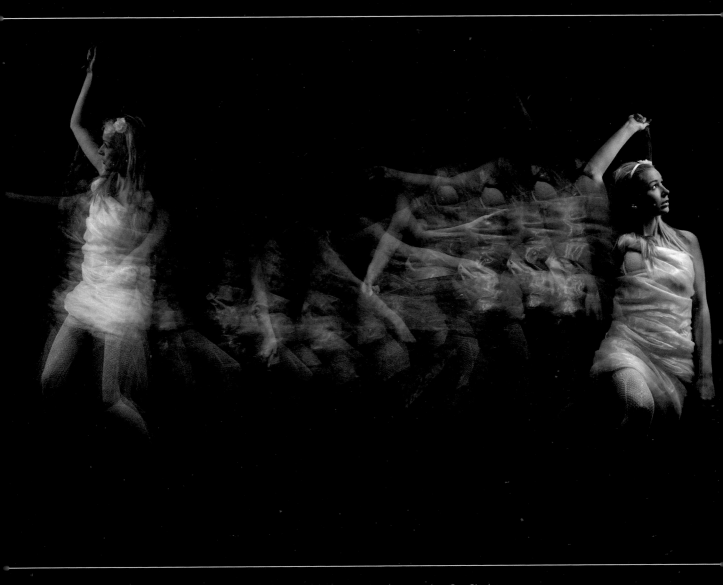

▲ *Dancer captured with five stroboscopic flashes (Model: Vanessa; co-photographer: Ray Sjoeberg; studio courtesy of Ray Sjoeberg)*

Canon EOS 5D Mark II | EF 24–105mm f/4.0L set to f/6.3 and 35 mm | M mode | 4 seconds in bulb (B) mode with cable release | ISO 320 | RAW | white balance set to flash | two edge flashes in white umbrellas and five additional flashes set to function as stroboscopes

Camera Settings and Shooting

We set up our seven flashes and controlled them as follows:

1. YN-460, radio triggered on channel A using a RF-602 mounted on the camera. The flash was mounted in a white umbrella and set to 1/8 output.
2. YN-460 in S1 mode (i.e., as an optically triggered slave). This flash was set to 1/64 output and followed the stroboscopic flashes emitted by flash **4**.
3. The same as flash **2**.
4. Speedlite 580EX II, radio triggered on channel A by the transmitter mounted on the camera. This flash is set to stroboscopic (MULTI) mode (see the camera user's manual to learn how) and 1/32 output. It flashes simultaneously with flash 1. The stroboscopic cycle lasts about four seconds at a frequency of 2–3 Hz.
5. The same as flash **2**.
6. The same as flash **2**.
7. YN-460, radio triggered using a RF-602 receiver on channel B. As soon as the model reached the end of her movement, I fired this flash manually with a second radio trigger in my hand. The flash was mounted in a white umbrella and was set to 1/8 output.

Flashes **2**, **3**, **5**, and **6**, were set as slaves (S1 mode) and were triggered optically by the stroboscopic flashes from the 580EX II. This was possible because of the low output setting and the clear line of sight between the master and the slave units. All five flashes were aimed at the slightly reflective floor, so the optical slave cells, which are located near their fronts, all pointed in the same direction.

Only flashes with a built-in stroboscopic mode—such as the Nikon SB-900 Speedlight, the Canon Speedlite 580EX II, or the Yongnuo YN-468—can be used as a master in a setup like this. Setting up stroboscopic mode involves selecting the number, frequency, and output of the flashes you want to fire. If the sequence doesn't work properly, you most likely selected an output setting that is too high to recycle fast enough between flashes. Stroboscopic mode cannot usually be

▲ *Schematic of our stroboscopic setup, showing the two flashes in white umbrellas that capture the dancer's start and finish positions and the five stroboscope flashes in between that we set up without additional light shapers*

▼ *Our studio setup showing our start and finish flashes on their stands and our stroboscope flashes mounted on a beam between them. A larger space would better prevent unwanted reflections from the walls.*

fired with a test button, so you have to trigger your test flashes with the camera's shutter release or a radio trigger.

The two transmitter channels used in this setup can be set using the little DIP switches on the trigger. I referred to them as channels A and B, but the actual numbering may vary from model to model. The important thing is that you use two separate channels for the first flashes and for the last flash.

Post-Processing in Photoshop

The studio we used was small, which meant we had to deal with unwanted light spill and reflections from the walls. A large stage or a clearing in a forest at night would have been better. Most of the post-processing steps we performed were aimed at suppressing unwanted details in the studio background. Everything else was standard: crop, color and contrast adjustments, add text/logo, and sharpen.

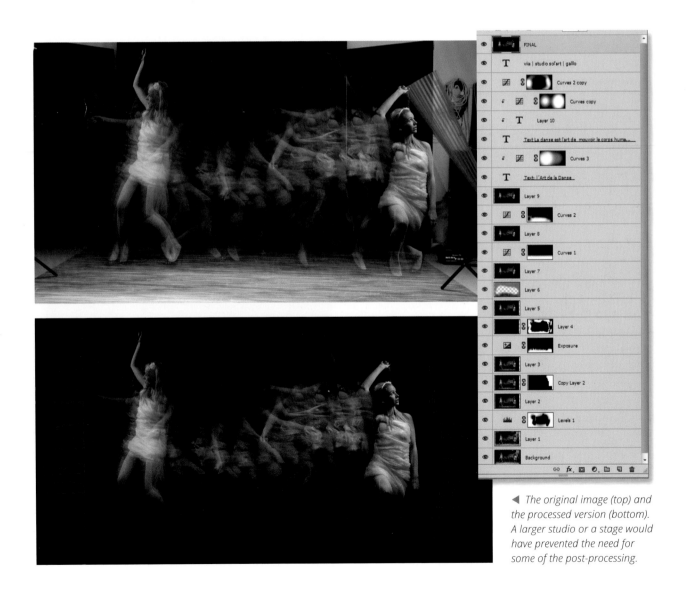

◄ *The original image (top) and the processed version (bottom). A larger studio or a stage would have prevented the need for some of the post-processing.*

Tips, Tricks, and Notes

For this setup I used the second most expensive Canon flash on the market. An alternative is to use a cheap non-stroboscopic flash set to its lowest output setting. You can fire it by manually pressing the pilot/test button as quickly as you can, and then fire optically triggered slave flashes with that hand held master. However, stroboscopic flashes are getting cheaper: the Yongnuo YN-568 is a good example of a bargain flash with a high-end feature set.

If, like Joe McNally, you have access to a lot of dedicated system flashes (his are Nikon CLS models), you can program them to automatically function as an intelligent master and slaves group. In our setup the terms master or slave meant just the simple non-intelligent optical triggering.

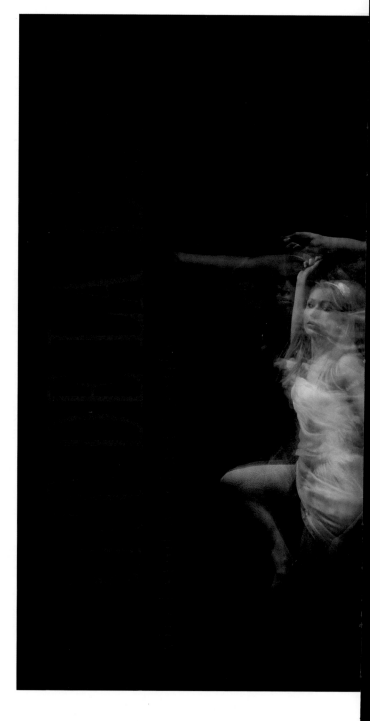

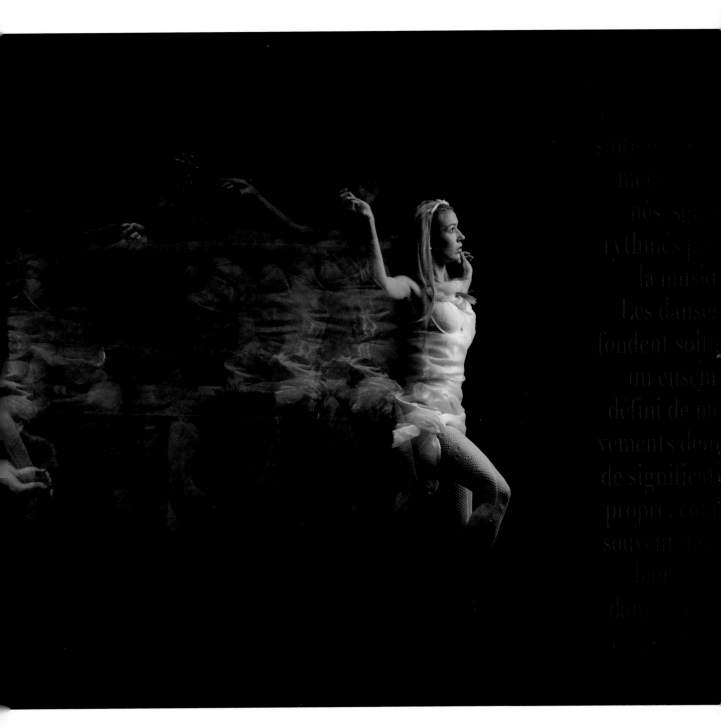

▲ *Another variation of the image that we captured during the shoot with the same parameters as those listed on page 103. This technique is perfect for capturing dance and sports scenes.*

Workshop 13
Underwater Shoot

- ▸ *How to make your gear waterproof on the cheap*
- ▸ *How to trigger flash under water*
- ▸ *Stay safe!*

Heidi Klum showed us the way, so we decided to follow. Underwater fashion shots look really cool, but be warned: a shoot like this involves a lot of hard work and some frustration. The safety aspects of shooting underwater must not be ignored (see the textbox below), but I am lucky enough to know the owner of a heated outdoor pool, so I grabbed the opportunity. I was slightly nervous by the time we actually started shooting, but the guidelines outlined in this workshop made the effort a great success.

This workshop is intended to allow you the opportunity to experiment with this technique. For this project, we chose not to use our best camera in the event of a mishap, and the underwater housing we used was not high-end, nevertheless they served the purpose well. If you really want to get into shooting underwater, an investment in high-end equipment would be the next step.

The Setup

If you are still interested despite the warnings on this page, read on. You may consider not using flash, which would make things simpler, but you'll be dependent on the position and angle of the sun. The walls of the pool will block a lot of available sunlight, so you can work only within a limited space where the light is at its brightest. Also, the camera's built-in flash doesn't really help, because it produces unattractive direct lighting. If you want your shot to look natural, the underwater light should come diagonally from above. If you are thinking about using a couple of those cheap construction site floodlights, forget it! It's worth repeating that anything that requires a power outlet is strictly off limits near a pool. Construction lights wouldn't produce enough illumination anyway (see appendix A for an example calculation for flash versus continuous light).

Safety First!

If you follow some basic rules, shooting underwater can be safe and a *lot* of fun. Make sure at least one team member is certified in first aid, and have at least one person on dry land to make sure everyone is comfortable with the situation at all times. Ideally, the photographers should be qualified divers, even if they are only using snorkels.

If you need to use additional lights, anything that requires a power outlet is strictly off limits near a pool.

I have been told by a number of experts that using an electrically isolated battery-powered flash underwater is completely safe because the electrical current dissipates over the shortest possible distance between the poles of the flash (or the poles of the capacitor) and cannot be grounded through the water. This sounds plausible, but we decided not to try it. Instead, we used a triple safety mechanism to mount a flash head, a battery pack, and a 230-volt inverter, all positioned on a diving board, above the surface of the water.

Don't blame me if your camera drowns when you attempt a shoot like this. Two of our radio receivers and one of our flashes died during this shoot, so don't underestimate the risks—water can get inside everything!

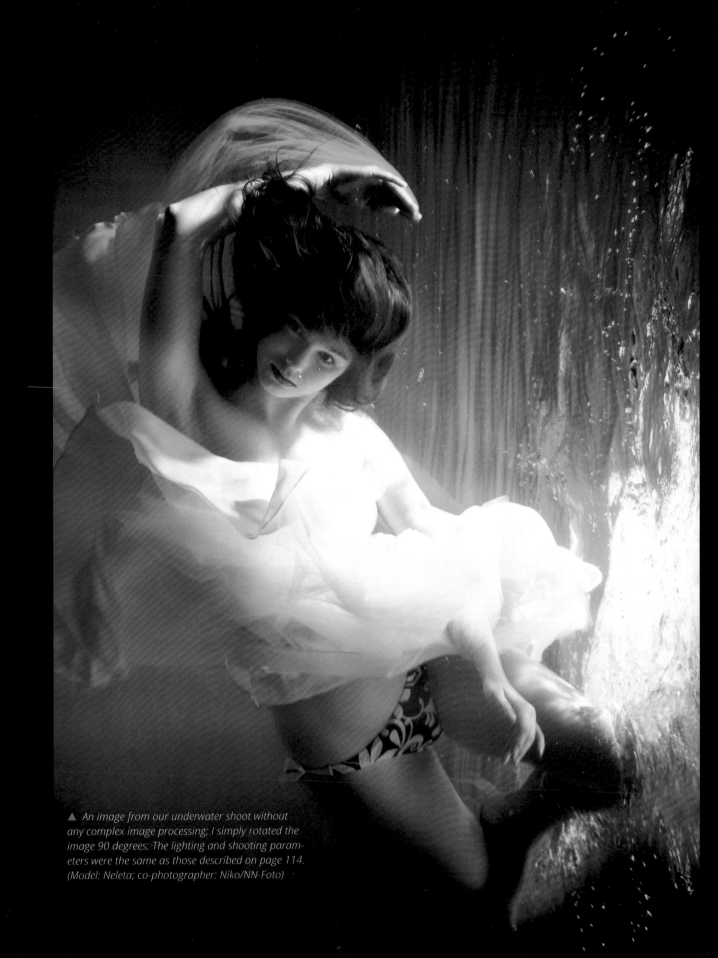

▲ An image from our underwater shoot without any complex image processing; I simply rotated the image 90 degrees. The lighting and shooting parameters were the same as those described on page 114. (Model: Neleta; co-photographer: Niko/NN-Foto)

Using a radio trigger mounted on the camera to fire a flash above the surface of water doesn't work either. Even a fairly powerful trigger, like my RF-602, has a range of only about 4 in underwater. Having said that, the setup shown in this workshop is based on that idea. We used an old Canon EOS Rebel T1i (EOS 500D) with a RF-602 radio trigger packed into a DiCAPac WP-S10 waterproof case **1.** This case is cheap and works well, although it is impossible to use a cable with it because of leaks. There are more expensive and more reliable housings available, but this case served our purpose. It's better to use a receiver module in a separate bag mounted close to the camera **2** with a 33 ft spiral flash cable connected to the battery-powered studio flash—in our case, a 400 Ws Walimex flash/battery combo with a parabolic reflector **3** and **4.**

So far I haven't talked about the weak spot in this system. It's the point where the cable exits the bag containing the receiver. In our first attempt, we used multiple fish-carrying bags from a pet shop; we sealed the bags with tape and rubber bands. They remained watertight for a while, but after about an hour they began to leak. If you plan to spend a fair amount of time shooting underwater, get an electronics specialist to seal a radio trigger in a plastic housing with the cable fed through a watertight connection. If you are still experimenting, get a long roll of vacuum packaging foil and have your local butcher or grocer seal a long bag with one open end. You can then use the bag to house your trigger and your cable. Using this approach and a DiCAPac housing, we were able to set up an underwater flash kit for less than $120.

We affixed our battery-powered flash to the diving board using rope, tape, and cable ties, and we fitted it with a parabolic reflector and used it at 1/4 to 1/2 output. If you don't have access to a studio flash, you can

▼ *The setup for our underwater shoot*

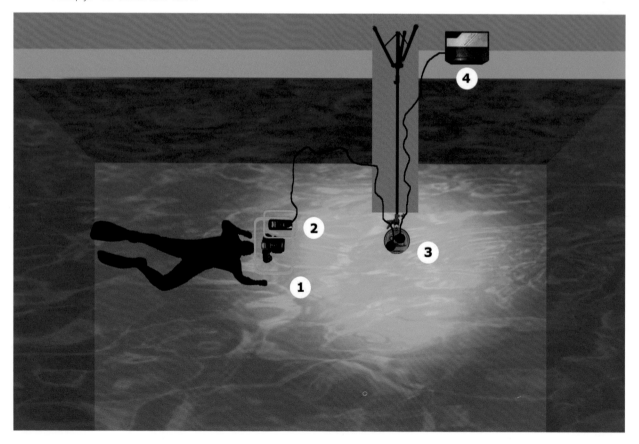

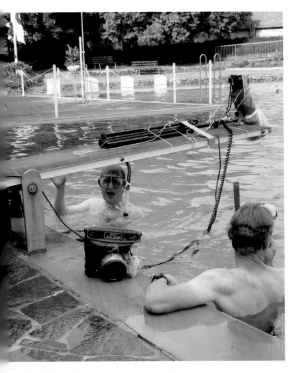

▲ *The photo crew at work*

use the Duke Nukem solution described on page 60, although you will probably have to omit the umbrella to produce enough light.

Camera Settings and Shooting

After we had everything set up, the shooting was fairly simple. It is surprisingly dark underwater if there is no direct sunlight, so we set our cameras to ISO 400. Fortunately, autofocus works quite well underwater, so we didn't have to look through our masks, the water, and the camera housing to focus. We set the zoom lens to wide angle to ensure sufficient depth of field and to make sure we captured the model and her reflection in the surface of the water. Using a small aperture helps keep everything sharp, but it reduces the already minimal light that enters the lens. We ended up compromising with an aperture of f/7.1. Set the camera up the same way you would on dry land: use a reasonable ISO and shoot in manual mode to select a suitable aperture.

Make some test shots and check them when you get out of the water to see if the settings show the pool and the water at their best. If not, adjust the exposure and try again. After you finalize the exposure settings, add flash and let the model do her thing. Once again, use test shots to fine-tune the distance between the flash and the subject and to decide on the optimal flash output setting.

Post-Processing in Photoshop

Shooting in RAW format gives you the greatest leeway for adjusting your images at the processing stage. For this shoot, we performed the following steps:

▸ Imported our RAW files and increased the vibrance, slightly lightened the shadows, sharpened the files slightly, and increased the clarity
▸ Did some general cleanup in Photoshop, including deleting the pipe and the gaps between the tiles with the Clone Stamp tool
▸ Increased contrast, added a vignette, and adjusted the colors
▸ Merged our image with a stock image of the ocean for the background (Photograph from Fotolia), and added text and a logo

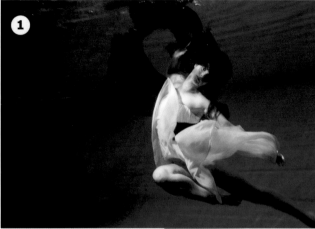

▶ *Our processing steps:*
1. *the original image*
2. *the background image*
(Photograph © AirMaria, Fotolia)
3. *the result of two hours of work in Photoshop*

THE MERMAID

Who would be
A mermaid fair,
Singing alone,
Combing her hair
Under the sea,
In a golden curl
With a comb of pearl,
On a throne?

And all the mermen
under the sea
Would feel their
immortality
Die in their hearts
for the love of me.

Alfred Lord Tennyson

GALLO

Tips, Tricks, and Notes

▸ The DiPACac housing worked great, but the lens sleeve was too long. We pulled it back and fixed it in place with tape.

▸ The closer the model is to the surface of water and the deeper you are, the more you can use reflections from the surface in your photos.

▸ We couldn't fire our battery-powered studio flash with a cable because we didn't have the right adapter; our flash cable had hotshoes at both ends. Instead we attached a flash to the end of the cable above water, which we used to fire our main flash via its built-in optical trigger.

▸ Although the models were wearing long, heavy dresses, they still had to combat their own buoyancy. We solved this problem by having them dive deep and photographing them as they floated slowly upward. We weren't able to compensate for our own buoyancy using just lead-weighted belts, so we held on to a pipe on the pool wall with our legs for 30–40 seconds while we shot.

▲ A finished image with an image of a sea floor added in Photoshop. The lighting and shooting parameters were the same as those listed on page 114. (Model: Anne; co-photographer: Niko/NN-Foto; background image © XL-Luftbild-fotograf, Fotolia)

THE MERMAID

Who would be
A mermaid fair,
Singing alone,
Combing her hair
Under the sea,
In a golden curl
With a comb of pearl,
On a throne?

And all the mermen
under the sea
Would feel their
immortality
Die in their hearts
for the love of me.

Alfred Lord Tennyson

GALLO
www.gallo-photo.com

▶ *If you follow our tips and stick to some important safety rules, you can create effective flash photos, even underwater (Model: Neleta, makeup and styling: Layka; co-photographer: Niko/NN-Foto)*

Canon EOS Rebel T1i (EOS 500D) | 24–105mm lens set to 24mm and f/7.1 | M mode | 1/160 second | ISO 400 | RAW | white balance set to flash | battery-powered studio flash

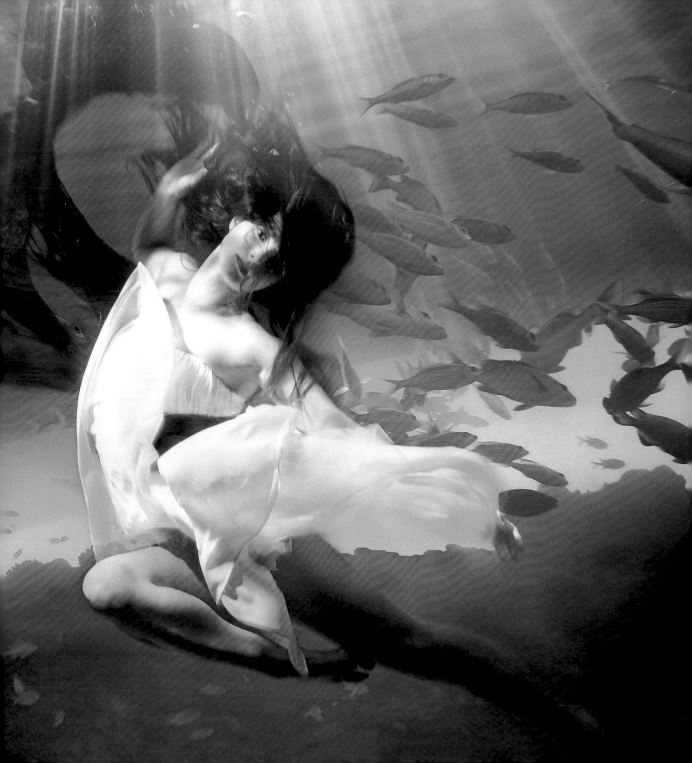

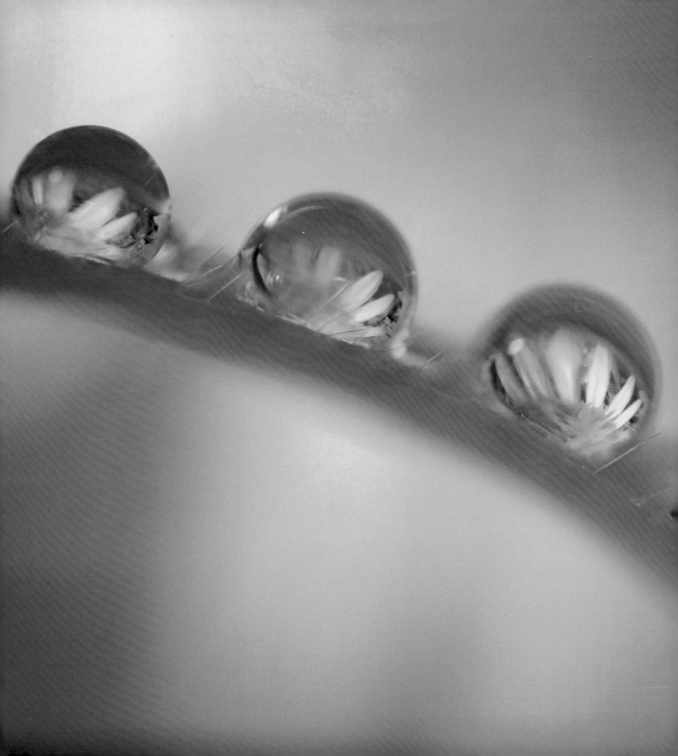

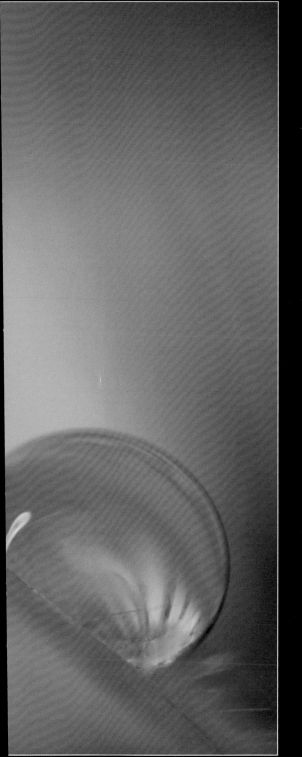

Workshops 14–17
Macro with Flash

Flash plays an important role in the world of macro photography. It allows you to shoot macro images that are free from camera shake and have plenty of depth of field. This chapter explains how to set up a powerful macro flash rig and uses the eye of an insect to explain focus stacking. The chapter also includes a section on dark field lighting.

Workshop 14
Using a Macro Rig

> ▸ *Setting up a portable macro rig*
> ▸ *Set up and unleash your flash*

Macro photography reveals tiny details that the human eye may not be able to see—the delicate pistils of a flower in bloom or the individual elements of an insect's compound eye suddenly appear in wonderfully clear detail. Macro photos can be shot with closeup lenses, extension tubes, or reversing rings. These types of images are relatively easy to take on a limited budget.

In macro situations you will quickly find that daylight isn't bright enough to capture a subject because small apertures are required to provide sufficient depth of field. That's when flash comes into play. Shoe-mounted or built-in flash is poorly suited to this kind of work because the direct light is too harsh and doesn't illuminate the area directly in front of the lens. Off-camera flash allows you to position the flash exactly where you need it.

The Setup

To build a macro rig, you need some kind of base plate. I use a Novoflex flash grip with an additional 19P ball head. This enables me to position the flash head at the front of the lens where I need it. The light from close-range flash can be softened with a dedicated flash diffuser or a simple paper cuff around the lens.

Macro Lenses | Conventional lenses can be used for macro photography if you add either closeup filters to the front of the lens or extension tubes between the camera and the lens. Specially designed macro lenses are also available at a range of prices. I used an extension tube to shoot the photo of a dandelion on page 120, and I used a reversing ring for all the other pho-

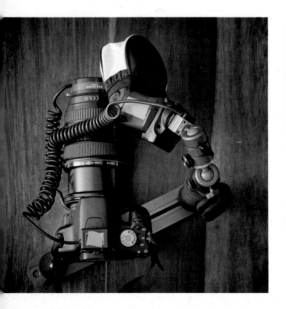

◀ *My simple but powerful macro rig, which includes an APS-C Canon EOS Rebel T1i (EOS 500D) and a Canon 24–105mm EF lens mounted on a Novoflex EOS-RETRO reversing ring. The camera is mounted on a Novoflex flash grip with two 19P ball heads and a Canon Speedlite 430EX II TTL flash that is connected with a Walimex spiral TTL flash cable.*

▶ The movement of a pocket watch captured with the reversing ring described in the text and the lens set to the telephoto end of the zoom scale

Canon EOS Rebel T1i (EOS 500D) | EF 24–105mm set to 100mm and f/16 (mounted on a reversing ring) | M mode | 1/125 second | ISO 100 | RAW | white balance set to flash | TTL flash | –2/3 EV FEC

▶ The same setup, but this time with the lens at a wide-angle setting

Canon EOS Rebel T1i (EOS 500D) | EF 24–105mm set to 24mm and f/16 (mounted on a reversing ring) | M mode | 1/125 second | ISO 200 | RAW | white balance set to Flash

◀ *Macro shots are best captured with off-camera flash. This allows you to work without a tripod and still produce a sufficient depth of field*

Canon EOS 500D | 50mm f/1.4 at f/10 with extension tube | M mode | 1/125s | ISO 100 | RAW | WB set to flash | Flash-setup: macro rig

▲ *I captured this fly with my macro rig and a reverse-mounted 18–55mm standard kit zoom lens stopped down to f/18. For this shot I used a paper collar around the lens as a diffuser.*

Canon EOS Rebel T1i (EOS 500D) | EF 18–55mm set to 33mm and f/18 (mounted on a reversing ring) | M mode | 1/125 second | ISO 100 | RAW | white balance set to Auto

tos in this section. A reversing ring allows you to mount a lens backwards so you can shoot at close distances and high magnifications. Wide-angle lenses that are reversed can provide magnifications up to 7x, which is equivalent to high-end macro lenses such as the widely favored Canon MP-E 65mm f/2.8.

Macro Flash | You can use TTL or non-TTL flash in macro situations, but, because TTL flash cables are manufacturer specific, you have to be careful when you choose how to connect your flash to the camera. I use a 2-meter Walimex spiral Canon E-TTL cable. For non-TTL flashes, you can use any compatible radio trigger. A TTL flash is a real boon for macro work, especially if you are shooting handheld, because small differences in the distance to the subject make a huge difference to the exposure settings (because of the inverse square law); a TTL flash compensates for the changes in distance automatically. Ideally you should switch your camera to FE Lock (Canon) or FV Lock (Nikon), which means a spot metering in combination with a storage of that metering (for recomposing afterwards). If you are shooting from a tripod, you will have much more control and can use non-TTL flash just as effectively.

Camera Settings and Shooting

After you have your rig set up, it is a good idea to take some test shots before you head off on your first insect safari. I usually stop down to around f/18, which means I have to dial up the flash output accordingly. If you increase the ISO to 200 or 400, you will reduce the recycle time of your flash. Such ISO levels present few image quality problems in today's high-performance cameras (ISO 200 is the default ISO in many Nikon DSLRs).

Tips, Tricks, and Notes

▸ Extension tubes and reversing rings are available in passive and (more expensive) active versions. Passive gear provides a mechanical connection between the camera and the lens, but it doesn't transmit any focus or aperture data between the two. This usually means you must work with the aperture either stopped all the way down or wide open (depending on the manufacturer of the lens). If you are willing to modify the mechanics of your lens (and most likely void the warranty), you can trick it into using a different-sized opening by setting the desired aperture, pressing the depth-of-field preview button, and removing the lens while you hold the button down. You can then mount the lens in the reverse position with the aperture set. If you are using an active reversing ring (they are available only from Novoflex and only for Canon), the aperture works automatically as usual.

▸ Reversing rings often have 58mm threads, so you may need an additional step-up or step-down ring for your particular lens.

▸ As usual, Flickr is a great resource for gear and shooting tips. To view a great macro portfolio by John Hallmen visit www.flickriver.com/photos/johnhallmen/popular-interesting, or see www.flickr.com/photos/johnhallmen/sets/72157604592459772 to check out his gear.

▸ Insect photography is a science in itself. If you want to capture great insect images, you need to know a lot about how they behave. Early mornings in late summer are perfect for photographing flies and dragonflies because the lower temperatures slow them down and make them easier to capture at rest. At these times you can even shoot with a tripod and flash without disturbing them.

In Depth:
Optimum versus Critical Aperture

Optimum aperture and *critical aperture* are terms that we encounter often. They describe the constant battle that photographers wage with the relationship between light and the equipment used to capture it. Put simply, the wider the aperture, the shallower the depth of field in an image. Conversely, the more you stop down, the greater the risk of reduced overall sharpness due to diffraction within the lens. The aperture that produces the best balance between depth of field and diffraction blur is known as the optimum aperture. Calculating the

optimum aperture is no simple matter (start by searching Wikipedia for "depth of field"). Generally speaking, the optimum aperture is between f/16 and f/20 for full-frame and APS-C cameras, and it can be as low as f/5 or f/8 for compact cameras with small sensors. There are various online tools available for calculating optimum aperture.

Even if the subject has little physical depth, two opposing values work together to help you capture the sharpest possible image: diffraction blur, which occurs at small apertures; and optical aberrations that are inherent in lens construction and are most prevalent at wide apertures. The relative aperture at which an optical system (i.e., the lens) delivers the best balance between aberration correction and contrast rendition is known as its critical aperture. An old rule of thumb says to set the aperture to f/8 in normal daylight. This may sound oversimplified, but a look at test charts (www.slrgear.com) supports the theory. Put simply, if the situation allows it and if the subject requires no special treatment with regard to depth of field, you can usually get good results at f/5.6 or f/8. Most full-frame and APS-C cameras produce their best overall resolution at these apertures.

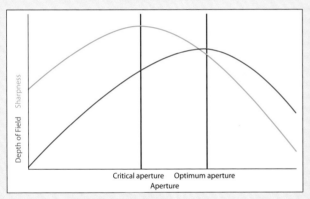

▲ *Optimum versus critical aperture*

▼ *The critical aperture of the popular Canon EF 50mm f/1.8 II is f/5.6. This is the aperture at which the lens produces its sharpest results in absolute terms. (Illustrations courtesy of Dave Etchells, www.slrgear.com)*

Workshop 15
Extreme Macro Photography

▸ *How to set up your gear to shoot extreme closeups*
▸ *Shooting focus stacking sequences*
▸ *Optimizing depth of field using focus-stacking techniques*

Extreme closeup photography requires unusual equipment. Normal extension tubes and closeup lenses no longer suffice if you wish to shoot at magnifications of 4x or more. You can use a macro lens with extension tubes or a highly specialized lens, such as the Canon MP-E 65mm f/2.8. Reversing rings can be used to convert just about any lens into an extreme macro lens. Photographing an insect's compound eye is a particularly challenging photographic exercise, but the results are often fantastic. Check out the Flickr group dedicated to the subject at www.flickr.com/groups/compoundeyes.

The Setup and Camera Settings

I used two non-TTL flashes set up on either side of the subject and mounted the fly on a piece of Plasticine that I placed on a micrometer vice. I cut open a Ping-Pong ball to use as a diffuser and fired my flashes with RF-602 radio triggers. The APS-C camera was mounted on a tripod with a reverse-mounted 10–20mm zoom lens set to 14mm. I used an active reversing ring from Novoflex that automatically transmits all aperture data to the camera. I used this setup to shoot a sequence of 33 images, each with the subject distance adjusted by 50 µm (micrometers). The single image at the top of page 126 shows how shallow the depth of field can be in such extreme macro situations. Stopping down the aperture would provide additional depth of field, but it would move further away from the critical aperture and thus reduce the overall sharpness. The most effective way to produce additional depth of field in macro images is to shoot a sequence of photos at various distances and merge them into a single image during post-processing to reveal the enhanced depth of field.

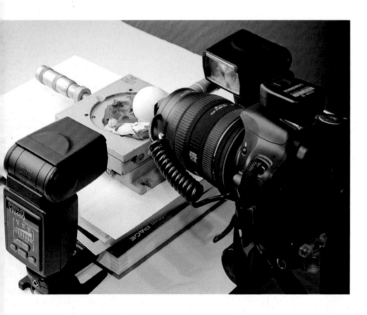

▲ *The setup for our compound eye shot, showing a micrometer vice and two off-camera flashes. A Ping-Pong ball served as a makeshift diffuser.*

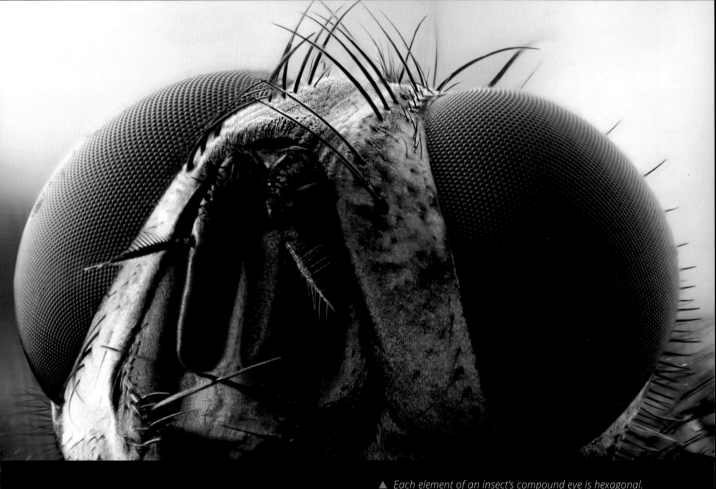

▲ *Each element of an insect's compound eye is hexagonal. Fine details like these can be captured effectively only with flash and focus stacking techniques.*

Canon EOS Rebel T1i (EOS 500D) | Sigma 10–20mm f/4–5.6 set to f/8 (Novoflex reversing ring and a 77–58mm step-down ring) | M mode | 1/125 second | ISO 100 | JPEG | white balance set to flash | two off-camera, non-TTL flashes | focus stacking from a sequence of 33 source images

▲ *One of the 33 source images showing how shallow the depth of field is*

▼ *Our sequence of source images, each shot at a slightly different distance*

Introduction to Focus Stacking

There are various ways to shoot focus-stacking sequences. Simply altering the focus between shots can work, but this also slightly alters the magnification and therefore makes it more difficult to merge the images. It is preferable to use a setup that allows

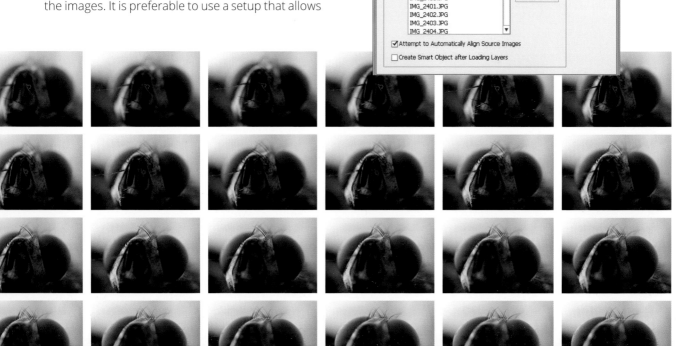

you to keep the focus constant and alter the distance between the subject and the lens. The best tool for this approach is a high-precision macro rail. The source images can then be merged in a dedicated stacking program, such as Helicon Focus, or with standard tools in Photoshop.

Focus Stacking in Photoshop

Load your source image into a new stack using the File > Scripts > Load Files into Stack command and check the Attempt to Automatically Align Source Images option. Now select all the layers in the resulting stack and navigate to the Edit > Auto-Blend Layers command and select the Seamless Tones and Colors option in the dialog that follows. Photoshop will then take a while to process the stack. When it is done, you can flatten the image to a single layer and fine-tune the result, using whatever contrast and color adjustments are necessary. After you remove any remaining halos or seams with the Clone Stamp tool, you can sharpen your enhanced depth-of-field image for output.

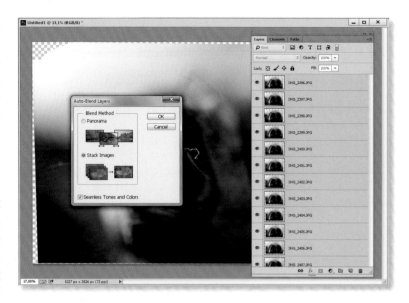

Workshop 16
Dewdrop Flowers

▸ *Reproducing nature scenes in the studio*
▸ *Capturing extreme magnifications*
▸ *Optimizing depth of field using focus-stacking techniques*

I like images in which colorful objects are magnified by dewdrops (that serve as tiny lenses), so I decided to produce the effect in my studio. I began by checking on Flickr to see what other photographers have done and found the photostream and tutorials of Brian Valentine (his alias is Lord V) at www.flickr.com/photos/lordv. Brian is obviously more of a nature fan than I am because he shoots outdoors, but he uses the same off-camera flash approach as described in this workshop.

Brian's tutorial sounded easy, but my attempt took a lot longer than I anticipated. The first major hurdle was creating dewdrops on the blade of grass. An eyedropper didn't work because the drops simply rolled off.

▼ *The setup for my dewdrop image, showing the two off-camera flashes fired through a white sheet of paper. The blade of grass with the water droplets was just a couple inches from the flowers, and I used a desk lamp as a focusing aid.*

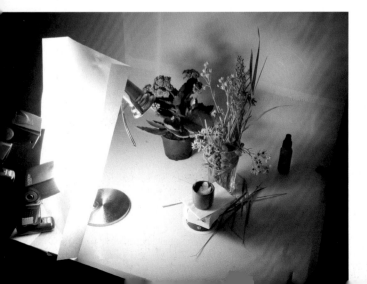

I finally produced effective drops by filling a perfume atomizer with water and spraying it on the grass. After I created a row of drops, I removed excess water by carefully dabbing it with the corner of a paper towel.

The next thing I had to figure out was the optimum distance between the flowers and the drops. Very small flowers can be placed just an inch or so away. The other major challenge was photographing the drops because they were much smaller than I thought they would be—only about 1mm across. I couldn't magnify the scene enough with my extension tubes, so I decided to reverse mount my 24–105mm f/4L on a Novoflex adapter. This setup gave me magnifications of 1–5x that I could vary with the zoom ring. All I needed now was a suitable light source.

The Setup

As you can see in the photo at left, I used two off-camera flashes fired through a sheet of paper that acted as a diffuser. I set both flashes to 1/2 output with the intention of simulating a single full-output flash with a shorter recycle time. In spite of the relatively high output setting, I had to use ISO 320 and f/5.6, which is close to the critical aperture. Instead of using a smaller aperture, I compensated for the shallow depth of field by focus stacking the results.

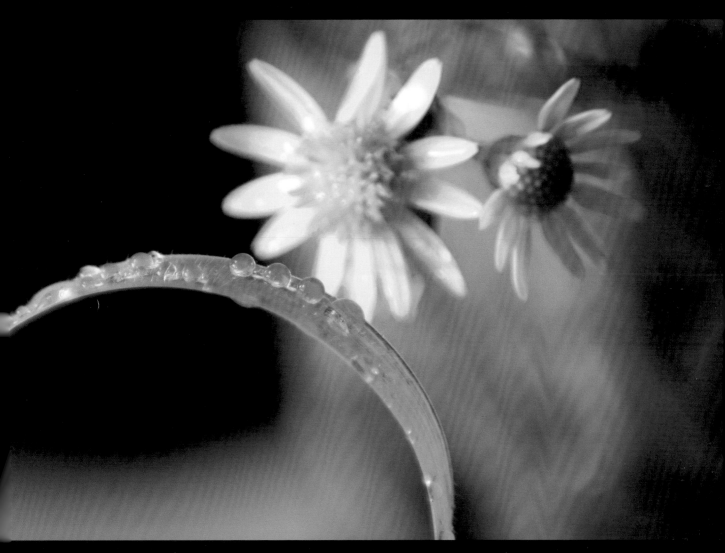

▲ *The setup in detail*

Camera Settings and Shooting

Although images like this can be shot handheld, slight variations among multiple images make it difficult to stack them accurately, so it's better to use a macro rail. If you don't have one, proceed as follows: Select your desired zoom setting and set the camera to manual focus. Move the camera gently back and forth until one of the dewdrop flowers is in focus, then release the shutter. Continue focusing on other dewdrops and capture multiple images. This technique will work only if you have a strong continuous light source to help you focus. I used a halogen desk lamp.

Post-Processing in Photoshop

Photoshop and Zerene Stacker failed to automatically stack my handheld source images. I ended up selecting the two images that had the most similar framing but were focused on different drops, and then Photoshop successfully stacked them. For the second series of images (with the red flowers), I selected three source images that I manually aligned and merged with layer masks.

Here are the steps I used:

▶ **Automatic focus stacking (yellow flowers):**

1. Select the source images that are aligned most similarly and load them as a stack using the File > Scripts > Load Files into Stack command. Check the Attempt to Automatically Align Source Images option. The selected images will load into an automatically aligned stack.
2. Select all the layers in the stack and navigate to the Edit > Auto-Blend Layers command.
3. Flatten the image by selecting the top layer and pressing Ctrl+E (Windows) or Command+E (Mac).
4. Perform any necessary repairs with the Clone Stamp and Patch tools.

▶ **Manual focus stacking (red flowers):**

1. Load your images into a stack as described for automatic focus stacking, but don't check the Automatically Align Source Images option. Instead, align the images manually (Ctrl+A to select and Ctrl+T to transform). You can also distort a layer by keeping the Ctrl key pressed while you transform it. Reducing the opacity of the layer you are adjusting makes it easier to align it with the layer below.

▼ *The two images I selected for automatic stacking*

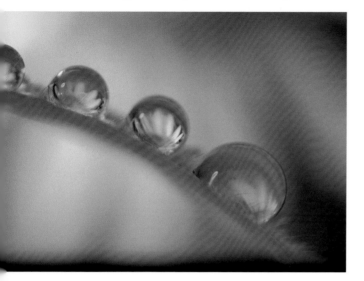

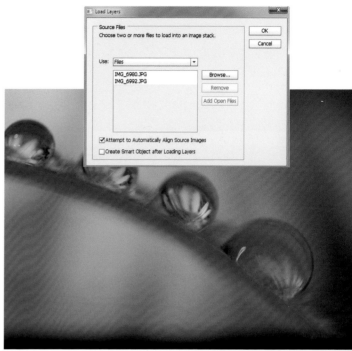

▼ *Automatic focus stacking using two source images. I fine-tuned the final image with the Clone Stamp tool and sharpened it a little to give it a final polish.*

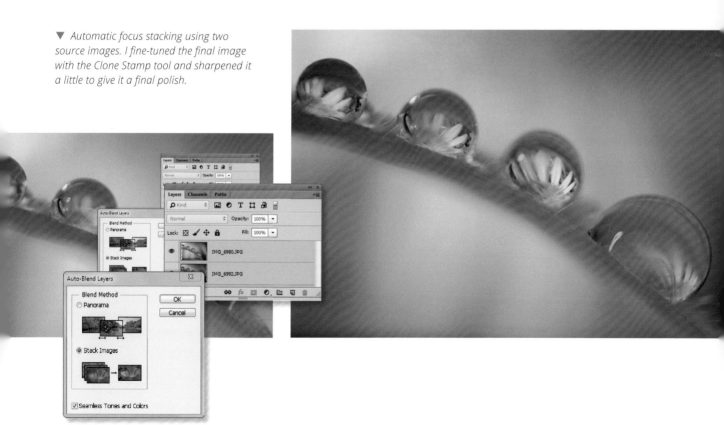

2. Add layer masks to each layer, invert them (Ctrl+I), and use a soft white brush to reveal the in-focus areas.
3. Flatten the merged image by selecting the top layer and pressing Ctrl+E (Windows) or Command+E (Mac).
4. Perform any necessary repairs with the Clone Stamp and Patch tools.

Tips, Tricks, and Notes

There are a number of stacking tools available. You will have to experiment to see which one handles your stack the best. In addition to Photoshop's built-in stacking tools, you can also try these:

▸ Zerene Stacker: http://zerenesystems.com
▸ Helicon Focus: http://www.heliconsoft.com
▸ Enblend/Enfuse: http://enblend.sourceforge.net/
▸ CombineZM and CombineZP

See appendix C for more information on focus stacking and macro photography in general.

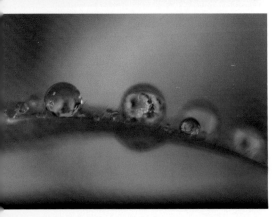

◀ The three source images that I stacked manually

▼ The aligned layers with their corresponding layers and masks

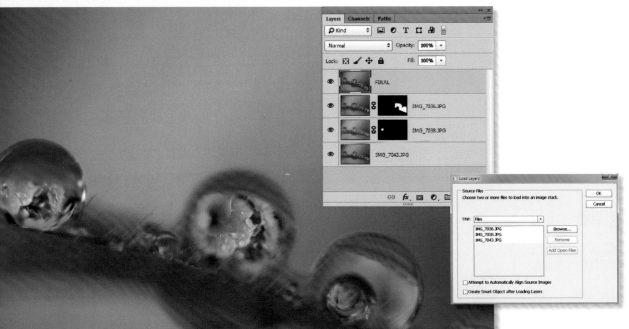

In Depth:
How to Use Mirror Lockup and Live View

Because telephoto and macro lenses greatly magnify the subject, even the smallest camera movements can lead to significant blur in your images. Such movements include the vibrations caused by a DSLR's mirror swinging out of the light path during the exposure. The solution is mirror lockup. This feature is built into most DSLRs, and the setting can usually be found in the custom settings menu. When it's enabled, mirror lockup causes the mirror to swing up when you press the shutter button, then you can wait for the vibrations to dissipate before you press the shutter button again to release the shutter. After the shutter is released, the mirror swings back into place. Mirror lockup is less useful if you take a long exposure because the time it takes the vibrations to dissipate is negligible compared to the total time the shutter is open. But for shorter exposure times, even the movements of the focus motor can cause camera shake. To get the maximum possible sharpness, always prefocus, wait a moment, then release the shutter.

In live view mode, the mirror is locked in the up position anyway, so using live view is another good way to reduce camera shake. Be aware that some cameras (such as the Nikon D700) swing the mirror down and up again when you release the shutter in live view mode. If you're not sure if this occurs with your camera, listen carefully to the sounds the shutter makes—the *clack* of the mirror is much louder than the movement of the shutter.

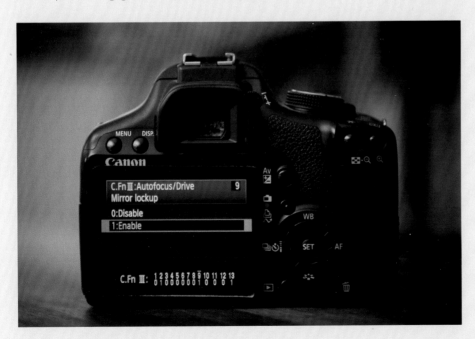

▲ *Using mirror lockup and live view are great ways to ensure maximum sharpness in telephoto and macro shots*

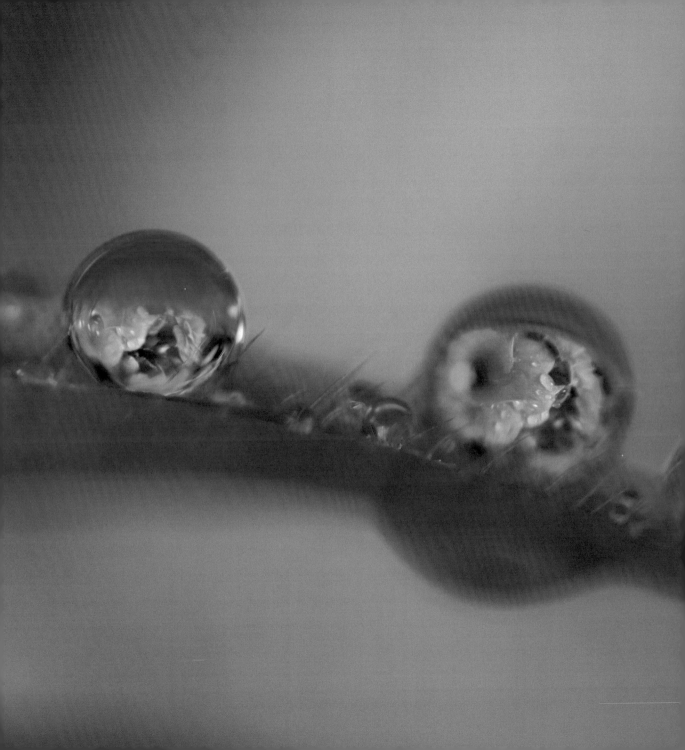

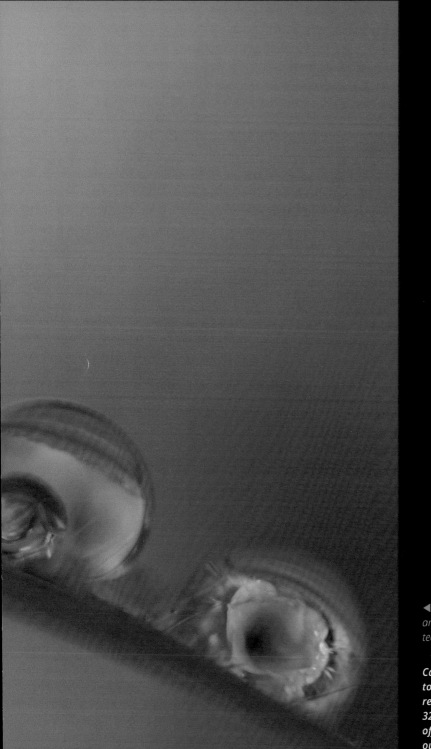

◄ *Reflections of flowers in dewdrops are pretty, and they're easy to photograph if you use the right technique*

Canon EOS 5D Mark II | EF 24–105mm f/4 set to 24mm and f/5.6 (mounted on an active reversing ring) | M mode | 1/160 second | ISO 320 | JPEG | white balance set to flash | two off-camera flashes set up in parallel at 1/2 output

Workshop 17
Coins in a Dark Field

▸ *Producing dark field lighting effects using flash*
▸ *Emphasizing the patterns in coins using a dark field lighting setup*
▸ *Exploiting the inverse square law to optimize your lighting*

Dark field lighting involves setting up your lights so they graze the side of the subject. This technique is perfect for emphasizing engravings, embossed patterns, and other details on the surface of a subject. Real-world applications include photographing etched codes in industrial work, emphasizing the shape of a subject's body in nude photography, and gazing light techniques (see Workshop 35). This workshop demonstrates a simple and effective way to use dark field lighting techniques to photograph coins.

The Setup

I used a Canon EOS Rebel T1i (EOS 500D) with an EF 50mm f/1.4 lens mounted on a 21mm extension tube taken from a three-piece set made by Kenko. I also used a Manfrotto Magic Arm, three non-TTL flashes with RF-602 triggers, and a homemade cardboard tube. A tripod will work instead of a Magic Arm if you prefer. I also used a bubble level to help keep the camera horizontal.

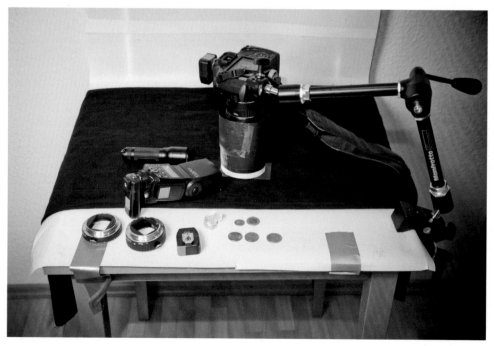

▲ *The generic YN-560 strobist flash has no built-in TTL functionality and must be controlled manually*

▲ *Dark field lighting is perfect for emphasizing the embossed patterns on a coin*

Canon EOS Rebel T1i (EOS 500D) | EF 50 f/1.4 mounted on a 21mm extension tube | M mode | 1/125 second | ISO 100 | RAW | white balance set to flash | three off-camera flashes set up in a dark field

▲ *The final setup, which includes three flashes set up at a slight distance from the tube*

The cardboard tube is the key to the whole setup. We stuck it together with tape. Aside from a half-inch piece of translucent paper attached to its bottom edge, it doesn't allow light inside. We placed the tube over the coin and pointed the camera into the top of the tube. The flashes illuminated the coin through the translu-cent paper; the coin was therefore lit exclusively from the sides to reveal the patterns on its surface in sharp relief. In a dark field lighting setup, the surface of the subject looks dark and the details are emphasized.

Camera Settings and Shooting

Setting up this type of scene requires a little patience. I began by mounting the camera on the Magic Arm and fitting a bubble level to the flash shoe. I switched to manual focus, programmed auto (P) mode, and live view before I polished the coin and set the focus to the middle of the available range (this makes it easier to fine-tune the focus later). I then positioned the cardboard tube between the subject and the lens. To focus in live view mode, I zoomed the monitor image to 10x and shined a pocket flashlight on the subject from the side. In situations like this it is essential to adjust the focus, in addition to the alignment of the camera and the subject, every few shots as needed.

After everything was set up, I replaced the level with a flash trigger, set the camera to manual (M) mode, and switched out of live view mode. The RF-602 flash trigger doesn't work with that camera in live view mode, but the monitor is dark in manual mode anyway, so it doesn't matter. To ensure maximum sharpness, I used mirror

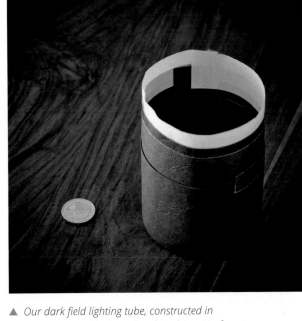

▲ *Our dark field lighting tube, constructed in five minutes from black cardstock and a strip of translucent copy paper*

lockup and a cable release to fire the shutter. Keep in mind that you have to press the shutter button twice when you use mirror lockup.

Because the translucent paper ring works as an internal reflector, this setup can be used with a single flash, although three flashes arranged in a symmetrical star pattern create a more balanced lighting. To avoid producing hot spots I set the flashes to their widest-angle setting and used their built-in flash diffusers. Place your flashes as far away from the subject as your flash output setting and exposure parameters allow. This ensures that the light produced by the flashes remains consistently bright across the entire surface of

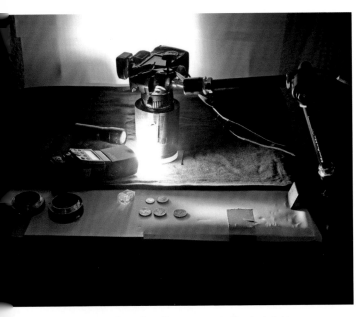

▲ *Our setup in action. You can create the dark field lighting effect and relatively balanced illumination with a single flash.*

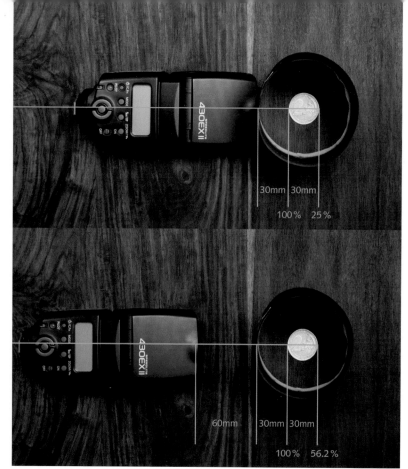

the subject. The calculation for this example is listed in appendix A.

I used 1/2 output at a distance of about 60mm from the cardboard tube. This is a fairly extreme setup that allowed me to use an aperture of f/11, which is a good compromise between the critical and optimum settings (see www.slrgear.com for

◀ *The inverse square law in practice. Increasing the distance between the flash and the subject means the intensity of the light from the flash decreases to just 56% of its initial value, instead of 25% at a closer distance (see also the sample calculation in appendix A).*

▲ *Left to right: The original image; a preliminary result; and the final image, which we straightened, cropped, and retouched before we increased the contrast. This image was captured with a single flash.*

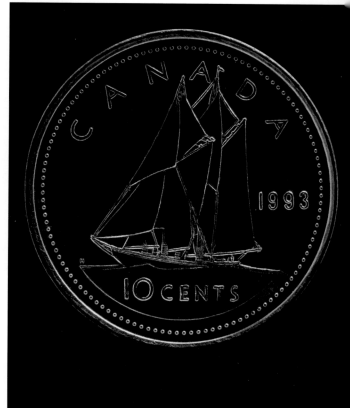

more details about this topic). Using the critical aperture wasn't a good idea because the subject distance varied a little due to slight flexing in the Magic Arm. Using a smaller aperture ensured sharp images without the need to keep readjusting the focus.

Post-Processing in Photoshop

I straightened the photo, selected the coins, and inserted a solid black background. I also removed the dust particles and increased the contrast using the Curves tool.

Tips, Tricks, and Notes

▶ Dark field illumination is a standard tool for performing visual inspections in industrial settings, although the setups in that context usually use LED or fluorescent ring lights rather than flash. Search the Internet for "industrial dark field inspection" to find out more. You can get flashes specifically made for dark field lighting, such as the Canon Macro Ring Lite MR-14EX.

▶ The Manfrotto Magic Arm I used for this setup is not cheap, but it is a worthwhile investment if you shoot a lot of tabletop setups. It is stable and centrally lockable, and you can use it to mount cameras, flashes, and reflectors. It is also available in a kit that includes the Camera Platform, Super Clamp, and Backlite Base.

▶ Dark field lighting is only one of many ways to effectively light coins. For a great example of how to photograph coins with a different lighting setup using a homemade light box, see www.flickr.com/photos/tomd77/3951747640/in/set-72157603959095587 and check out www.flickr.com/photos/tomd77/sets/72157603959095587/with/3951747640 for a portfolio of the results.

Workshops 18–24
Still Life and Product Shots

Whether you are photographing items to sell on eBay or you are working on more sophisticated photos for a catalog or other project, flash is a great tool for displaying your subject in the right light. This section explains how to use bounce flash, how to set up a product shot stage, how to effectively photograph reflective subjects such as watches and jewelry, and how to use modeling flash to enhance your work with flash.

Workshop 18
Still Life with Bounce Flash

- ▸ *How to bounce TTL flash*
- ▸ *Using a black foamie thing to soften direct light*
- ▸ *Long-distance bounce flash*

Many photographers avoid using built-in flash because of the harsh and often unattractive results it produces. Portraits shot with direct flash usually look like mug shots, and product photos look cheap. Direct flash is not diffused and is directed along the camera's optical axis, resulting in very short shadows. The small size of the light source also contributes to its hardness. The obvious solution is to enlarge the light source and alter its location—two adjustments that can be made by simply aiming your flash at a wall, which reflects the light and looks like daylight through a window.

Bouncing flash is a reliable technique that requires few (if any) additional settings and can be used at weddings and other events where you have little time to set up or make test shots. The potential stumbling blocks are stray light, the color temperature of the reflected light, and the effective range.

The Setup

The simplest way to prevent light from reaching the subject directly is to use a shade or flag, like a snoot or Neil van Niekerk's wonderful black foamie thing (see page 43 for details). If you don't shade your flash, some light may illuminate the scene directly. The schematic on page 146 demonstrates the geometry of bounce flash, which more or less adheres to the rule *angle of incidence = angle of reflection*.

▼ *The familiar unattractive look of a scene captured with direct flash*

Canon EOS 5D Mark II | 50mm f/1.4 set to f/5.6 | M mode | 1/160 second | ISO 200 | RAW | white balance set to auto | straight on-camera TTL flash

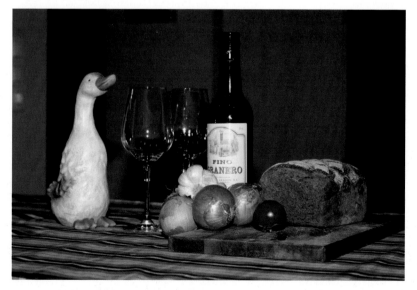

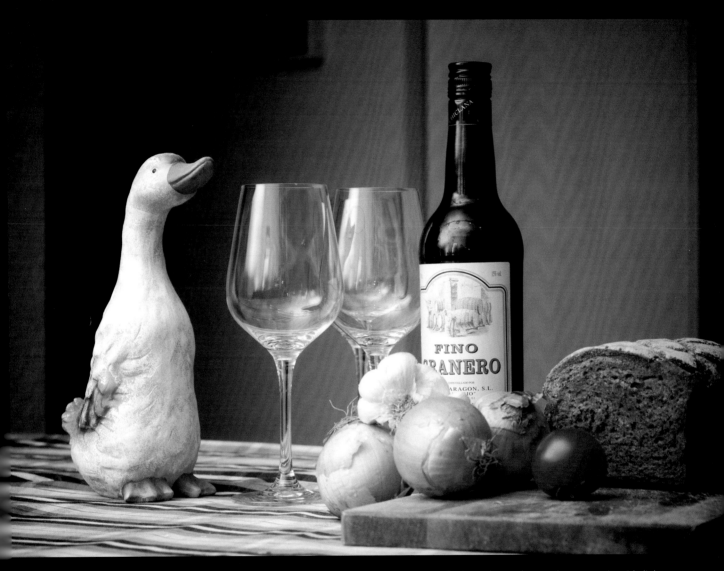

▲ *On-camera flash can be used to produce attractive side light if you learn how to direct it*

Canon EOS 5D Mark II | 50mm f/1.4 set to f/5.6 | M mode | 1/160 second | ISO 200 | RAW | white balance set to auto | on-camera TTL flash, angled toward the wall on the left and shaded with a flag

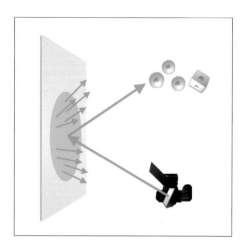

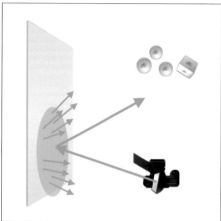

◀◀ *A wall used as a reflector bounces the flash light and acts as a large, diffuse source of light. A black foamie thing mounted on the flash prevents stray light from illuminating the subject directly.*

◀ *Changing the angle of your flash alters the angle at which the reflected light shines and affects the look of the image*

Camera Settings and Shooting

After you set up the scene, attach the flash to your camera and mount a flag. You can leave your camera set to auto mode (i.e., set your flash to TTL mode) and simply shoot away. The downside of the auto approach is the camera decides how much ambient light is included in the scene.

In the example for this workshop, I wanted to completely suppress the ambient light. To do so, I switched to manual (M) mode and adjusted the exposure so a test shot (without flash) turned out almost completely dark. I used ISO 200 and 400 for my test shots so the flash would retain sufficient power to recycle quickly and illuminate the subject over a greater distance. I used automatic white balance to compensate for a

potential color cast due to the ochre color of the wall. All I had to do for the flash was switch it on and select TTL mode. Always take some test shots and, if necessary, adjust the flash exposure compensation (FEC). If you require more light, try using +0.3 or +1.3 FEC. You can adjust the angle of the flash if you need to.

You can use cheaper non-TTL flash units in situations like this, but slight changes in the subject distance and flash angle make it difficult to produce consistent results. Because of the inverse square law, a slight difference in distance makes a surprisingly big difference to the effect of the flash, and you will spend most of your time fine-tuning the settings. Bounce flash works best in TTL mode; it produces satisfying results without the need to adjust settings. Using bounce techniques is

▼ *The initial test shot of the surroundings, shot without flash to confirm that the ambient light was suppressed*

Canon EOS 5D Mark II | 50mm f/1.4 set to f/5.6 | M mode | 1/160 second | ISO 200 | RAW | white balance set to auto | no flash

▼ *The same shot with a swiveled TTL flash fitted with a black foamie thing*

the perfect way to produce great-looking flash images without additional equipment. In fact, I used bounce flash to shoot most of the photos of gear and setups in this book.

Using Bounce Flash over Long Distances

Bounce flash is usually best for short distances because walls usually have less than ideal reflective characteristics, and bouncing light significantly reduces the amount of light that reaches the subject. On the other hand, modern cameras produce perfectly good results at higher ISO settings. See our sample calculation on page 273 for how to use a high ISO value for long distance bouncing. For that example, I set everything up as previously described, but I selected an aperture that caused the TTL flash to automatically switch to full output so I could see how far the flash would reach.

You won't usually have the time (or the inclination) to calculate each individual exposure. However, with a little practice you will learn to judge the distance of the subject in relation to the surface you're using to bounce the light, and you can set an appropriate ISO value without much trouble.

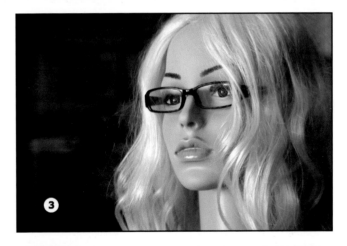

▶ *The results of using bounce flash over longer distances:* **1.** *test shot at ISO 1600 to show the effect on ambient light;* **2.** *shot from 1 meter at ISO 100;* **3.** *shot from 2 meters at ISO 400;* **4.** *shot from 4 meters at ISO 1600. The results are almost identical.*

Canon EOS 5D Mark II | 24–105mm f/4L set to f/6.3 and 105mm | M mode | 1/125 second | ISO 100, 400, and 1600 | JPEG | white balance set to auto | TTL bounce flash

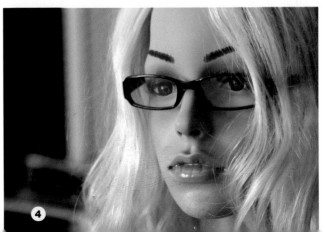

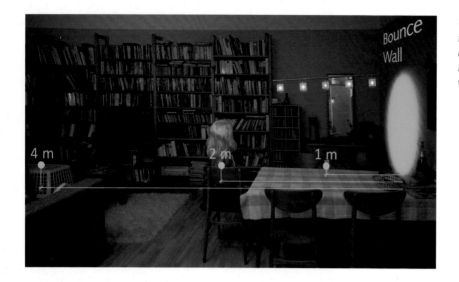

◄ Bouncing light over longer distances. You will quickly learn to predict the effects of the inverse square law and choose an appropriate ISO value.

Tips, Tricks, and Notes

Thanks to TTL flash metering, the approach described in this workshop is reliable in most situations. If, however, you wish to take more control of the flash, you can always use FE Lock (Canon) or FV Lock (Nikon, the two terms mean the same, see page 49). Portraits are a good example of when spot flash metering comes into its own, as it allows you to meter precisely for the subject's cheek.

In this example, I once again used a black foamie thing (BFT), invented by Niekerk. In his *Tangents* blog (neilvn.com/tangents), Neil van Niekerk describes not only how to build a BFT, he also provides a wealth of valuable flash and general photography tips. I use felt and foam BFTs a lot. Both types have pros and cons—the foam version (made from a mouse pad) is stickier and is less likely to fall off the flash, but the felt version is easier to shift and reshape. The experimental aspect is part of the fun. Perhaps you will come up with some other material that works just as well or better. The accompanying figure shows 6 x 7 in BFTs made of felt and foam, both fixed to flash units with hair ties.

▼ *Black foamie things made of felt (left) and foam (right).*

▲ *Another example that should get your bounce flash juices flowing. This photo was captured the same way as the one on page 145.*

Workshop 19
Shooting for eBay

- ▸ *Using a white shoot-through umbrella*
- ▸ *Setting up a rim (or kicker) light*
- ▸ *Creating an effective reflection*
- ▸ *Inserting artificial backgrounds*

A light tent may be the first thing you think of when you consider what equipment you'll need to photograph an item for eBay. However, a light tent that is large enough to accommodate anything but the smallest item can be quite expensive and gives you virtually no leeway in how to set the light. Using a white umbrella with the main light produces a more elegant look, and you can enhance it with a fill light or rim light. You can use a large sheet of paper to create a seamless background to shoot against, or you can use corrugated aluminum or ceramic tile as a stage.

A mirror or a sheet of Plexiglas is not as useful as you might think because it will produce reflections in both of its surfaces. Shiny plastic or sheet metal is much more effective. For this workshop I used a polished cake plate. It wasn't large enough to serve as a complete stage and background, so I created an artificial background during the photo-editing process. Read on to see how.

The Setup

The simplest setup for product shots consists of a single diffused light set up at 30 to 45 degrees to the left and above the subject. For your first steps in product photography you can use a simple tripod as a stand, and a cheap white umbrella mounted with tape or a hose clamp shouldn't cost much more than $10. You can fire your flash with a cable, a slave cell, or a cheap radio trigger, and a cardboard box or a piece of Styrofoam can act as a simple reflector.

In this example I enhanced the photo with a second accent flash positioned opposite the main light. This effect is called *cross lighting;* it is a popular setup for portrait shots. An accent light for the edge of the subject is known as a *rim light*, and one that illuminates the subject squarely from the side is known as a *kicker* (like the one I used here). To keep things simple, I set my accent flash to low output and used it with no additional modifiers.

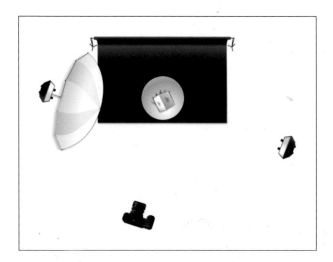

▲ *Schematic of our product shot setup, showing the kicker and the main light in a white shoot-through umbrella*

▲ *A simple product shot is more interesting using side light and a reflective surface*

Canon EOS 5D Mark II | 24–105mm f/4 set to f/16 and 75mm | M mode | 1/160 second | ISO 400 | RAW | white balance set to flash | two off-camera flashes, one fired through a white umbrella and one with no additional modifiers

▲ *Our setup showing the polished cake plate we used as a stage*

Camera Settings and Shooting

Product shots for eBay should make the item look good and inform potential buyers. It is important to shoot with a sufficient depth of field from a variety of angles, so full-frame focal lengths of 50–90mm are the best options.

For the shot shown here, I set my zoom to 75mm and the aperture to f/8. My test shots revealed slightly too little depth of field, so I switched to f/16 and increased the ISO from 100 to 400 (i.e., equivalent to f/8 > f/11 > f/16). These settings allowed me to set my flashes at 1/4 output, which reduced the recycle time and saved me from having to charge the batteries too often. Noise was not a problem with my full-frame camera, but these ISO values shouldn't be a problem for cameras with APS-C sensors, either.

I placed the subject on a chrome-plated cake plate to create the desired reflection. The next step was to make the background and the other surroundings more attractive.

There are various ways to enhance the background in your product shots. You can use textured aluminum or a piece of granite as a stage, or you can use a simple paper as a seamless background. Any of these can be combined with a dark, distant background. Alternatively, you can extract your object from the image file and place it in an entirely synthetic background created in Photoshop.

▼ *The original photo. The overall lighting and the reflection are fine, but the background and the stage still need work.*

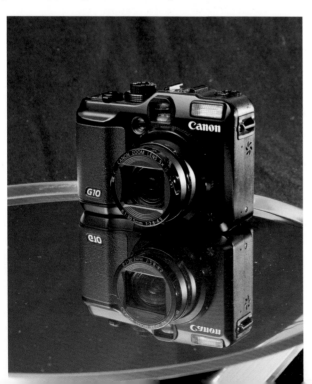

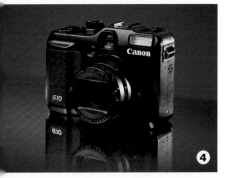

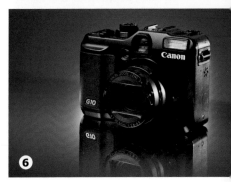

▲▲ *The image-editing steps:*
1. *The original image;*
2. *The selected object;*
3. *The background gradient;*
4. *The background with the object inserted;*
5. *The background gradient and spotlight without the subject;*
6. *The complete image;*
7. *The finished image after retouching and color adjustments*

Post-Processing in Photoshop

If you are using Photoshop Elements, you can make effective selections using the Quick Selection tool and the Refine Edge dialog. In Photoshop, the Paths tool produces more accurate results. With a little practice, it should take only about 15 minutes to make a precise selection of an object like ours. For our example we used two separate gradients and an artificial spotlight to highlight the subject. We also retouched the remaining dust particles and adjusted the colors and contrast to give our image its final look. The illustrations on the previous page demonstrate the individual steps we took.

Tips, Tricks, and Notes

It is possible to create mirror effects in Photoshop, either using the standard tools or a plug-in such as Flood by Flaming Pear. If you want the results to look convincing, the camera's optical axis must be in close proximity and parallel to the reflective surface, and it must be at a right angle to the surface of the subject—our example does not meet this criteria. You can also dismantle an artificial reflection and straighten the individual surfaces individually, but this involves a lot of effort that you can avoid if you take time to create a suitable mirror effect during the shoot.

As always, Flickr is a great source of tips and tricks. You can check the exchangeable image file format (EXIF) tags of individual photos, check out other people's setups, and initiate a conversation using Flickr Mail. Some of the best groups are as follows:

▸ Creative Tabletop Photography: www.flickr.com/groups/creative_tabletop_photography/
▸ Product Shot: www.flickr.com/groups/994055@N23
▸ Product Photography: www.flickr.com/groups/product
▸ Product ART: www.flickriver.com/groups/461653@N24/pool/interesting

▲ *Synthetic mirror effects look authentic only if the camera's optical axis is close to the reflective surface and runs at a right angle to the subject. This is not the case here. The subject was shot from too steep an angle.*

▶ *In this example, the basic requirements are met and the mirror effect looks realistic. The original shot was captured using the parameters listed on page 150.*

Workshop 20
Photos for Catalogs

▸ *Setting up a classic three-light shot*
▸ *Fine-tuning the main light to emphasize subject detail*
▸ *Using manual white balance and a gel to produce warmer colors*

This workshop builds on the simple setup demonstrated in the previous chapter and shows you how to light a more complex object using a classic three-light setup. The fine-tuning steps that follow explain how to enhance the light for the knife blade and give the image a warmer, more appealing look.

The Setup

It is always best to begin building a setup like this by mounting your camera on a tripod and positioning the subject in the viewfinder before you place any lights. For this shot I positioned the main light first, which was mounted behind a white diffuser. I used the rim light without modifiers to ensure that the shape of the knife grip was emphasized (see page 150 for explanations of the terms *rim light* and *kicker*). A wooden board illuminated by a flash with a red gel served as the background.

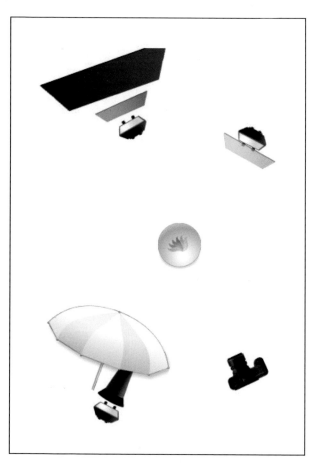

▲ *Schematic of the setup showing the main light (behind a diffuser and set to telephoto), the rim light (set to wide angle with a yellow filter), and the background light (with a red filter, also zoomed)*

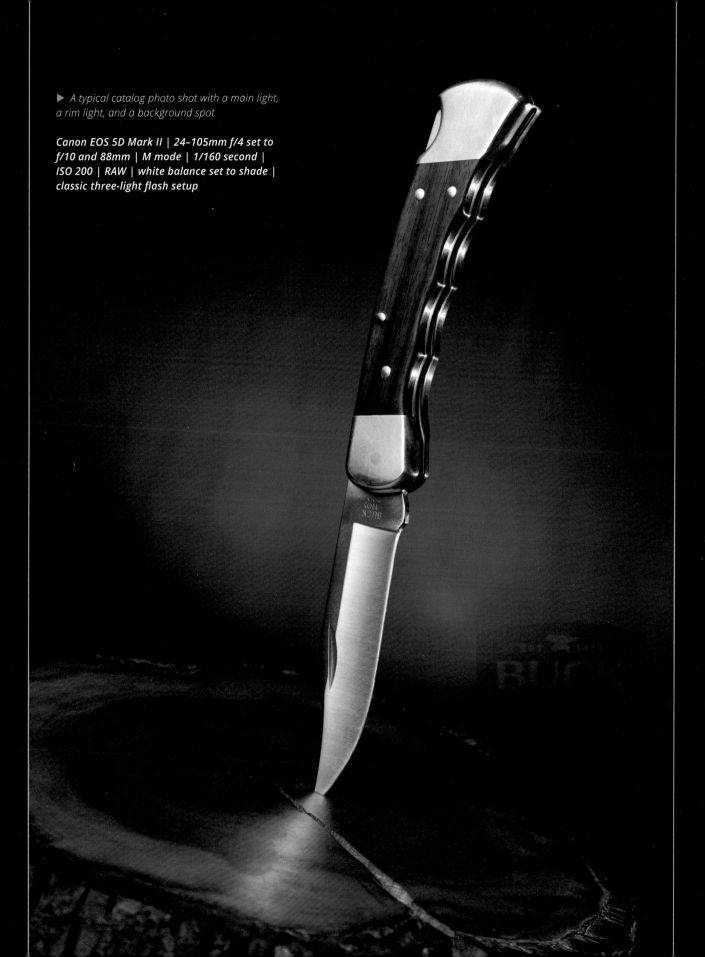

▶ *A typical catalog photo shot with a main light, a rim light, and a background spot*

Canon EOS 5D Mark II | 24–105mm f/4 set to f/10 and 88mm | M mode | 1/160 second | ISO 200 | RAW | white balance set to shade | classic three-light flash setup

Camera Settings and Shooting

I used a medium zoom setting of 88mm on my full-frame camera to make the subject look natural. An aperture of f/10 ensured plenty of sharpness throughout the image, and an ISO setting of 200 allowed me to set my main light to 1/4 output, the rim light to 1/16, and the background spot to 1/8. After I set my lights up to produce an acceptable result, I began fine-tuning the setup:

▸ The ground edge of the knife blade wasn't clear enough, so I added a BFT snoot to the flash, set the reflector to telephoto, and experimented with the position of the flash within the diffuser until the blade was nicely accentuated.

▸ I zoomed the background spot to 105mm to emphasize its effect.

▸ To give the wood and brass in the knife an appropriately warm, luxurious look, I set the white balance to shade. A yellow gel that covered half the rim light provided the final touch.

▸ Finally, I moved the camera to a slightly more dynamic angle and altered the position of the background spot to match.

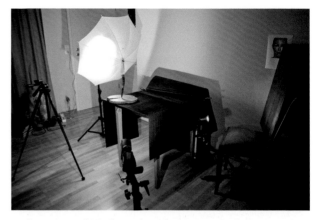

▲ *Our setup, which shows three flashes crammed into a relatively small space. But as always, only what the camera sees is important.*

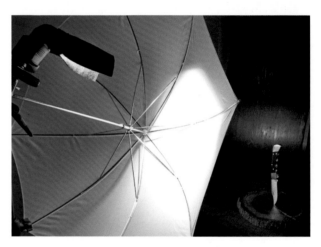

▲ *Fine-tuning the shot. The flash in the diffuser is fitted with a snoot, enabling us to position the light precisely and emphasize the ground edge of the knife blade.*

▼ *The steps in the creation of our image: **1** the basic main light (the blade is not yet emphasized); **2** the rim light; **3** the basic main light, rim light, and background spot light, which improved the overall look; **4** the final setup with the repositioned main light, a yellow gel on the rim light, and a warmer white balance setting*

Post-Processing in Photoshop

All I did in Photoshop was crop the image according to the golden ratio, intensify the background spot with a vignette, and adjust the color and contrast to taste. To finish, I retouched a couple of dust particles and sharpened the image for output.

Tips, Tricks, and Notes

For more workshops and tutorials about product photography, check out the following website: www.photigy.com.

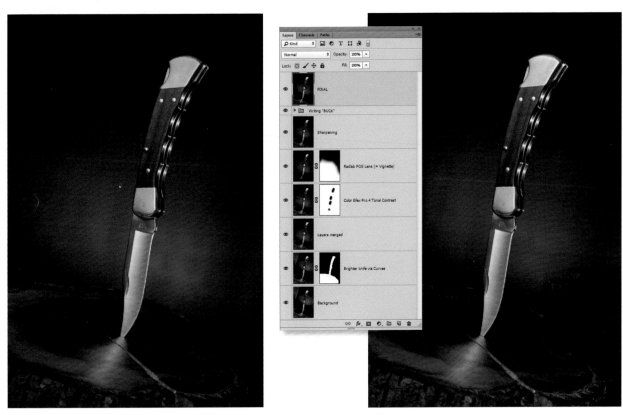

▲ *Left to right: The original image, the Photoshop layer stack, and the finished image*

In-Depth:
Optimum Focus

With or without flash, it is often difficult to focus with a wide aperture. The most common way to ensure correct focus is *focus and recompose*, which involves focusing with the central AF point and locking focus before you adjust the camera to frame the subject. This is a useful approach, but it risks altering the subject distance relative to the camera's optical axis.

It can be more useful to focus with a different AF point, although the central point is usually backed by a cross-type sensor that can focus on both vertical and horizontal edges. The best way to decide which AF point to use depends on the focal length of the lens. The lon-ger the lens, the less detrimental it will be to change the viewing angle, and the less likely it is to affect the sharpness of the image.

Focusing manually through the viewfinder is often imprecise because of the small size of the viewfinder image. Live view with a zoomed monitor image is a more reliable approach. For stationary subjects, tethered shooting (i.e., projecting the camera's monitor image onto a laptop screen with a USB connection) is a great solution. It's best not to use automatic AF point selection because the camera will focus on whatever is closest. This approach is sure to fail quite often.

▼ *The focus and recompose approach leads to focus errors when used with a short lens. The closer the subject and the shorter the focal distance, the more pronounced the error will be.*

Focus on (1),
pan to (2)
produces the error
$\varepsilon = g - g'$
$\quad = g(1 - \cos \alpha)$

▼ *A quick test with a focus test chart will tell you if your lens is focusing correctly*

This test chart shows that the lens is working correctly

If you think your lens is focusing incorrectly, you should test it. I use the free downloadable test chart at www.dphotojournal.com/focus-test-chart.pdf. If a test reveals continued errors, you should send your camera and lens to the manufacturer for calibration. Some high-end cameras have a built-in calibration chart in which you can enter appropriate error correction factors for individual lenses, although I have not found this approach to be perfectly accurate.

Portraits shot at maximum aperture are a special challenge. If you focus on the subject's eye, you will usually end up with a usable image, although autofocus often focuses on the subject's eyelashes. One way to work around this issue is to switch to continuous shooting mode. If you then take a series of shots while moving back and forth very slightly, at least one of the images is sure to be in correct focus.

Remember that even the most expensive lens will produce softer-looking results at the maximum aperture, and it will provide optimum sharpness when it is slightly stopped down. It is extremely difficult to focus accurately with a very shallow depth of field, and the results can be frustrating.

With practice you will get to know your lenses better, and you will be able to estimate which apertures will produce the best results at a variety of distances, and which apertures are too risky.

▲ *The focus in this shot is perfect. Be careful—using wide apertures can be addictive!*

Workshop 21
Photographing Reflective Objects

- ▸ *Setting up an improvised modeling light*
- ▸ *How to photograph reflective surfaces*
- ▸ *Using a collage to create a mood shot*

Now that we have taken a look at the practical aspects of product photography, this section demonstrates how to produce a mood shot. Mood shots are often used in advertising and are usually less practical than conventional product shots; they communicate with less tangible information and more atmosphere. Watches and jewelry present a challenge because the reflections they produce are difficult to control. Most photographers who do this type of work use studio

▲ *Schematic of our watch shot showing the off-camera flash in a diffuser and the clip-on spot we used as a modeling light. Two small shades produced dark accents in the metal.*

flash with modeling lights and high-end macro or tilt/shift lenses. This chapter shows you how to produce similar results with simpler equipment. A modeling light is an important component of the setup. It allows you to keep an eye on the reflections in the subject while you adjust your settings.

The Setup

We placed the watch on a piece of black velvet and used black card to produce dark accents in the metal case. Then we mounted the camera on a tripod and used a 50mm lens with a polarizer filter mounted on a macro extension tube. Although it cannot combat reflections produced by metal, the filter helps reduce unwanted highlights in glass and other shiny surfaces.

Camera Settings and Shooting

Closeup focusing is easiest in live view mode with the camera monitor zoomed in. Some DSLRs do not display a usable live view image on the monitor in manual (M) mode, so you have to use an automatic mode to focus and then switch back to manual (M) mode to make the exposure. My Yongnuo RF-602 radio trigger doesn't work in live view mode with this camera anyway.

▲ *Detail photos that communicate a strong feeling are popular in advertising*

Canon EOS Rebel T1i (EOS 500D) | EF 50mm f/1.4 set to f/7, with an extension tube and a polarizer filter | M mode | 1/125 second | ISO 100 | JPEG | white balance set to auto | camera tripod mounted, focused manually in live view | off-camera flash fired through a white shoot-through umbrella

▲ *The setup for our watch shot*

▲ *One of the unprocessed detail shots*

▲ *The collage before final processing*

Post-Processing in Photoshop

To create the desired effect, shots like this have to be perfect. In this case I used the Clone Stamp tool to retouch visible scratches and dust particles, and I added some blur to each of the metal surfaces. I then created a collage from a selection of the detail shots. The processing steps were as follows:

▸ Crop following the golden ratio
▸ Retouch scratches and dust particles
▸ Unify and soften the metal surfaces
▸ Create a collage
▸ Tone and manipulate the image with the RadLab Photoshop plug-in (Oh, Snap at 75%, Prettyizer at 100%, Super Fun Happy at 61%, Warm It Up, Kris at 88%)
▸ Sharpen for output

▲ *Work in progress in Photoshop showing the RadLab plug-in we used to give the images their final polish*

Tips, Tricks, and Notes

Ming Thein is a specialist when it comes to capturing images of highly reflective watches and jewelry. Check out his setup and results on his Flickr photostream at www.flickr.com/photos/mingthein/843974766/in/photostream. I have used a similar setup to produce some really satisfying images.

▲ *A setup using Ming Thein's triangular milky Plexiglas setup*

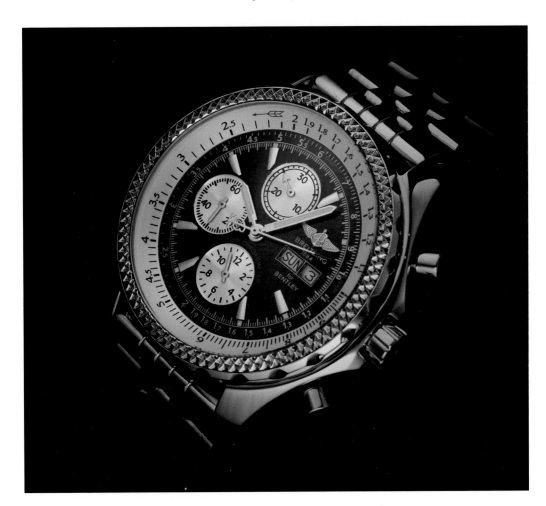

▶ *An image captured using the triangular setup after RAW conversion and before processing*

▶ *A finished, color-adjusted image shot with Ming Thein's setup and inserted into a new background*

Canon EOS Rebel T1i (EOS 500D) | EF 18–55mm f/3.5–5.6 IS set to 53mm and f/14 | M mode | 1/125 second | ISO 100 | RAW | white balance set to auto | three off-camera flashes and three milky Plexiglas diffusers

Workshop 22
Perfume Bottle in Translucent Backlight

Perfume bottles are attractive objects and are perfect for testing new lighting setups. In this workshop I used a blue bottle and matching blue Aqua Pearls (water absorbing beads) as a background. Backlight is the obvious technique to make the bottle and the pearls really shine (see the "Backlit Fruit" workshop 30 for a similar setup). In this case, a second flash brightened the background, and I used a tilt lens to adjust the plane of focus. The finished image had a rather monotone feel, so I added a color gradient in Photoshop to pep it up.

The Setup

The basic setup was simple and took only about five minutes to build. I placed a sheet of translucent Plexiglas on two large books and placed a glass dish with the pearls and the bottle on it. I used a flash to light the dish from below. I decided to shoot at an angle, so I used a second flash to brighten the background, which would otherwise have been too dark. After I took a couple of test shots, I decided to cover the main flash with a sheet of white paper to soften the light. For this shot I used an 80mm Lensbaby Edge 80 lens mounted in a Lensbaby Composer, which allowed me to tilt the optical axis. This tilt lens uses the Scheimpflug principle to alter the plane of focus and create all kinds of interesting effects. In this shot I used it to provide a very shallow anti-Scheimpflug field of focus.

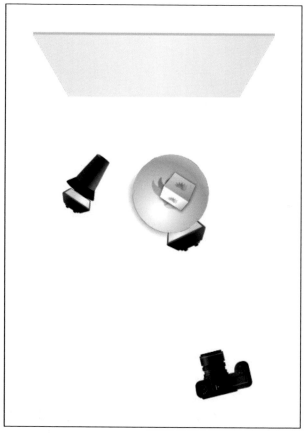

▲ *Schematic of the setup showing the main flash from below and the additional background flash*

EXX MAN EAU DE TOILETTE

▲ *Perfume bottles make stylish photographic subjects. Here a*

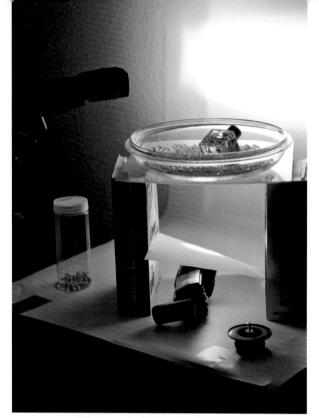

▲ *An overview of our setup. The second flash illuminates the background and is zoomed to 105mm.*

▲ *The camera, showing the Lensbaby Composer and Edge 80 lens, and the LCD magnifier*

Camera Settings and Shooting

The Lensbaby requires the aperture and focus to be set manually. I prefer to do this with a display loupe and a live view image that is 10x zoomed in. To frame and focus in live view, you need to use one of the camera's automatic exposure modes. Remember to turn live view off when you switch back to manual (M) mode. If I failed to turn live view off, my RF-602 radio trigger wouldn't work with that camera (note: this bug is fixed in the Canon 5D Mark III).

I began with 1/16 output for the backlight flash and ended up covering it with a sheet of paper and using ISO 50 before I was happy with the result.

Post-Processing in Photoshop

You can see that the unprocessed image needs to be cropped, and the colors have a cast and look dull. To rectify these issues, I took the following steps in Photoshop:

▸ Crop to the golden ratio using the Crop tool
▸ Make an adjustment with Auto Levels
▸ Add a warm color gradient from the left side in Color Burn blend mode
▸ Add text to make the image look like an advertisement
▸ Sharpen the image for output

Tips, Tricks, and Notes

I could have created a similar color gradient using a gel on the flash, but it probably would not have been as accurate. You have to consider which effects are best created in the setup and which are easier to achieve in post-processing. Because they are virtually impossible to manipulate without looking artificial, the focus and the direction and quality of the light have to be set up correctly during the shoot.

If a Lensbaby is not in your budget, you can experiment with a technique called *freelensing*. You loosely hold a prime lens in the lens mount of your camera and then tilt it, but be careful! I damaged the mirror in one of my cameras this way.

These two Flickr groups provide further insights about the anti-Scheimpflug techniques mentioned in this workshop:

- ▶ Lensbaby Edge 80 Optic: www.flickriver.com/groups/1964552@N23/pool/interesting
- ▶ Freelensing: www.flickriver.com/groups/freelensing/pool/interesting

▶ *The layer stack showing the additional color gradient*

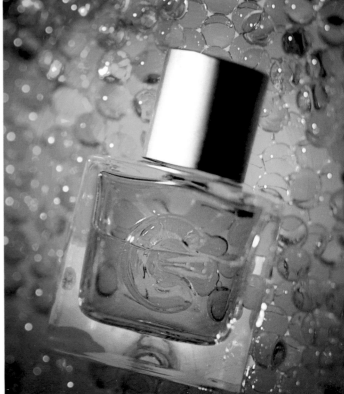

▼ *Another version of the same shot captured with the same setup, but the perfume bottle was recolored in Photoshop*

Workshop 23
Acoustic Guitar

- ‣ *Looking for an interesting perspective*
- ‣ *Creating a bidirectional double-kicker setup with homemade mini softboxes*

Subtle focus effects for an image of a musical instrument are fine if you plan to use the image for a CD cover or a similar purpose. The closer you get to the subject, the more extreme the effect will be. In this workshop we focused on the head of the guitar, and the extreme vanishing point perspective accentuated the shallow focus. I used a Canon EOS Rebel T1i (EOS 500D) APS-C camera with an EF 50mm f/1.4 lens. I shot in manual (M) mode at 1/125 second, which gave me plenty of leeway regarding the camera's flash sync speed of 1/200 second. The light came from four inexpensive Yongnuo YN-460 flashes fired with CTR-301 radio triggers, which are no longer manufactured and have been replaced by the more powerful and more reliable RF-602.

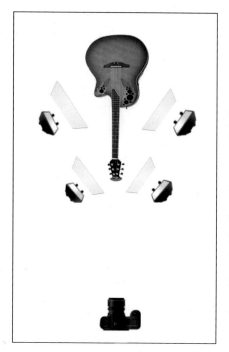

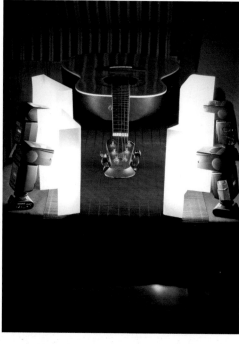

◄◄ *Schematic showing the four non-TTL flashes set up in two pairs. Each flash is fired through a folded sheet of copier paper.*

◄ *The actual set-up: Four non-TTL, shoe mount flashes; two on each side of the guitar. The flashes sit on their radio receivers, and white paper is used to soften the light.*

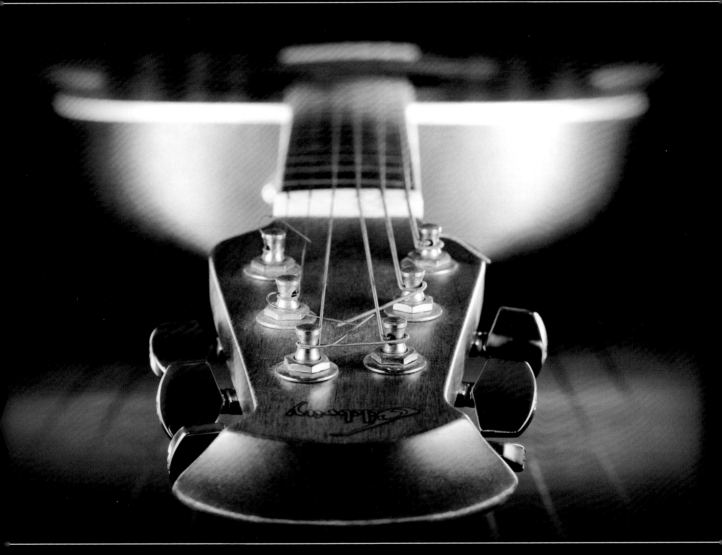

▲ *Mood shot of a guitar lit with a double-kicker lighting setup*

Canon EOS Rebel T1i (EOS 500D) | 50mm f/1.4 set to f/6.3 | M mode | 1/125 second | ISO 100 | RAW | white balance set to auto | four off-camera, non-TTL flashes fired with Yongnuo radio triggers

The Setup

We placed the guitar flat on a table surrounded by two pairs of flashes set up in a double-kicker formation. Folded sheets of copier paper were used as diffusers to soften the light.

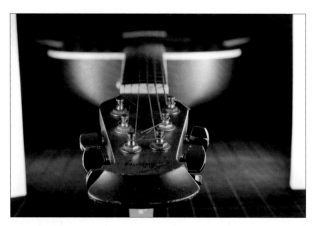

▲ *The original image. The lighting and focus are okay, but some retouching is required.*

Camera Settings and Shooting

An aperture of f/6.3 might seem small for such a shallow focus effect, but the proximity of the camera to the subject made it possible. If we had selected a wider aperture, the guitar's neck and body would have been unrecognizable. As usual, I made my initial test shots without flash to make sure the surroundings were adequately lit. I began testing my flashes at 1/4 output and fine-tuned them from there. I captured the shot handheld, so I had to straighten it during post-processing.

Post-Processing in Photoshop

These are the steps I performed:
- ▸ Straighten, crop, and add the background pixels that were missing at the edges of the frame
- ▸ Subtly broaden the guitar body
- ▸ Retouch the green support below the guitar head as well as the scratches and dust particles
- ▸ Slightly desaturate the image and increase the contrast
- ▸ Adjust the color
- ▸ Sharpen the image for output

▲ *The layer stack is relatively simple. The retouching layer is the only one that required a significant amount of time and effort.*

In-Depth:
The Pros and Cons of Using TTL Flash

The next workshop demonstrates how to use modeling light in conjunction with manual flash output settings. This raises the question of when it is preferable to use TTL mode and when to stick with manual. TTL mode is preferable in some situations:

▸ TTL is essential when you have to work quickly, such as at a wedding or other fast-paced event when there is no time to make complex settings or take test shots.

▸ TTL is extremely useful in handheld situations when the subject distance is constantly changing. Manual flash has to be readjusted every time the subject distance changes.

▸ For the same reason, TTL flash is also perfect for moving subjects—for example, when you are using a handheld softbox or are shooting models on a runway. Manual flash settings under these conditions would take too long.

In most other situations I prefer to set up my flashes manually. This approach is more deliberate, and you get exactly the amount of light you want. You can, of course, use FEC to compensate for any changes, but this increases the risk of TTL metering discrepancies in subsequent shots. And if you take time to make a compensation setting, you might just as well set up your flash manually.

▼ *TTL mode is the best option for moving subjects. This shot was captured with a Canon Speedlite 430EX II mounted in a softbox and fired with a 33 ft spiral TTL flash cable (the same setup as in workshop 2).*

Canon EOS Rebel T1i (EOS 500D) | EF 50mm f/1.4 set to f/1.8 | M mode | 1/50 second | ISO 200 | RAW | spot metering with FE Lock and AI Servo AF

Workshop 24
Studio-Like Modeling Light

▸ *How to make a flash work like a modeling light*
▸ *Lighting a simple tabletop scene using modeling flash*

Aside from their lower output, one of the main disadvantages of using portable flash instead of studio flash is the lack of a modeling light. A modeling light is a continuous light source that helps you visualize the shadows, highlights, and reflections the flash will produce before it fires. Nowadays, higher-end flash units by Canon and Nikon have built-in modeling flash, which fires a series of weak flashes to emulate a conventional modeling light (see workshop 35). Canon's modeling flash is activated by pressing the depth-of-field preview button on the camera body.

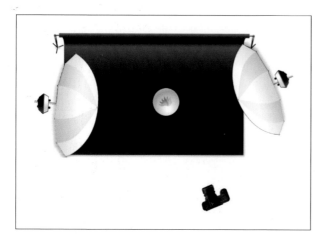

▲ *Schematic of our tabletop scene with two off-camera Canon flashes mounted in umbrella diffusers*

This is fine if the flash is mounted on the camera, but if you want to use this function with an off-camera flash and regulate the flash output manually, you have to take a slightly different approach.

The Setup

My trusty RF-602 radio triggers were not smart enough for this setup, so we had to use a Canon ST-E2 infrared transmitter (or Yongnuo's cheaper version with the same name) to transmit data to the flashes. Both units were mounted on umbrella swivels in white shoot-through umbrellas.

Camera Settings and Shooting

I set my Canon Speedlite 430EX II to channel 4 and M mode (by pressing the Mode button for four seconds). I manually set the flash output to 1/8 and fine-tuned the setting after I took a couple test shots. Then I set up my Canon Speedlite 580EX II the same way and fine-tuned the output setting. Finally I mounted my Yongnuo ST-E2 transmitter on the camera and set it to channel 4. This setup allowed me to fire the modeling flash by pressing the depth-of-field preview button on the camera. The intensity of the modeling flash depends on the flash output setting you select.

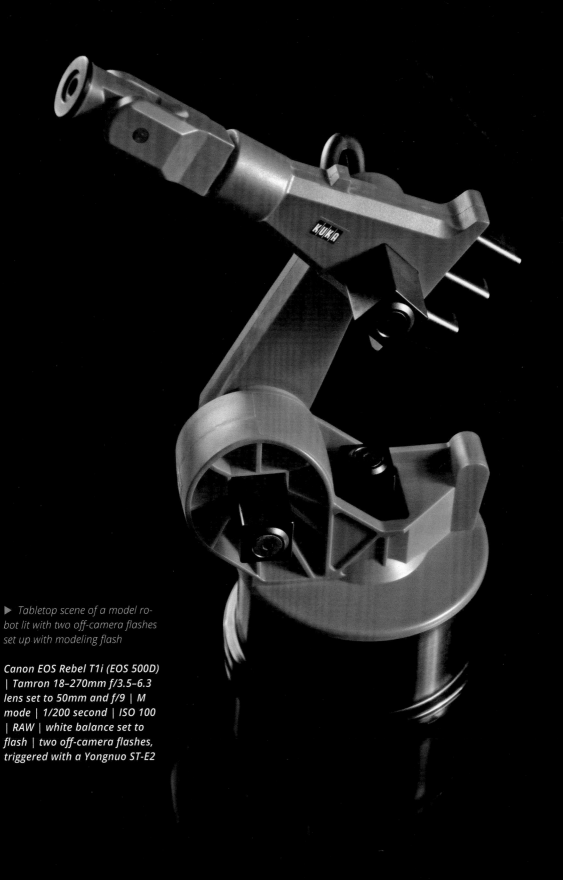

▶ Tabletop scene of a model ro-
bot lit with two off-camera flashes
set up with modeling flash

Canon EOS Rebel T1i (EOS 500D)
| Tamron 18–270mm f/3.5–6.3
lens set to 50mm and f/9 | M
mode | 1/200 second | ISO 100
| RAW | white balance set to
flash | two off-camera flashes,
triggered with a Yongnuo ST-E2

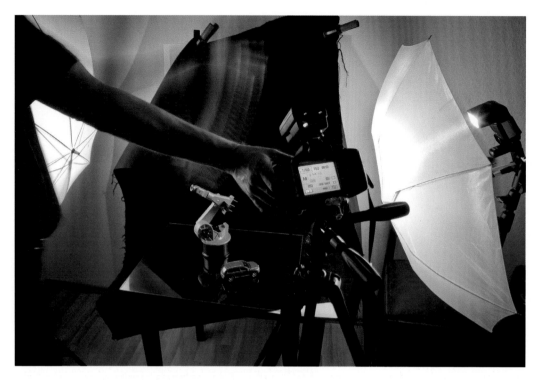

▲ *Our tabletop scene, showing the two Canon off-camera flashes mounted in umbrella diffusers fired with a Yongnuo ST-E2. The movement of the photographer's hand demonstrates the stroboscopic effect of the modeling flash.*

Post-Processing in Photoshop

Even though this workshop is about modeling light, the post-processing steps still play an important role in producing the finished image. The steps we performed were as follows:

▸ General cleanup, including removing dust particles and scratches

▸ Adjust, lengthen, and enhance the background and the reflection

▸ General enhancement with the RadLab plug-in from Totally Rad

▸ Sharpen the image for output

Tips, Tricks, and Notes

Actually, the shot of the setup at the top left was far more difficult to capture than the featured image in this workshop. Because I wanted to capture the strobe-like effect of the modeling flash, I had to use a second tripod-mounted camera in bulb (B) mode and a cable release. I also needed three hands: one to wave in front of the lens (for the stroboscopic effect demonstration), one to release the shutter on the second camera, and one to press the depth-of-field preview button on the main camera! The room was completely dark, and the modeling flash lasted about 1 second.

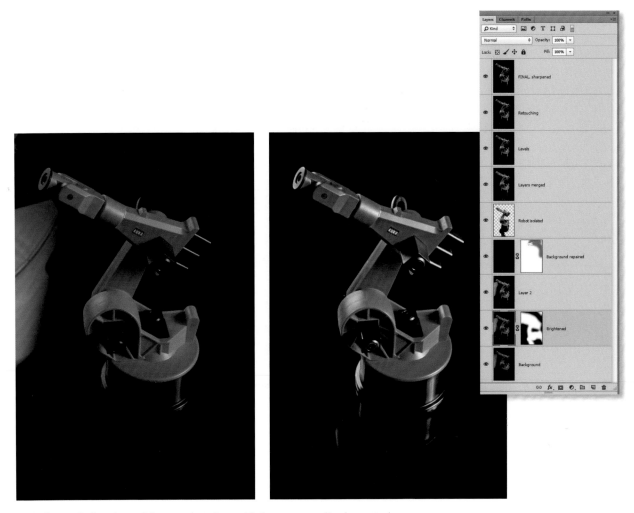

▲ *Before and after shots of the toy robot along with the corresponding layer stack*

Food Photos: The Most Important Ingredient is Light!

Food photography isn't easy. If you are lucky, you will have a north-facing window that provides plenty of daylight—otherwise you will have to use flash. The workshops in this section show how to produce elegant-looking food shots with minimal equipment.

Workshop 25
Basic Flash Setup for Food Photos

▸ *How to capture attractive food shots in low light—at home and out and about*
▸ *Bouncing on-camera and built-in flash*

Everybody loves good food, and the numbers of amateur chefs and food bloggers are increasing daily. What's better than a delicious-looking photo to whet people's appetites? They're easy to take in the right conditions. For great-looking food shots all you need is daylight as a side or main light, a reflector, slight overexposure, and a wide aperture! But if you have a day job and have to cook and photograph in the evening, things are a little trickier. Although continuous light is a possible solution, HTI lamps that emulate daylight are expensive, and

normal energy-saving bulbs make food look decidedly unappetizing. The visible spectrum provided by studio flash is perfect for the job, but it is also expensive and can be difficult to set up. What's wrong with using the gear you already have? A system flash, or even the popup flash built into your camera, will do. This might sound risky, but it works very well if you know how to do it. This workshop shows you how to use a single flash, a mouse pad, and a couple sheets of Styrofoam (or even a white wall) to build an effective food photo setup that will provide the look of soft daylight.

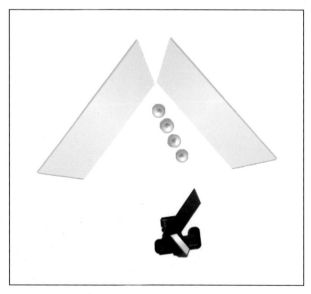

▲ *Schematic for our basic food setup, showing the bounced on-camera flash*

▶ *Is it possible to take attractive food shots in soft sidelight with on-camera flash if you play off the cushions (see workshop 1)*

Canon EOS Rebel T1i (EOS 500D) | EF 50mm f/1.4 set to f/1.6 | M mode | 1/100 second | ISO 100 | RAW | white balance set to flash | on-camera Canon Speedlite 430EX II TTL flash | FEC set to +1.33 EV

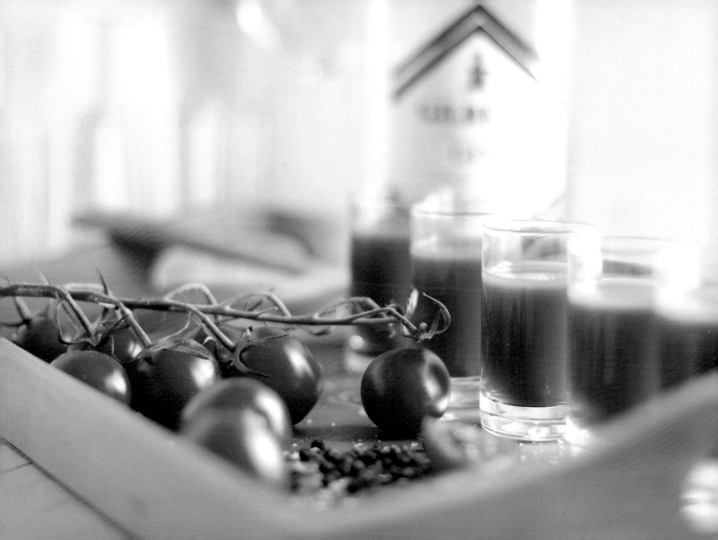

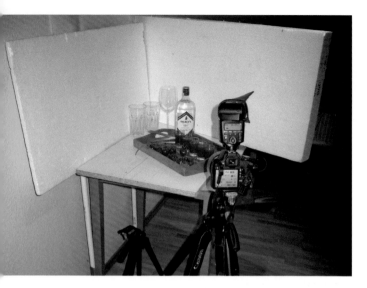

▲ *Our setup, showing two Styrofoam reflectors and a black foamie thing attached to the on-camera flash*

On-Camera TTL Flash: Camera Settings and Shooting

For this type of shot, you need to suppress the ambient light as much as possible because it will usually have the wrong color temperature and will come from the wrong direction. I set the camera to manual (M) mode, chose my parameters to eliminate the ambient light, and I checked my settings in a couple test shots. I then mounted the flash and switched it to TTL. A test photo was adequately exposed, but the look and feel of the lighting was terrible—harsh frontal light filled the frame. For my next attempt I dialed in +1.33 EV FEC to give the shot a more open and inviting look.

The Setup

The spectrum that an on-camera or popup flash produces is identical to that of expensive studio flash units. It is very similar to daylight, which makes it perfect for food shots. Of course, accessory flash has a lower output than studio gear, but that doesn't matter at the close distances involved in this workshop. In its basic form, on-camera flash is not particularly well suited to food photography due to the small size of the light source and its orientation along the camera's optical axis, which produces short, hard shadows. The obvious solution is to modify the light from the flash to make it seem like it comes from a larger, softer source. The easiest way to accomplish this is to bounce light off a large reflector and use a black foamie thing (see page 43) to prevent stray light from directly illuminating the subject. For this shot I used two sheets of Styrofoam: one acted as the main reflector, and the other produced a fill accent from the other side. If you are shooting in a room with white walls, you can use them to produce the same bounce effect.

For these shots I used a Canon EOS Rebel T1i (EOS 500D) and a Canon Speedlite 430EX II flash. For the next shots, I even used the camera's built-in flash.

▲ *Test shot with manual exposure settings and without flash as a test to make sure the ambient light is suppressed*

Canon EOS Rebel T1i (EOS 500D) | EF 50mm f/1.4 set to f/1.6 | M mode | 1/100 second | ISO 100 | RAW | white balance set to flash | no flash

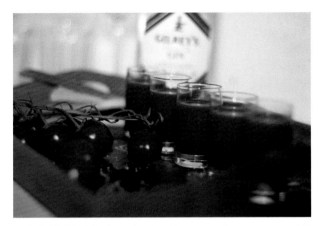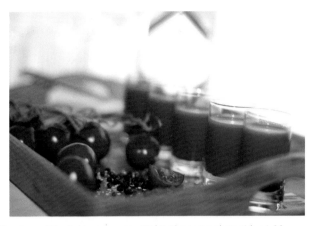

▲ Left: With TTL flash and without bouncing, the exposure and the direction of the light are wrong. Right: The same shot with +1.33 EV FEC. This version looks better, but the direction of the light and the hard, short shadows it produces are still not right.

Canon EOS Rebel T1i (EOS 500D) | EF 50mm f/1.4 set to f/1.6 | M mode | 1/100 second | ISO 100 | RAW | white balance set to flash | on-camera Canon Speedlite 430EX II in TTL mode | 0 EV FEC (left) and +1.33 EV FEC (right)

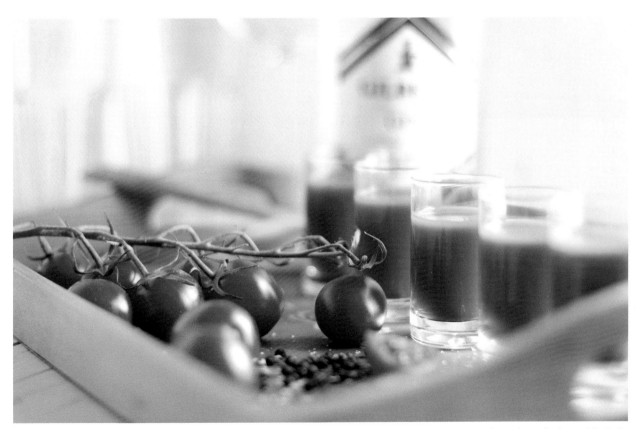

▲ In this final version, the flash was bounced off a Styrofoam sheet placed to the right of the subject, and any direct flash was blocked by a black foamie thing that was mounted on the flash. The result is a scene that is lit exclusively by soft, lateral light.

Canon EOS Rebel T1i (EOS 500D) | EF 50mm f/1.4 set to f/1.6 | M mode | 1/100 second | ISO 100 | RAW | white balance set to flash | on-camera Canon Speedlite 430EX II with a black foamie thing | Styrofoam reflector | FEC set to +1.33 EV

The shot was starting to look better, but the direction of the light was not how I wanted it. To fix it I rotated the flash toward the Styrofoam reflector and blocked any remaining direct light with a black foamie thing. This simple step transformed the flash into a much larger and softer light source. The light now came from the side and made the tomato juice in the glasses really shine.

The amount of flash exposure compensation required to get this kind of shot varies from flash to flash and from scene to scene, so you will have to experiment to find your own solution. Values between +0.3 and +1.33 usually do the trick.

Popup Flash: Camera Settings and Shooting

You can use the same bounce trick with popup flash, but because you cannot rotate a popup flash, you need to direct the light a different way. I used a black foamie thing covered in reflective tape and transformed it into a silver foamie thing. You can usually attach a black foamie thing to a flash unit with a hair tie, but you have to hold it for a popup flash. With a little practice you will find that a silver foamie thing made from a mouse pad is easy to hold and manipulate.

▲ *A popup flash cannot be rotated, so I handheld a black foamie thing covered with reflective tape to direct the light*

◀◀ *The setup for our popup flash shots. You can see the glasses and glittery red ribbon we used to produce the back-ground bokeh.*

◀ *Schematic of the popup flash setup showing the black foamie thing covered with reflective tape (it is now a silver foamie thing)*

▲ *Photos like these can even be captured with popup flash if you know how to manipulate it*

Canon EOS Rebel T1i (EOS 500D) | EF 50mm f/1.4 set to f/2.2 | M mode | 1/200 second | ISO 100 | RAW | white bal-ance set to flash | popup flash and a silver foamie thing | +1.33 EV FEC

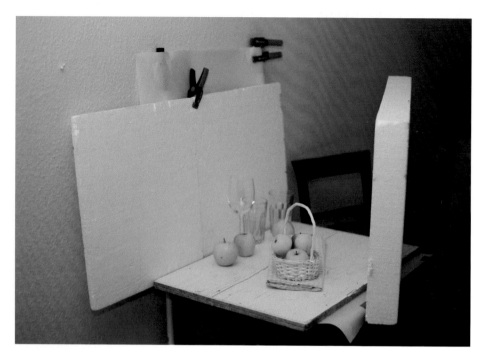

◄ *The setup for a photo of some apples, again with bounced flash. The glasses in the background produced the bokeh.*

The rest of the setup was like the previous one of the tomato juice glasses. Once again, we used one sheet of Styrofoam as a reflector (a wall could work just as well) and a second sheet of Styrofoam opposite the first one to brighten the shadows. For this shot I added some glasses and I used a wide aperture to create the background bokeh.

Tips, Tricks, and Notes

The on-camera TTL bounce flash technique is quick to use and easy to perfect for shooting food photos in restaurants, but bouncing popup flash can be tricky and it requires practice. Popup flash is less powerful, so you might have to use flash exposure compensation or increase the ISO setting to get satisfactory results. If your budget allows it, a TTL flash with a swivel head from your camera manufacturer is the best option, and of course, you can also use this type of flash off-camera (see the next workshops for examples).

A silver flag is necessary only if you use it with popup flash. Shading a flash that rotates is more easily accomplished with the unmodified black foamie thing.

▶ *I think it is impossible to tell that this photo was captured with an on-camera flash and just a few simple accessories*

Canon EOS 5D Mark II | EF 50mm f/1.4 set to f/1.4 | M mode | 1/125 second | ISO 100 | RAW | white balance set to flash | on-camera Canon Speedlite 580EX II set to TTL mode | +1.66 EV FEC | shot with a black foamie thing to block direct flash light

Workshop 26
A Simple Off-Camera Flash Setup

> ‣ *Improvised reflectors and diffusers*
> ‣ *How to create attractive effects with a single backlight*
> ‣ *How to shoot quickly and discreetly with flash even in restaurants*

Food prepared by a professional chef in a good restaurant tastes great, looks appetizing, and serves as a great photographic subject. If you have a window table during the day, photographing your food is relatively simple, but capturing it effectively in evening light is virtually impossible. Restaurant lights provide neither the spectrum nor the direction and softness you need to capture usable images.

You have a lot more options if you use flash. If you are sitting in the open, ask for permission before you use flash, but if you are sitting in a booth or in a corner of your own, you can usually go ahead and shoot. With a little practice you will learn to shoot quickly and unobtrusively so you don't annoy other guests. Generally speaking, low-end restaurants don't mind photogra-

◀▼ *Flash versus artificial light—in this case there is no contest! These two photos were captured with the same camera, but the one on the left was shot with the camera on M mode and with flash, while the one on the right was shot with the camera's auto exposure mode and without flash. Neither image was post-processed.*

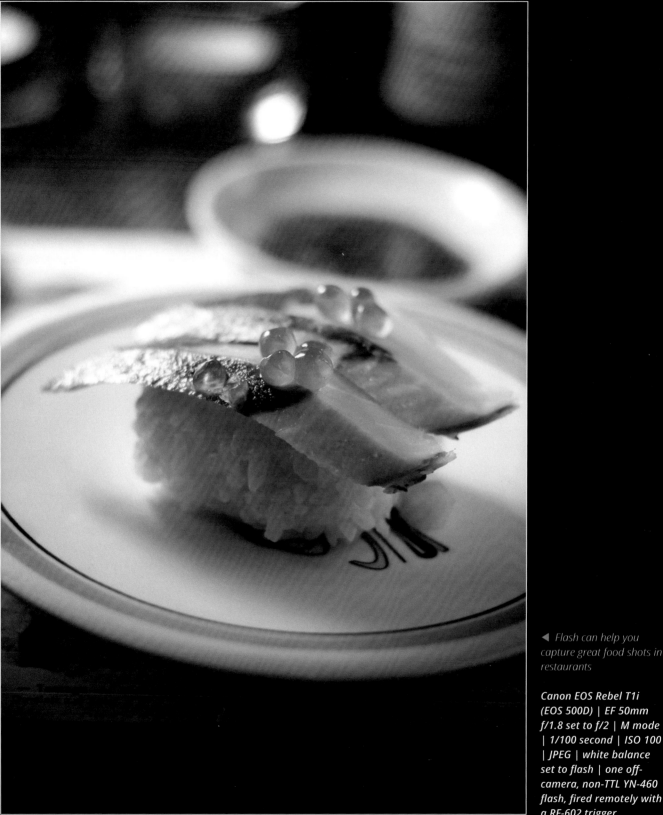

◀ *Flash can help you capture great food shots in restaurants*

Canon EOS Rebel T1i (EOS 500D) | EF 50mm f/1.8 set to f/2 | M mode | 1/100 second | ISO 100 | JPEG | white balance set to flash | one off-camera, non-TTL YN-460 flash, fired remotely with a RF-602 trigger

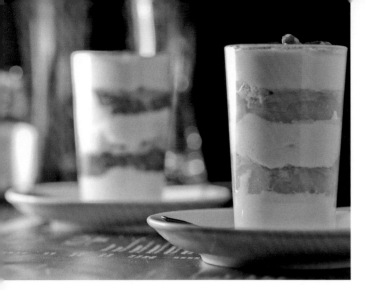

▲ *Another unprocessed restaurant shot. The focus and lighting are fine, but the background is dark and uninteresting. Photoshop can provide the solution.*

phers, but high-end establishments prefer that people do not take pictures. At the same time, if you want a high-quality photo, you need a high-quality subject, so it might be worth asking.

The previous workshop showed you how to use lateral light to improve the quality of food photos. As your skills improve, you will want to add light from behind. Direct or angled backlight positioned opposite an accent or fill light guarantees attractive results, but it is impossible to set up this kind of shot with on-camera flash. The solution is an off-camera flash fired through a diffuser, ideally with an additional reflector opposite the flash. This might sound complex, but it is actually quite simple.

The Setup

Our setup consisted of a single YN-460 non-TTL flash placed diagonally behind the subject, a RF-602 radio trigger, and two sheets of copier paper; one used as a reflector and the other as a diffuser. We simply folded the paper to make it stand up, and we placed one sheet in front of the flash and the other opposite the flash in front of the subject. If paper is not available, you can probably find a light-colored advertising flyer to use instead. You can either mount your flash on the radio trigger or lay it on its side.

Camera Settings and Shooting

In a setup like this it is preferable to almost completely suppress the ambient light and allow the flash to dominate the scene. In manual (M) mode, select a wide aperture to create some background bokeh, choose ISO 100 for low noise, and set the exposure time to about 1/125 second. The short exposure time will suppress the ambient light in an artificially lit evening scene without overstepping the camera's flash sync speed. As usual, the first step is to take a test shot without flash to check the ambient light level.

When you are satisfied with the settings, you can set up your flash and the paper reflectors. The close proximity of the subject and the wide aperture allows you to use a low output setting. Start at 1/32 and increase the output slightly if your test shots call for it (remember that one full increment doubles or halves the amount of light). Adjust the flash distance and angle to optimize the look of your shot. After some practice you will be

▲ *This same setup was used for both our sushi and dessert shots. The schematic shows our off-camera backlight flash with a paper diffuser and a second sheet of paper used as a reflector*

able to set up and capture a shot like this in two or three minutes.

After you have found the right settings, shots like this will usually require very little processing. However, our sample photo had a dark and rather dull background. If you have access to Photoshop or Photoshop Elements, it is easy to insert a completely new background. For optimum results, in this case, use Hard Light blend mode, mask the subject, and adjust the intensity of the background colors with the Opacity setting.

In our example we also used the Clone Stamp tool to remove a couple of messy details. We increased the contrast and virbrance, and we added a warm-toned filter with low opacity.

▲ Using Photoshop to create a more interesting background. The screenshot shows the mask and the settings we used (Hard Light blend mode and 87% Opacity).

▶ The final result is a delicious-looking photo that was shot in two minutes at a restaurant with a simple setup

Canon EOS 5D Mark II | EF 100mm f/2.8L macro set to f/4.5 | M mode | 1/125 second | ISO 100 | RAW | white balance set to flash | off-camera, non-TTL flash fired with a RF-602 radio trigger

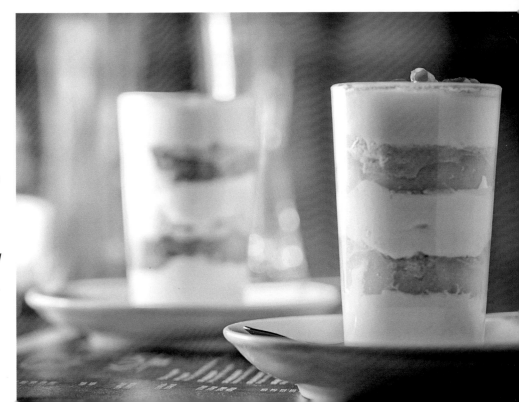

Tips, Tricks, and Notes

The background in food photos is important, even if it is completely blurred in the final image. Drinking glasses, glittery giftwrap, and other objects in the background provide interesting and attractive bokeh bubbles—the farther away from the subject, the larger the circles of confusion. Food photos usually look best when the background is blurred, so a long lens, a close subject distance, a wide aperture, and a distant background are ideal. Professional food photographers such as David Loftus use medium-format cameras, but an APS-C or DX camera coupled with a full-frame 50mm f/1.8 standard lens can produce great food shots, too. If you dare to get really close to the subject, the background will automatically blur.

▶ *Another sushi shot to inspire you*

Canon EOS Rebel T1i (EOS 500D) | EF 50mm f/1.8 set to f/2 | M mode | 1/100 second | ISO 100 | JPEG | white balance set to flash | radio-triggered off-camera, non-TTL flash

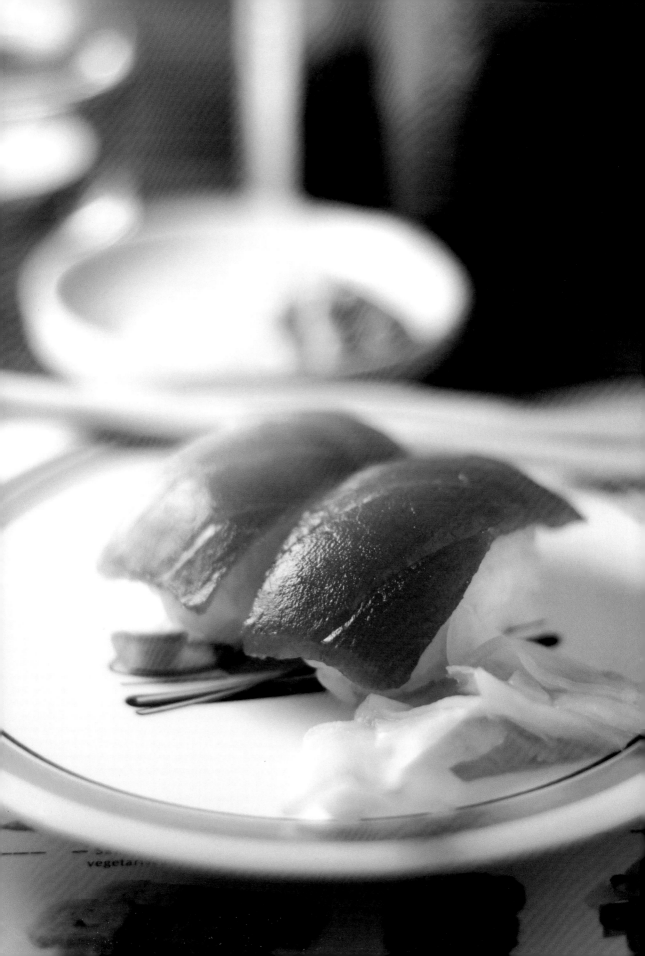

Workshop 27
A Complex Flash Setup for Food

▸ *How to build a backlit setup*
▸ *Using Translum sheeting instead of a softbox*
▸ *Doing a contract job for a restaurant*

A local restaurant owner asked me to shoot some photos for his website, so I began looking for a simple but reliable setup that I could use to capture a variety of dishes. My search took me to a setup created by Thomas Ruhl ([1] www.tiny.cc/un7wlw) that uses a Translum diffuser backdrop and a reflective silver umbrella. I used the same basic elements in a less expensive and more portable form.

The Setup

I used flash fired through Translum sheeting for my main light and backlight. I mounted the sheeting on two telescopic painting poles, which are available from any hardware store, and I attached the poles to a table with tape. The Translum sheeting is easy to roll up, and you can adjust the flash position and angle. Both of the YN-460 flashes (with RF-602 radio triggers)

▲ *Our setup, showing two flashes and the stage we made from a restaurant table and a roll of Translum sheeting mounted on the painting poles*

[1]*Although this video is in German, you will understand his setup by watching it even with the sound off*

▲ *Schematic of our setup, showing the main flash fired through the Translum sheeting and the reflector umbrella at the front left. The camera was positioned directly above the the scene and is not shown here.*

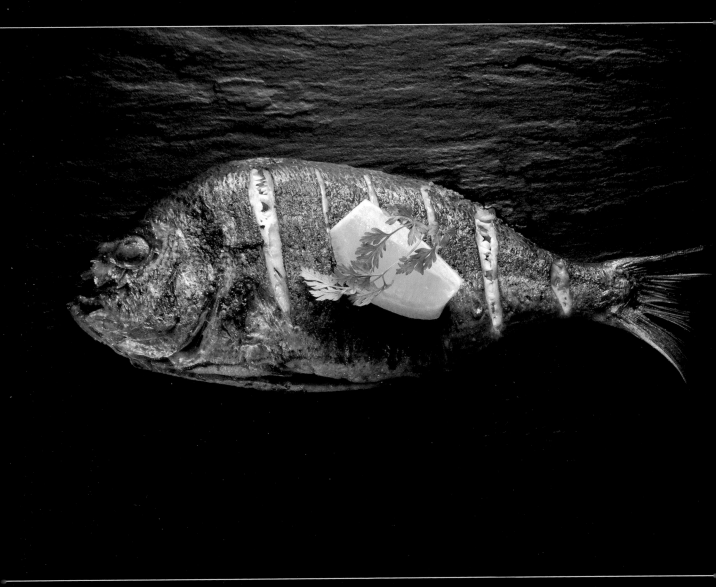

▲ *A quick and easy food photo. The setup included a roll of Translum sheeting and a reflector umbrella.*

Canon EOS Rebel T1i (EOS 500D) | Tamron 18–270mm f/4– 5.6 set to f/8 and 46mm | M mode | 1/125 second | ISO 100 | RAW | white balance set to flash

were mounted on light stands with Manfrotto MA026 umbrella adapters, and the second light was pointed into a reflector umbrella. I used my trusty Canon EOS Rebel T1i (EOS 500D) with a Tamron 18–270mm zoom. During the shoot I stood on a ladder and shot down toward the subject.

Camera Settings and Shooting

This is another setup in which we want only flash light and no ambient light. In this case, the color temperature of the ambient light and its angle of incidence were undesirable. Shooting at f/8, 1/125 second, and ISO 100 should produce sharp, low-noise images with little influence from the ambient light. As always, make some test

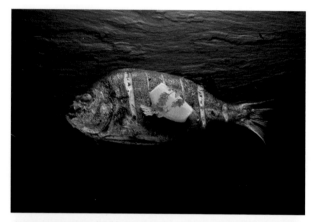

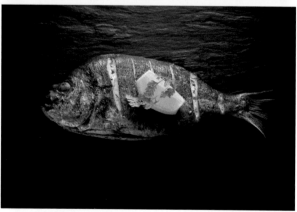

▲ *The original, unprocessed image (top); the same image with some subtle tweaking (bottom)*

shots without flash to check the lighting balance before you add the backlight and reflected flash. The Translum sheeting reduces the flash output by 1–2 EV, and the medium aperture means you have to dial up the flash to compensate. In this setup, the umbrella light should be less prominent than the diffused light, so 1/4 output is a good place to start, and then you can adjust the setting as necessary.

This setup is simple and gives you the flexibility to shoot a variety of subjects. The camera position directly above the subject makes it unnecessary to adjust the lighting for each shot, as would be required when using a conventional viewpoint diagonally above the table. The question of aperture and depth of field is precluded by the unusual viewpoint and the relatively small aperture, and even our midrange lens produced perfectly sharp images with the chosen aperture.

Post-Processing in Photoshop

If the lighting setup is done properly, there will be little need for post-processing. For this photo I straightened and cropped the image before I removed a couple of excess water droplets and checked for unwanted artifacts. To finish up, I added a subtle vignette and sharpened the final image.

Tips, Tricks, and Notes

The 18–270mm Tamron lens we used for this shot has one of the largest zoom ranges available. It is a lot of fun to use, but it doesn't produce the high-end sharpness we normally like to see throughout its entire range. If you know which focal lengths you are likely to use during a shoot, you can check in advance which apertures produce the best results. SLRgear (www.slrgear.com) lists the critical apertures for a wide range of popular lenses. I used focal lengths between 55mm and 70mm for this session, and f/8 provided the best compromise.

◀ *Graphs of the resolution produced by our Tamron lens at f/5.6, f/8, f/11, and f/16. Bright pink is better, dark blue is worse. (Illustrations courtesy of Dave Etchells, www.slrgear.com)*

An aperture of f/11 would also provide the necessary depth of field in a situation like this, but stopping down any further would result in diminished image quality due to diffraction within the lens.

Thomas Ruhl (mentioned earlier) uses BD Trans-lum foil from Manfrotto, which is availale in Europe. An alternative that may be found in the U.S. is Savage Translum sheeting. We used a similar product from an architectural shop. Check around the stores in your neighborhood to see what alternatives you can find.

The background in our photo is an imitation slate tile from a hardware store. It was cheaper and easier to clean than the real thing, and I think it actually looks even better!

The photos on the overleaf came from the same shoot and present more examples of how you can use this simple but versatile setup. The basic shooting parameters were the same as those we used for the image on page 197.

◄▲ *Two more shots made with our restaurant lighting setup*

Workshop 28
Lighting Like Cannelle & Vanille

▸ *How to build a backlit setup*
▸ *Using Translum sheeting instead of a softbox*
▸ *Doing a contract job for a restaurant*

Lots of great food photographers display their work on Flickr. Two of my favorites are Cannelle & Vanille (Aran Goyoaga) and IngwerVanille (Svetlana Karner). Along with their great styling, they use light in clever ways to make their subjects look good enough to eat. Aran and Svetlana use mostly diffuse daylight, so I decided to take up the challenge of producing a similar mood with flash. My goal was to keep things as simple as possible to increase the chances of capturing great photos before the cream topping collapses or the sauce separates. The result is a simple setup that uses a single flash and the corner of a room. The "Tips, Tricks, and Notes" section at the end of this workshop gives you some ideas about how to further refine the setup.

The Setup

Aran and Svetlana use diffuse daylight coming from the front or the side, as backlight, or diagonally from above, depending on the dish. Both photographers use reflectors across from the main light to illuminate any unwanted shadows. Their main light is a north-facing window covered with a large diffuser, such as a bedsheet. I could use a large softbox positioned near the subject to reproduce this type of light, but there is an easier way.

The walls in most rooms are just as large as a window or a bedsheet. If they are painted white they can produce a similar effect when used with bounce flash. I have produced some of my best results by bouncing flash into a corner and using a reflector opposite the

▲ *Schematic of the corner bounce setup*

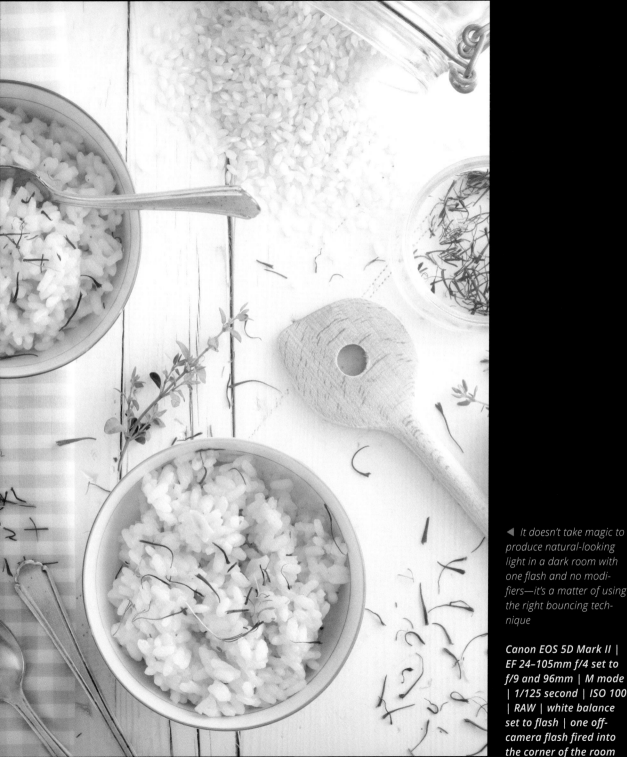

◄ It doesn't take magic to produce natural-looking light in a dark room with one flash and no modifiers—it's a matter of using the right bouncing technique

Canon EOS 5D Mark II | EF 24–105mm f/4 set to f/9 and 96mm | M mode | 1/125 second | ISO 100 | RAW | white balance set to flash | one off-camera flash fired into the corner of the room

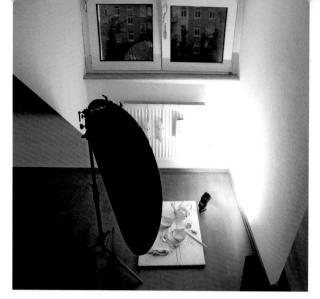

▲ The flash fires into the corner, and the silver reflector lightens the shadow. Although the view outside looks dark, this shot was taken during the day; the ambient light was underexposed with a short shutter speed.

▼ Always test and fine-tune your lighting setups with dummy dishes before you shoot the real thing. This is an original, unprocessed test shot.

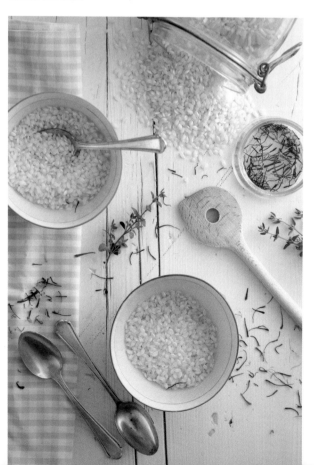

corner to lighten the shadows that are created by the main light. In this workshop I used the silver side of a 5-in-1 reflector mounted in a Manfrotto Nano Clamp that I attached to a tripod (tape would work just as well).

My setup was ready for shots captured from above. It is important to use at least a medium telephoto lens to prevent the scene from looking distorted. I set up my scene on the floor and stood on a chair to give me sufficient distance from the subject. I then shot with a full-frame camera and a zoom lens set to about 100mm. I made sure that I shot as perpendicular and accurately as possible with the subject in the center of the frame.

Camera Settings and Shooting

This scene doesn't have much depth, and I didn't want a blurred background anyway, so I set the aperture to f/9, and I used ISO 100 to keep the noise levels low. I also used the built-in wide-angle diffuser and set my Canon Speedlite 430EX II to 1/2 output. To save battery power and reduce the recycle time, you could halve the output and double the ISO value. As usual, I made a test shot without flash to check the lighting balance, then I made some more test shots with flash, which I fired with a Yongnuo RF-602 radio trigger.

Always set up and fine-tune food shots with a dummy dish that looks similar to the real thing. For my test shots, I used two dishes of uncooked rice. After you are sure everything is set up correctly, add the real dish and then shoot quickly while the food still looks appetizing! This is the only way to effectively capture shots of foods such as ice cream, soufflés, whipped cream, and beer foam.

Post-Processing in Photoshop

I adjusted the exposure slightly in Adobe Camera Raw and then performed the following steps in Photoshop (they took about 15 minutes):

▸ Crop to the golden ratio using the Atrise Golden Section tool.

▸ Slightly reduce the blacks with the slider in the Levels dialog.

▸ Shift the color slightly to give the image a slightly cooler look (a technique often used by Cannelle & Vanille).

▸ Add a negative vignette on the light side by using a mask.

▸ Slightly lighten the shadows with the Shadows/Highlights tool and make subtle local color and brightness adjustments.

▸ Sharpen the image for output.

▼ *The original image (left); and the processed version (right). These are subtle alterations, but they give the image a cleaner, more airy look.*

Tips, Tricks, and Notes

Here are a few tricks for dealing with diffusers, reflectors, and bounce flash:

▶ North-facing window: A popular way to produce soft, balanced light is to hang a white bed sheet in front of a window. You can even fire the flash through the window to produce the same effect at night. Use a high output setting or a high ISO value (or both) to reproduce the effect of a north-facing window. Your neighbors might wonder what's going on, but it's all for the sake of art!

▶ Bounce flash: Some photographers recommend tilting the flash head up and bouncing flash off the ceiling. Try it for yourself, and you will see that light from above is not as pleasing as light that comes from the side. If you look at everyday situations, you will realize that the most aesthetically pleasing light is near windows, under balconies, or in doorways. In these situations the light is shaded from above. Targeted, frontal light gives a scene structure and contours.

▶ Reflector holder: In the photo at the top of page 204 you can see that the reflector is held in a clamp on a light stand. Clamps and other adapters, goosenecks, and ball heads are just a few of the indispensable helpers that flash photographers collect for their work in the studio and on location. The photos on the next page show a selection of applications for these types of accessories. One of my favorite tools is the Manfrotto Magic Arm (see page 136). It is not cheap, but it is really versatile.

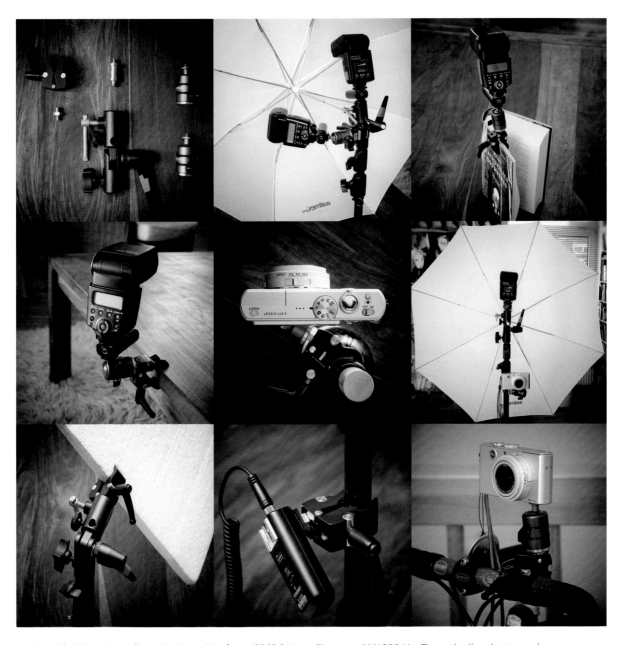

▲ *Versatile helpers in endless situations: Manfrotto 386BC Nano Clamp and MA026 Lite-Tite umbrella adapter, and Novoflex 19P ball head*

Workshop 29
Simulating the Sun

▸ *How to simulate sunlight using simple tools*
▸ *Modulating your artificial sun*

The light used for food and tabletop shots is often very similar to daylight, and often it is modulated to give it a soft look. The simplest way to produce soft light is to shine it through a diffuser or bounce it off a reflector. If you deliberately let some light from the flash spill over to light the subject directly, it can help give the scene a sparkling, sunny look. The downside is that the contrast increases and is more difficult to control, which often results in overexposed highlights. In situations like this, shoot in RAW format if you can. It will give you the most leeway for adjusting proportions of the shadows and highlights later.

In this section I discuss three different setups to obtain various looks to the images.

▲ *Schematic showing the flash pointed at the sloped ceiling and the reflector opposite the light source*

Setup I: Camera Settings and Shooting

For my first soft light shot I simply pointed my flash at a sloped white ceiling to bounce diagonal light from above. A reflector that I placed opposite the flash brightened the shadows.

You will have to experiment with the angle of the flash in relation to the camera's optical axis until you find the right position. This setup is less appropriate for a camera viewpoint from above the subject (see workshop 28), although the side view adequately mimics light from a north-facing window. The lens I used is not known for its great bokeh, but nevertheless it produces a nice soft background at its long end when combined with a wide aperture and a close subject.

▲ *Simulating the light from a north-facing window*

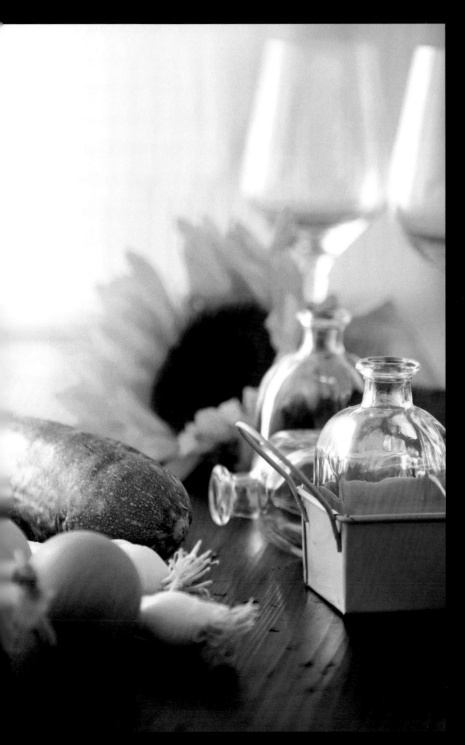

◀ *Warm, natural-looking light from a window on the left—or is it flash?*

Canon EOS 5D Mark II | EF 24–105mm f/4 set to 105mm and f/4 | M mode | 1/125 second | ISO 250 | JPEG | white balance set to shadow | off-camera flash pointed at the wall to the left

▲ *A test shot without flash shows if the ambient light has been suppressed*

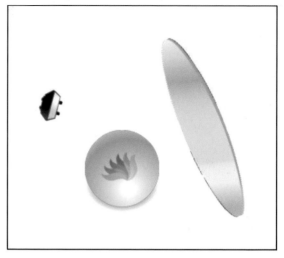

▲ *Schematic showing the flash aimed past the subject at the reflector, which brightens the scene and keeps the contrast manageable. Some of the light from the flash illuminates the subject directly.*

I used the wide-angle diffuser, and I used the little plastic catchlight reflector on the flash to block some of the light from heading straight up. Bouncing flash and using a diffuser significantly reduces the amount of light that reaches the subject, so I increased the ISO to 250 and switched to the maximum aperture (in this case, a less than impressive f/4). I made a test shot at 1/125 second to check the level of ambient light.

I then added the RF-602 transmitter and set the flash output to 1/4. This value can be adjusted as necessary. I set the white balance to shadow so the camera would produce a warmer tone to enhance the sunny look of the image.

Setup II: Camera Settings and Shooting

The second setup uses a similar technique to produce a very different effect with much harder light that looks like afternoon sunshine. For this shot I aimed the flash to fire past the subject onto a silver reflector. This approach meant that some of the hard light from the flash illuminated the scene directly, and the reflector helped keep the overall contrast to a manageable level. This setup allowed me to use ISO 100, and once again I set the white balance to shadow to give the image a warmer, sunnier look.

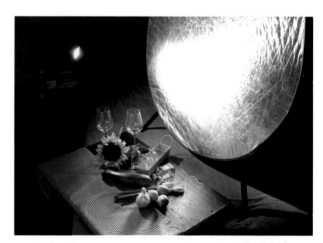

▲ *Our hard sunlight setup*

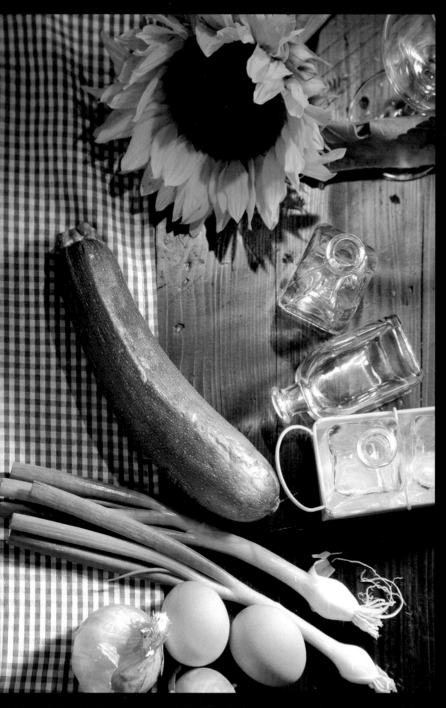

▲ *Direct afternoon sunlight—or is it flash? Another shot using Setup 2.*

Canon EOS 5D Mark II | EF 24–105mm f/4 set to 97mm and f/6.3 | M mode | 1/125 second | ISO 100 | RAW | white balance set to shadow | off-camera flash from the left fired past the subject at a reflector on the right

Setup III: Camera Settings and Shooting

This variation uses a small amount of direct light to give the subject a little extra sparkle. Once again, the reflectors provide the basic lighting and reduce the overall contrast. Less diffuse light would overwhelm the camera, just like the midday sun, and increase the risk of swamped shadows or burned-out highlights.

I used a non-TTL YN-460 flash with a radio trigger aimed past the subject at a Styrofoam reflector. Once again, some of the light from the flash lit the subject directly and provided the glittery highlights in the surface of the soup. I positioned a second reflector to the right to brighten the shadows, and I used a folded sheet of copier paper to brighten the foreground.

Post-Processing in Photoshop

In the first two shots the warm white balance provided the right look, and the camera's auto setting was spot-on in the third shot, so all I had to do was crop the images, slightly increase the vibrance, and sharpen the photos for output.

Tips, Tricks, and Notes

If you want to dive deeper into the wonderful world of food photography, check out the sources listed at Fotopraxis (http://fotopraxis.net/workshops-2/food-food-food-iii/). Flickr food portfolios are a great source of inspiration. You can look at the EXIF data for tips and information, and you can check out other people's setups. Flickr Mail is also a great tool for asking questions and sharing tips.

▶▶ *Our partial direct light setup*

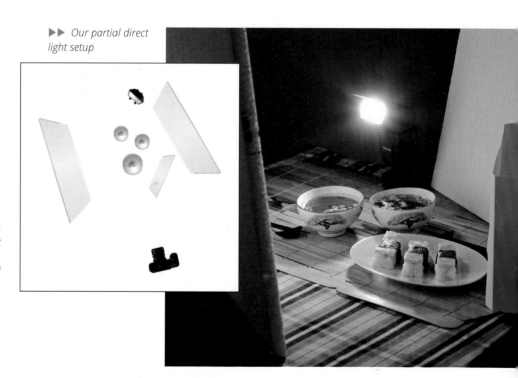

▶ *Schematic that shows the flash illuminating the subject both directly and indirectly. Two reflectors are positioned opposite the main reflector.*

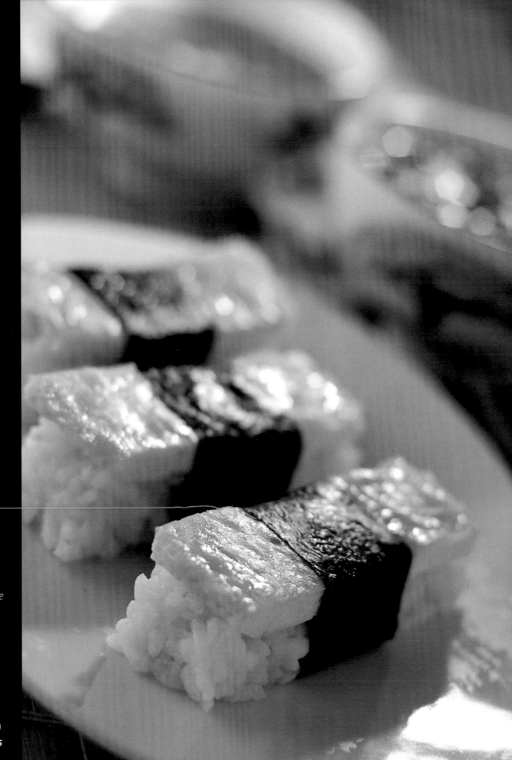

▶ Sparkling light produced with a single off-camera flash creates a tantalizing food image

Canon EOS Rebel T1i (EOS 500D) | EF 50mm f/1.8 II set to f/5.6 | M mode | 1/125 second | ISO 100 | RAW | white balance set to flash | off-camera flash from the right, aimed past the subject at a Styrofoam reflector (left) with two additional reflectors (right and front)

Workshop 30
Backlit Fruit

▸ *Setting up a transparent, backlit scene*
▸ *How to disperse flash*

The transparent, backlit look is popular in advertising and is often used to photograph fruit and other foods. This technique looks great and is easy to set up. You might consider using a light table for shots like this, but flash provides light with better color temperature, spectrum, and output characteristics. All you need is some kind of stage for the subject and a diffuser to disperse the light produced by the flash.

The Setup

The stage is made from a sheet of milky acrylic set atop two piles of books. I placed the fruit in a glass cookware lid with the handle removed. For this shot I used a Canon Speedlite 430EX II flash (in manual mode), but any non-TTL model would work the same. I used RF-602 transmitter and receiver units to fire the flash.

Camera Settings and Shooting

I began with a 1/4 flash output setting, but it was too bright at f/8. I halved the output twice and eventually stopped the aperture down even further when I discovered the flash was still too bright. I ended up using f/13, although according to SLRgear (www.slrgear.com) f/8 is the optimum aperture for this lens when it is set to 40mm. If you are more patient than me, you can stick to the optimum aperture and adjust your flash output accordingly. The close proximity of the flash to the acrylic sheet increased the risk of producing a hot spot, so I set the flash reflector to its widest-angle setting and moved it to the side to increase the distance and help alleviate the problem. You can easily suppress the ambient light in a situation like this by selecting ISO 100, 1/125 second, and an aperture between f/8 and f/13 combined with a flash output setting of 1/32 or less. The blinkies that are displayed on the camera monitor when part of the image is overexposed are a great tool for checking your settings. In this situation, adjust your camera and flash settings so that everything white blinks and everything else doesn't.

▼ *The simple setup for this photograph consisted of two piles of books, a sheet of plastic, a glass cookware lid, and a flash aimed upward from below*

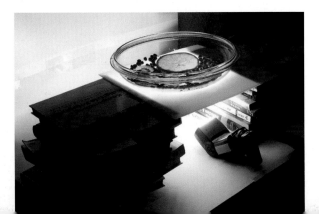

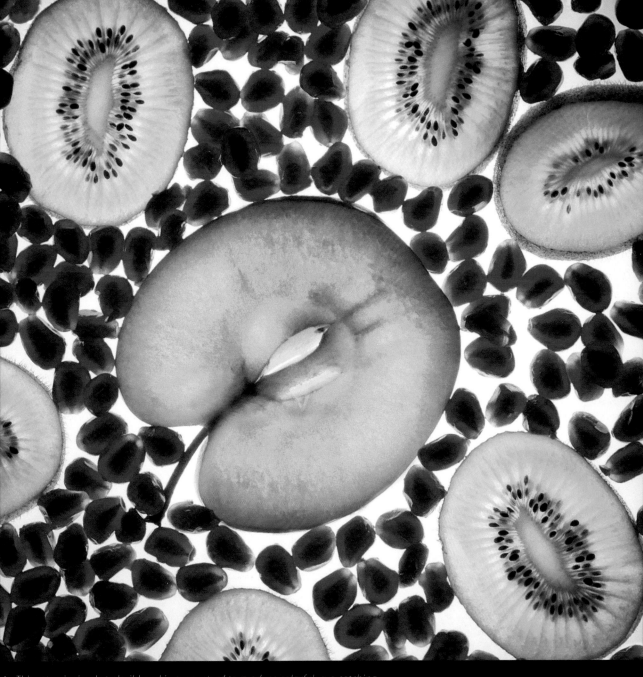

This setup is simple to build and is guaranteed to produce colorful, eye-catching

Post-Processing in Photoshop

If you get the exposure right, you won't have to adjust much during post-processing. For this fruit shot I restricted myself to the following steps:

▸ Cropped to square
▸ Slightly retouched unwanted artifacts
▸ Applied a Curves adjustment (slight lowering in the center of the curve) to the overexposed areas using a mask (invert the mask and paint the areas you need to adjust with a soft white brush)
▸ Repaired the parts of the apple that were too bright with a mirrored selection
▸ Selectively sharpened with the Smart Sharpening tool
▸ Used a mask to apply a dark green filter to the kiwifruit

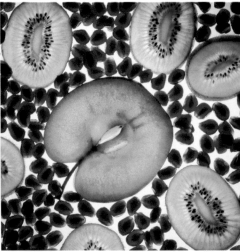

▲ *A Photoshop screenshot showing the layers and masks we used to process the image*

Tips, Tricks, and Notes

I mentioned using a light table for this kind of shot, but they usually contain neon tubes with gaps in their spectrum, which makes them less useful in food shots. The human eye is very sensitive to variations in color temperature, especially when it comes to photos of food and skin tones. Before you invest a in a light table, try using your computer monitor as a light source, but note that you will have to use much longer exposure times than the ones I used. A tripod is essential.

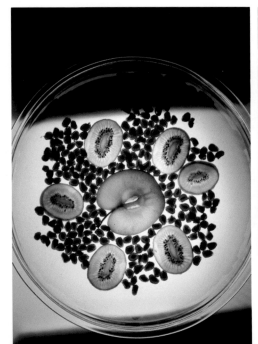

◀ *The original image (left), and the cropped and retouched version (right)*

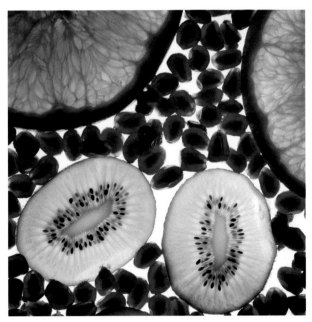

▲ *Another shot from our fruit session captured with the same parameters as before*

The Mystery of the Blinking Canon Flash Display

If you use the Canon wide-angle diffuser, like I did for this shot, you will become familiar with the blinking Canon display. It blinks when the flash senses that some aspect of the settings is incorrect, but it is often difficult to figure out what is wrong. Some of the things that can cause the display to blink are as follows:

▸ The flash is waiting for user input or a confirmation.

▸ The reflector is tilted 10 degrees down from its neutral position (this is easy to overlook).

▸ A custom function has been assigned or altered.

▸ The reflector is tilted or swiveled, or the wide-angle diffuser is in use or not completely retracted.

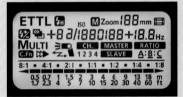

▲ *Sometimes the display on a Canon flash seems to blink for no apparent reason*

Workshop 31
Glowing Pasta

- ▸ *Another simple but effective light stage effect*
- ▸ *How to produce a fiery look*

The Setup

The previous workshop used a sheet of plastic as a stage for illuminating the subject from below. This section describes an even simpler way to produce an uplight effect using a slatted wooden shelf.

To set up the shot, I placed the pasta (in this case, large penne noodles) on the boards and put the flash on the shelf below, pointing upward.

Camera Settings and Shooting

I decided to work without ambient light. To do this, I selected an exposure time of 1/125 second, ISO 100 to keep the image noise down, and f/7.1 to provide sufficient depth of field. Due to its proximity to the subject and the lack of additional light modifiers, I was able to set the flash output to a relatively low 1/16 for my initial test shot.

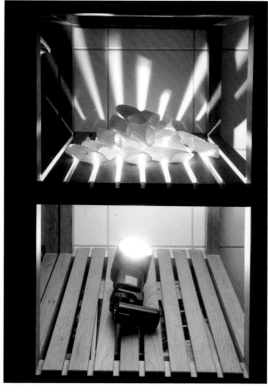

▶ *Our glowing pasta setup, with and without flash, using the settings detailed in this workshop. We created the warm look later at the RAW conversion stage.*

▲ *A simple but effective light stage effect shot on a wood shelf without flash modifiers*

Canon EOS Rebel T1i (EOS 500D) | EF 50mm f/1.4 set to f/7.1 | M mode | 1/125 second | ISO 100 | RAW | white balance set to flash | off-camera, non-TTL flash

Post-Processing in Photoshop

We processed this shot to increase contrast and give the pasta a glowing look. During RAW conversion I set the color temperature a little warmer and increased the Blacks and Contrast values before I cropped my images in Photoshop.

Tips, Tricks, and Notes

And how did I get the idea to place gigantic penne pasta in our bathroom shelf? I can explain that!

In my circle of friends, we invented this little game: Everyone brings along an object or two to photograph. The objects are handed out at random, and everyone has to come up with a cool lighting setup for their object. I received a pair of freezer bag clips, a box of chocolates (see workshop 36), and the pasta. This is a fun way to drive creativity. Try it with your friends or at your next photo club meeting!

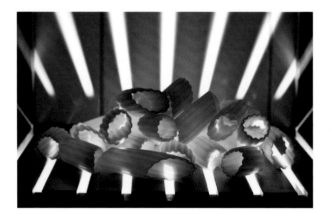

▲ *A couple of subtle adjustments during RAW conversion helped to add a glowing look to the pasta*

▲ *In a surprise subject contest, we took these photos of freezer bag clips, a box of chocolates, and a bag of pasta. The only rule of the game is that the resulting images have to look good.*

Workshop 32
Campari in a Bathtub

- ▸ *How to produce soft surrounding light*
- ▸ *Using a bathtub as a light tent*
- ▸ *Using Photoshop to create colors that pop*

If you want to create a setup that bathes the subject in light, where better to work than in a bathtub? I wanted to photograph some Campari bottles and give them a gaudy, pop art look. I used a bathtub and two flashes to completely bathe the scene in light.

The Setup

A white bathtub is the best location for this kind of setup, but you could also improvise with a bed sheet in a large cardboard box. I used Plasticene to keep the bottles in position and lit them from the sides using two non-TTL YN-460 flashes aimed at the sides of the tub and softened with paper diffusers. I used RF-602 radio triggers and my Canon EOS Rebel T1i (EOS 500D) fitted with an EF 85mm f/1.8 lens.

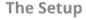

◀ *Schematic showing our bathtub setup with two flashes that flood the scene with light*

◀ *Two flashes with paper diffusers are aimed at the sides of the bathtub*

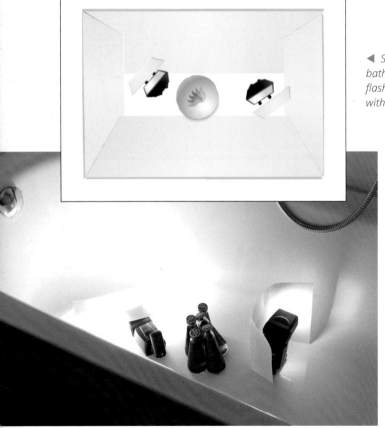

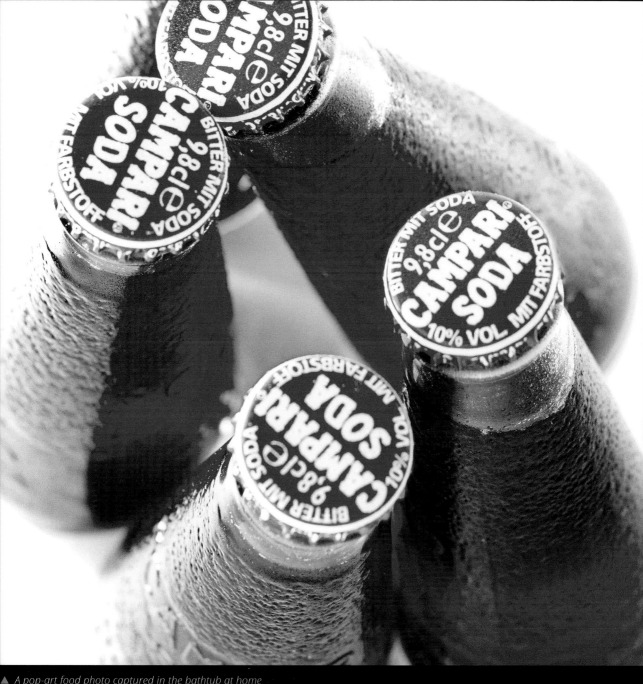

▲ A pop-art food photo captured in the bathtub at home

Canon EOS Rebel T1i (EOS 500D) | EF 85mm f/1.8 set to f/3.5 | M mode | 1/125 second | ISO 100 | RAW | white balance set to flash | two off-camera, non-TTL flashes fired with RF-602 radio triggers

Camera Settings and Shooting

The flash has to provide the bulk of the light in a shot like this, so you need to suppress the ambient light as much as possible. Select ISO 100 and f/3.5 for indoor lighting conditions. An exposure time of 1/125 second is normally sufficient to cut out most of the ambient light without undercutting the camera's sync speed (which is often around 1/200 second). Do not go to the limit, because the RF transmission also takes some time—1/125 or 1/160 second is a good choice. And then always make a test shot without flash to make sure your settings exclude enough ambient light.

At such a short distance and with two flashes, 1/16 output for each flash should be enough. As always, you can adjust your settings after you make some test shots.

▲ The original image

Post-Processing in Photoshop

Technically speaking, our original image was fine and had a great surround lighting effect. The bottoms of the bottles disappeared into the blur of the background, and the Campari itself had a nice glow. However, the image still required some processing.

We used three Curves adjustment layers: one to lighten the entire image and remove any traces of gray from the whites; one to reduce the red component slightly and enhance the blue tones; and one to emphasize the blue tones in the shadows.

◀ The original image is okay but a little dull. Post-processing gives it the necessary punch.

Tips, Tricks, and Notes

▸ Exposure times: You might wonder why I often select 1/125 second as my exposure time. My experience shows that this value often produces satisfactory results on location and in the studio. Longer exposure times increase the risk of too much ambient light, camera shake, and ghosting around flash-lit subjects. On the other hand, shorter exposure times often interfere with the camera's sync speed. Give yourself some leeway if you fire your flashes with radio triggers because they add a delay to the timing.

▸ Photographing trademarks: Care is required when you photograph a trademark because infringement is punishable by law. In an educational photography book like this one, there is no danger of the trademark owner thinking I am abusing their rights. However, if I were to use the Campari photo in a calendar that is sold commercially, I could end up in trouble. If you have any doubt, seek legal advice before you use an image commercially.

◀ *The three Curves adjustments we made and the effects they had on our image: the combined RGB values (top); the red channel (center); and the blue channel (bottom)*

Workshop 33
Using Smoke to Depict Aroma

- ▸ *How to photograph smoke*
- ▸ *Inverting and coloring smoke shots in Photoshop*
- ▸ *Capturing additional details for a photomontage*

A few months ago I saw an advertisement for Lipton tea that used some kind of cloud to symbolize the product's aroma. The effect looked like colored smoke, and I began to think about how to reproduce the effect. Smoke is relatively simple to photograph and can easily be inverted and colorized in Photoshop, but the rest of the scene shown was more difficult to construct. My final image is a composite of three different shots: the smoke, the teabag, and some tea leaves. By the time I produced a result that looked something like the original, I had used a lot of tea bags.

The Setup

The best way to capture smoke in a photo is to place an incense stick in front of a dark, distant background and light it from the side using flash with a snoot. A shade (or flag) placed between the flash and the camera limits flares and stray light and improves the overall results.

The backlit setup for the tea bag and tea leaves included a flash in a portable softbox that I placed on its back (see workshop 2 for more details). In the first shot, I photographed the tea bag lying on the softbox. For the second shot, I cut the tea bag open and spread the contents on the surface of the softbox. I began making test shots with 1/4 flash output and fine-tuned my settings from there.

▲ *Schematic of our smoke capture setup. An off-camera flash fitted with a snoot is aimed at the column of smoke, and a flag prevents flares and stray light from reaching the lens. The dark background is positioned as far away from the subject as possible.*

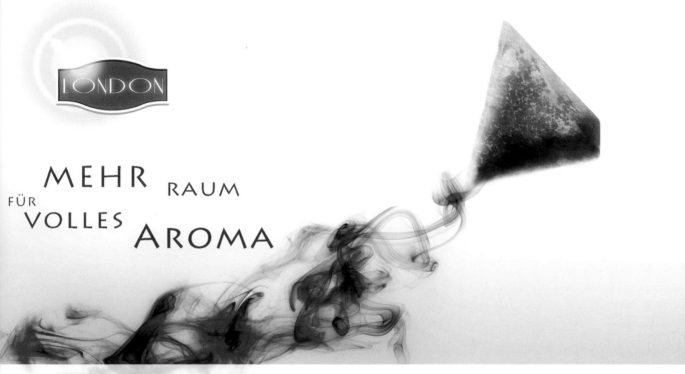

LONDON

FÜR MEHR RAUM
VOLLES AROMA

NEU DIE *LONDON* PYRAMIDE

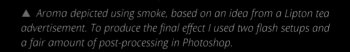

▲ *Aroma depicted using smoke, based on an idea from a Lipton tea advertisement. To produce the final effect I used two flash setups and a fair amount of post-processing in Photoshop.*

Canon EOS 5D Mark II | EF 24–105mm f/4 set to f/5.6 and 45mm | M mode | 1/125 second | ISO 100 | RAW | white balance set to flash | one off-camera flash

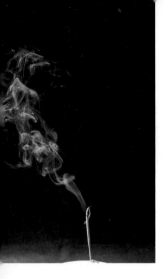
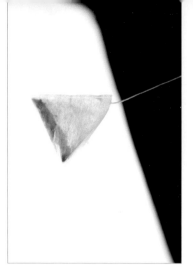

◀ *The three components of our tea advertisement: smoke, tea bag, and tea leaves*

Camera Settings and Shooting for Smoke

To capture the smoke I used a tripod-mounted Canon EOS 5D Mark II with a 24–105mm zoom set to about 50mm and f/5.6 (a moderate depth of field was required). I set the camera to manual (M) mode and ISO 100 and switched to RAW format. Using a tripod allowed me to move the incense stick around to produce different patterns while I shot. As with most of the other setups in this book, I took an initial test shot without flash to see how much ambient light my set-tings would capture, and then I began making test flash exposures starting at 1/8 output.

I used the same setup for the shots of the tea bag and tea leaves, but I set the lens to its longest telephoto setting to fill the frame with the relatively small subjects. I shot at ISO 100 and 1/125 second with a non-TTL Yongnuo YN-460 flash mounted in a portable softbox, and I fired the flash with a RF-602 radio trigger.

▼ **1** *The original, unprocessed photo of the smoke;* **2** *the inverted version of the smoke image;* **3** *the desaturated, cleaned-up version of the inverted image;* **4** *the colorized version, processed with a color gradient*

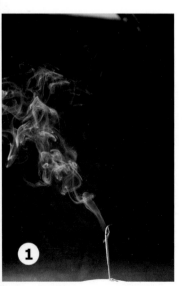
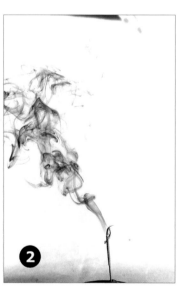
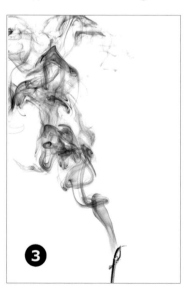

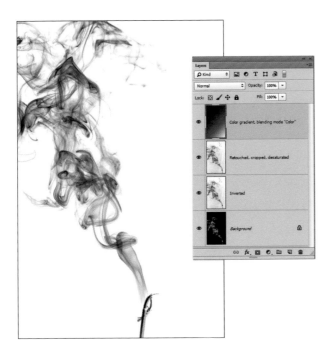

▲ *To colorize a smoke photo, create a new layer that contains your desired colors and merge it with the original image using the Color blend mode. In this example, I used a rainbow effect to better illustrate the process; I used red for the main photo.*

Post-Processing in Photoshop

Even if you perfectly capture all three elements of a project like this, you still have to create an effective photomontage to get the final result. I isolated the tea bag and tea leaves with the Quick Selection and Refine Edge tools and used layer masks to produce the final effect. The precise masking technique and blend mode you use will vary depending on the effects you want to achieve.

Tips, Tricks, and Notes

▸ For this workshop and the next one, I used Photoshop a bit more extensively than for the other examples in this book. If you are interested in delving deeper into the subject of Photoshop montages and compositing, see the sources listed in appendix C.

▸ For the smoke image I used a rolled up Rogue Flash-Bender as a snoot. The FlashBender is a nice tool, but for this shot a rolled-up piece of black card would have done just as well. There are a lot of useful flash accessories on the market, including gel holders, diffuser socks, translucent plastic half spheres, and many more. Homemade solutions like the ones I often use save money and usually work better than commercial gear. The best example of such a tool is Niel van Niekerk's black foamie thing (page 43), which is used throughout this book. This tool is just perfect and costs just a couple of dollars. Take my word for it—having spent money on a whole cupboard full of useless gimmicks, I wholeheartedly recommend that you better invest your money in good lenses instead!

Flavored Gins à la David Hobby

▸ *Building a light box*
▸ *How to use a light box with backlight*

The founder of the strobist movement, David Hobby, provided the idea for this project with his Flavored Vodkas image. The image shows five tall shot glasses, each with a different flavoring, such as chocolate, cinnamon, or lemon. David kindly published the details of his deceptively simple setup, so I had to try it for myself. This setup is virtually identical to David's, except I used gin instead of vodka (I prefer the taste and I happened to have some in the house). Water has a different refractive index than spirits and doesn't produce the same effect.

The Setup

David's setup consisted of a cardboard box with a hole cut in the top, which he then covered with translucent paper. This was the inlet for the light from the upper flash. Two more flashes were aimed at the background to keep it bright and white. The glasses themselves were placed on a sheet of white acrylic to create the reflection. David's camera was mounted on a tripod with a built-in level to make sure it remained perfectly straight.

◀ *Schematic of the flavored gins shot. There are two flashes to light the background, a cardboard box, and a diffused flash with a snoot fired from above.*

▼ *The setup with the almost-overexposed white background and the upper flash with its rolled-up paper snoot*

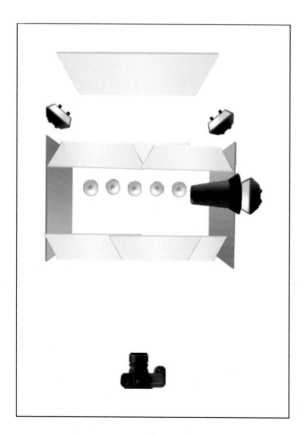

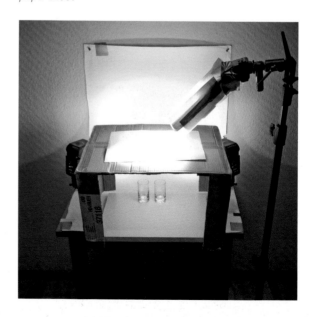

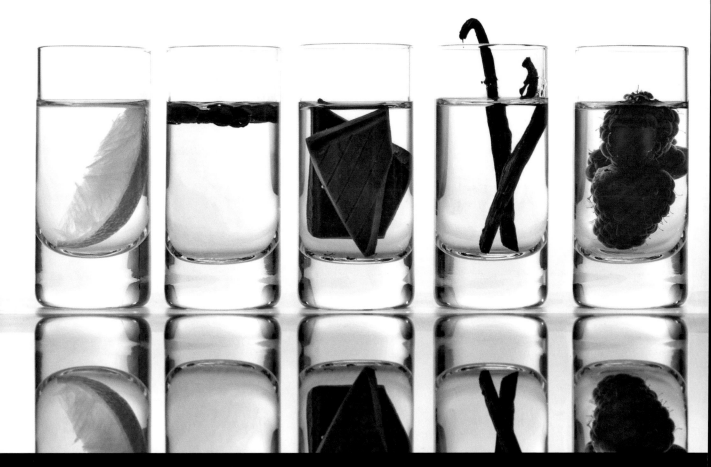

▲ *Delicious-looking flavored gins, captured at home with three flashes and a little improvisation*

Canon EOS Rebel T1i (EOS 500D) | EF 50mm f/1.4 set to f/11 | M mode | 1/125 second | ISO 100 | RAW | white balance set to flash | three off-camera flashes

Camera Settings and Shooting

The settings I used provided the usual combination of suppressed ambient light and dominant flash. I used ISO 100 to keep the noise levels low, and I set my camera to 1/125 second and f/11. The narrow aperture slightly reduced the overall sharpness but ensured that the depth of field was sufficient throughout the frame. I fired the flashes (any non-TTL units will do) with RF-602 radio triggers. For this setup a test shot without flash should turn out almost completely dark. Add the background flashes first, arranged symmetrically with identical output settings, and adjust the output until the white of the background just begins to overexpose (keep an eye on the blinking highlights warning in your viewfinder), then add the upper flash. I began making test shots at 1/4 output and fine-tuned my settings until I found the right values.

▲ *The somewhat sad-looking initial image (top) and the cropped and aligned version (bottom)*

▶ *The Photoshop layer stack and the result of having applied the steps it contains. I straightened, cleaned up, and stretched the image, and then I optimized the colors and added an artificial reflection.*

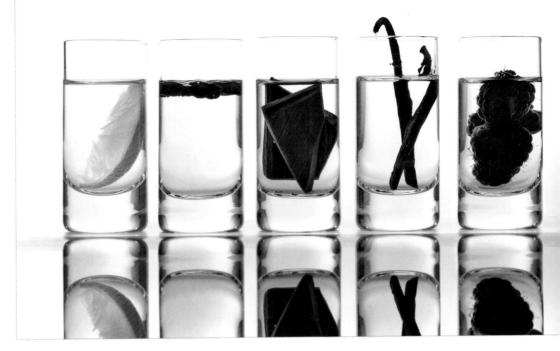

▶ *A cooler version of the same image. Here, I shifted the colors toward green to emphasize the glasses.*

Post-Processing in Photoshop

This image required quite some processing work. The most important steps were as follows:

▸ Apply a new crop.
▸ Stretch the glasses.
▸ Desaturate the gin to eliminate particles of the other ingredients, which had begun to dissolve.
▸ Retouch unwanted reflections, artifacts, and dust particles, in some cases by cloning parts of other glasses.
▸ Replace the real reflection of the glasses with a more attractive artificial version.
▸ Dodge the ingredients, increase the vibrance, and apply final sharpening.

I could have prevented some of these steps if I had been more careful during the shoot, but as usual I had to decide if adjusting the setup was more efficient than retouching the image. For the shoot itself, it is essential to make sure the lighting is right and that everything is in focus because you can't fix these things in post-processing.

Tips, Tricks, and Notes

For this shot I set the white balance to flash. Sometimes, it makes more sense to set the white balance to auto, but if I was using flash without color filters, I would usually set the white balance to flash. This will ensure that all photos in a session have the same color temperature, and so it's easy to correct them as a batch in Adobe Camera Raw or Lightroom.

Workshop 35
Chocolate

▸ *Light painting with flash*
▸ *Using modeling light as a continuous light source*

Chocolate isn't easy to photograph. Without close attention, photos of chocolate often look like the flat, unappetizing image shown on the bottom-right of the following page. The challenge addressed by this workshop is to reproduce the warm, tempting look captured in the main image on the same page.

Producing these effects with conventional lighting is virtually impossible, mainly because the individual pieces of chocolate are positioned at various angles and each piece requires separate lighting to make them look right. I solved this problem with light painting techniques to illuminate various areas of the image in a customized way. For this type of shot the camera has to be mounted on a tripod and set to bulb (B) or self-timer mode, and the room must be dark during the entire long exposure.

The Setup

The usual tool of choice for light painting is a pocket flashlight. Unfortunately, they are usually fitted with incandescent or LED lamps, and their spectra are not suitable for food photography. Flash, on the other hand, provides the perfect light, but it normally lasts for only a short duration. The solution is selecting the modeling flash mode, which we assigned to the Pilot button on our Canon Speedlite 430EX II. The result is a

perfect (albeit expensive!) flashlight that provides light with an even spectrum for about two seconds every time you press the button. To concentrate the light from the flash reflector, we cut the tube of a ballpoint pen to length and taped it onto the flash to form a kind of miniature snoot.

▶ *A Canon Speedlite 430EX II with a homemade miniature snoot. When the flash is set to modeling flash mode, it makes a perfect light brush.*

If your flash does not have a modeling flash mode, you can emulate this technique by setting your flash output to its lowest level and continually pressing the test flash button while you paint your subject. You can also use strobe or multi mode to achieve a similar effect (see workshop 12).

To make our chocolate scene look three-dimensional, I broke the bar into several pieces and carefully arranged them in front of a background made from the chocolate wrapper. I mounted my Canon EOS Rebel T1i (EOS 500D) on a tripod and released the shutter with the self-timer.

Camera Settings and Shooting

After the setup is ready, the rest of a shoot like this is routine. Switch the camera to live view and focus with the monitor magnified before you switch to manual (M) mode and set the self-timer to 30 seconds—bulb (B) mode and a cable release work just as well.

Darken the room, release the shutter, and paint with your light brush for the duration of the exposure. For such a small area of the subject, the angle and distance of the light source are critical, and you have to use very flat side light from close up to get the writing on the chocolate to look good.

The narrow aperture ensures that the entire subject stays sharp, even at the price of a little less overall image quality. In our photo I also had to increase the ISO setting to make sure I was done with the light painting within the 30-second exposure time.

The setup for our light-painted chocolate shot

ISO 400 is, in my opinion, the upper limit for the EOS Rebel T1i (EOS 500D)—higher values produce too much image noise. Other ways to increase the image quality

are to expose for a longer duration (in B mode), use a full-frame camera, or set a wider aperture. However, using a larger aperture provides less depth of field (see the first two photos on page 237, which were shot at f/5.6). Another way to increase the depth of field is to use focus stacking techniques. For an example, see my Flickr photostream at http://www.flickr.com/photos/galllo/4905689780/.

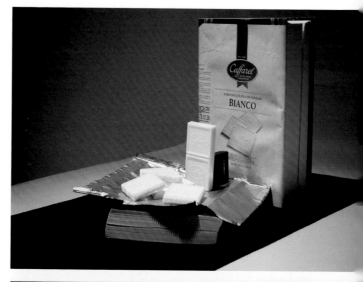

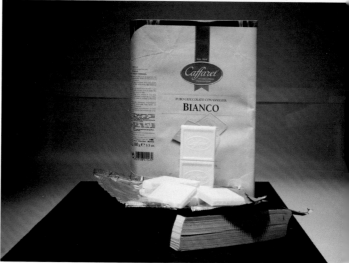

▲ *The setup for our light-painted chocolate shot*

Post-Processing in Photoshop

I used the Exposure, Blacks, and Vibrance sliders in Adobe Camera Raw to give the image a warmer, higher-contrast look before I brought it into Photoshop so I could crop and straighten it and eliminate any unwanted artifacts. To finish up, I added a strong vignette and sharpened the image with the Smart Sharpen tool.

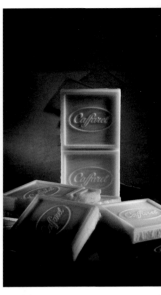

▲ *The original image (left) and the processed version (right)*

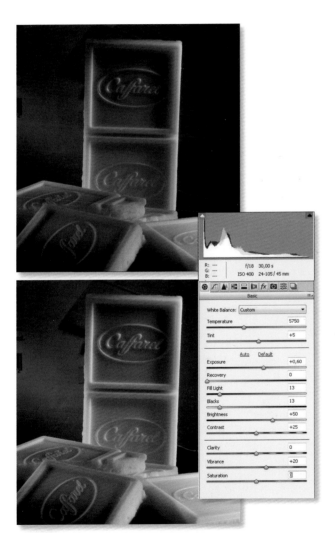

▲ *The settings I made in Adobe Camera Raw to increase the contrast and enhance the colors*

Tips, Tricks, and Notes

It's easy to check the quality of your images while you shoot, and there are some interesting parallels between industrial and artistic image processing techniques:

▸ **Pseudotethered shooting:** Nowadays tethered shooting software is often included with new cameras. It lets you view your camera monitor and adjust the shooting parameters in real time on a computer or laptop screen. Tethering is a great way to ensure high image quality, but it is complex to set up and gives you additional cables to trip over while you work. I have found it more effective to shoot four or five shots, check on the computer to see which settings I need to alter, and then return to the setup. These little checks take only two minutes but can be very helpful.

▸ **Industrial uses for grazing light:** The flat, lateral light I used to emphasize the writing on the surface of the chocolate is often referred to as grazing light. It is used in industrial contexts to inspect embossing, scratches on a product's surface, and etched codes (see workshop 17). Backlight used with a transparent background (see page 214) is another type of artistic lighting that is used in industry, and the ring light effects favored by *Vogue* magazine are also used in industrial applications when direct, shadow-free light is required. It's always worth keeping an eye out for new lighting ideas, and appendix C lists a collection of useful sources to get you started.

To complete this workshop, here are some of the other unprocessed results I captured during the chocolate session. They are all slightly different and underscore the benefits of experimenting while you shoot.

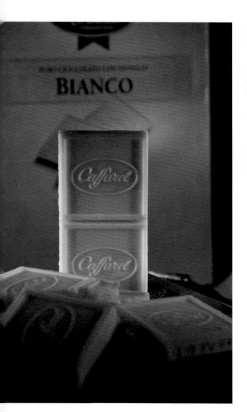
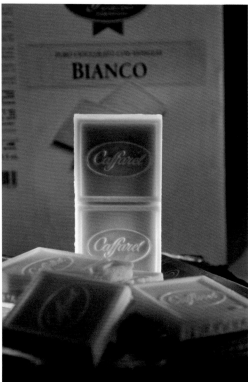
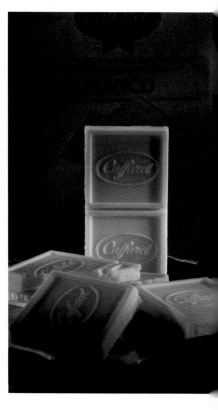

▲ *Unprocessed images from the same session, shot at f/5.6 (left and center) and f/8 (right)*

In-Depth:
RAW vs. JPEG

You may have noticed that I usually shoot in RAW but sometimes in JPEG. Both formats have their advocates, and discussions about the topic sometimes sound like a religious debate! The main advantages and disadvantages of shooting in RAW format are as follows:

1. The white balance **1** can be adjusted losslessly after shooting.
2. The color space **3** of a RAW image can be altered losslessly.
3. RAW images have much more leeway when it comes to digital processing—for example, with the Exposure slider **2**.

Generally speaking, you can apply more extreme processing to RAW images without running the risk of tonal clipping or banding effects. Always shoot RAW for important jobs and in tricky lighting conditions, such as in high contrast. You will have more options when it comes to processing or repairing your images later.

Arguments in favor of JPEG include the fact that they are about a fifth the size of their RAW counterparts and they are universally readable, making them ideal for sharing. RAW formats are manufacturer specific and, with the exception of Adobe's DNG format, they are also proprietary.

If you always shoot RAW, you will quickly get used to the greater dynamic range it offers, which increases the risk of getting lazy when it comes to planning your exposure parameters. Shooting in JPEG requires discipline and that can help you produce better photos that require less processing.

The flash shoots described in this book involve a lot of test shots that take up space on your computer hard disk. Shooting JPEG reduces the size of your archive and accelerates the process of deleting unwanted test shots later. Last but not least, JPEG contrast and white balance settings allow you to create looks in the camera that can be difficult to create in a RAW converter. For example, Canon's Fluorescent Light white balance setting is hard to duplicate perfectly in Adobe Camera Raw.

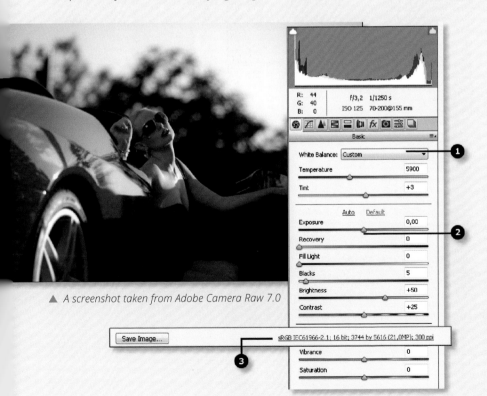

▲ *A screenshot taken from Adobe Camera Raw 7.0*

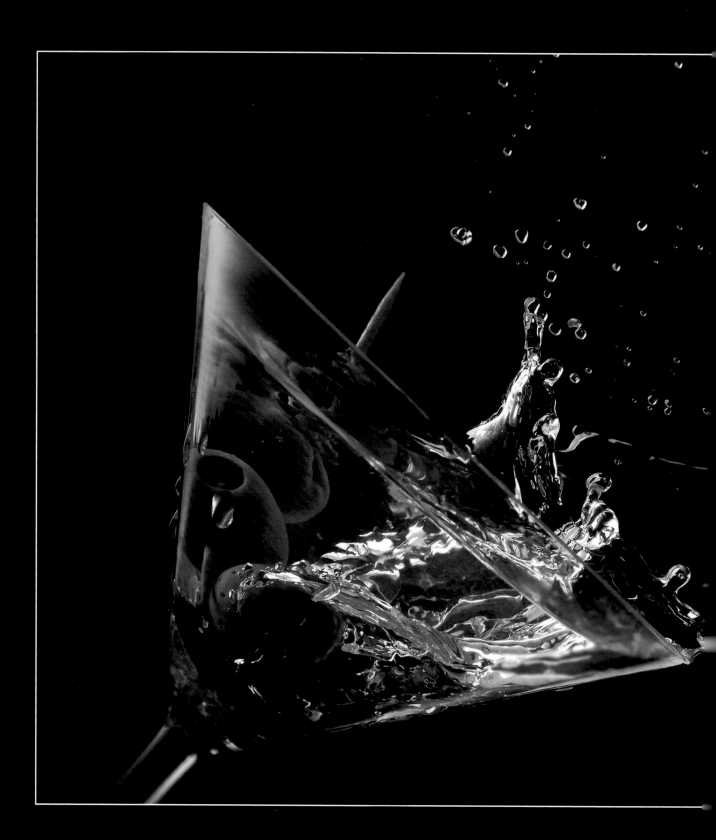

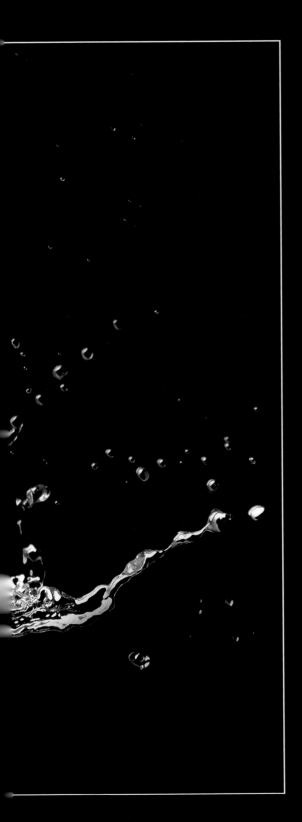

How to Make the Invisible Visible with High-Speed Flash

Flash guns are not only small, practical, clever, and battery powered, they are also fast! Their extremely short flash durations are perfect for freezing splashes or the movements of waves and other liquids. This chapter shows you how to capture perfect splash photos using simple gear and a little patience and skill, and it finishes up with how to use a cross-beam sensor.

Workshop 36
Milk and Chocolate Splash

▸ *Shooting with ultrashort flash durations*

▸ *Using snoots, flags, and colored gels for splash shots*

▸ *Creating a perfect splash image from three exposures*

Splatter and splash photos are popular, and you can find hundreds of coffee splashes on Flickr. More complex splash photos of olives, sugar cubes, ice cubes, and cookies falling into milk, cream, coffee, cola, or blue Curaçao are an integral part of the current advertising scene. Capturing splash photos is a lot of fun, but it involves some special gear and a fair amount of preparation. A [1]cross-beam sensor, like the Jokie I use (see workshop 39), is ideal for ensuring picture-perfect results every time. With a little patience you can even capture splash photos without a cross-beam sensor, and you could also use bright sunlight to freeze the splash. Nevertheless, using a flash gun enables you to better direct the light, and the very short flash duration provided by low output settings is ideal for freezing action. Actually, a little system flash works even better than a studio flash for capturing splashes, because it is faster.

The final image is a composite of three exposures.

The Setup

For the milk and chocolate splash, I used one flash with a blue gel to light the background and another flash with a snoot to capture the milk. I placed a flag made from a mouse pad in front of the filtered flash to prevent blue light from reaching the cup, and I used a book covered with white paper as a fill-in accent. I mounted the camera on a tripod and fired it with a cable release, and I fired the flashes at their second-to-lowest output setting with RF-602 radio triggers. To make cleaning up easier, I set up this scene in the bathroom. The basic setup consisted of two boards laid across the bathtub with a small infinity cove made of easy-to-clean Trans-Lum sheeting on top.

▲ *Schematic showing an infinity cove, two flashes (one with a blue gel and one with a snoot), and a flag*

[1]*A cross-beam sensor uses laser beams that cross at the focal point of a macro lens. When both beams are broken at the same time, the external shutter is triggered and the flash units are fired.*

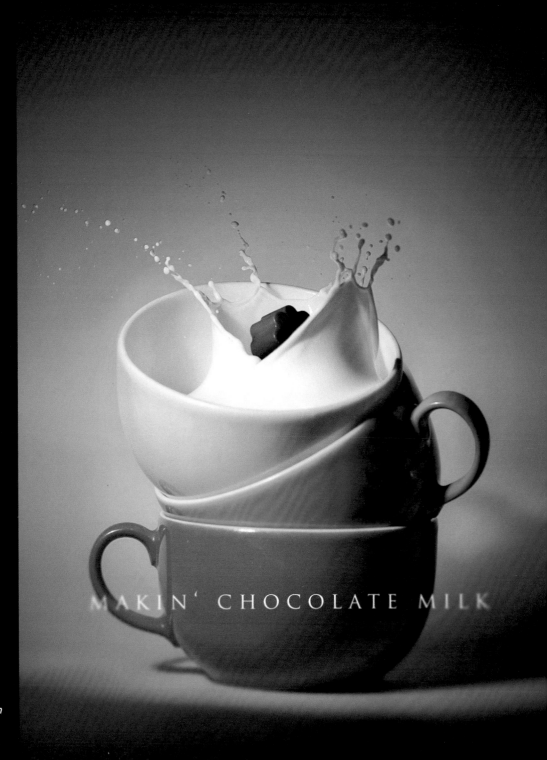

MAKIN' CHOCOLATE MILK

▶ *A splash like this works only if you are extremely patient or if you know a trick or two*

Canon EOS 5D Mark II | 24–105mm set to 105mm and f/7.1 | M mode | 1/125 second | ISO 100 | RAW | manual prefocus (autofocus switched off)

▲ *Our milk and chocolate splash setup*

Camera and Flash Settings

We set the flash output to its second-lowest setting to keep the flash duration as short as possible. The hard light from the flash gives a splash like this a clear, three-dimensional look, so we didn't use additional light modifiers or umbrellas. The black mouse pad flag prevented any of the blue-filtered light from coloring the milk. The background spot could be controlled with a snoot or honeycomb grid, but in this case, we just zoomed the flash to 105mm. The only additional tool we used was a Rogue FlashBender (RG040028) on the main flash for the milk, but a piece of rolled-up cardboard would have produced the same effect.

To protect the front lens element while shooting splashes, position your camera a long way from the subject or use a UV or skylight filter. For this shot I used my Canon EF 24–105mm f/4.0 zoom set to 105mm and f/7.1, which is slightly narrower than the critical aperture and provided us with sufficient depth of field throughout the frame (see the illustration below and information provided at www.slrgear.com).

I set the camera to manual (M) mode and 1/125 second to eliminate the ambient light. Even at such a low output setting, the close proximity of the flashes to the subject meant we could shoot at ISO 100.

▶ *The critical (i.e., sharpest) aperture for the lens we used is f/5.6. The setting of f/7.1 that we selected for this shot gave us a little more depth of field and almost the same degree of absolute sharpness. (Illustration courtesy of SLRgear, www.slrgear.com)*

The Shoot

For splash shots you have to prefocus to prevent the camera's autofocus system from searching for the subject at the critical moment. Switch your lens to manual and set the focus manually using the zoomed-in live view display. Remember to check the focus periodically during the shoot because the gears in an autofocus lens make it easy to inadvertently alter the focus. Test and calibrate the setup before you start splashing.

For this setup, it is important to set the background flash so that it forms a nice centric background spot, and to set all parameters in such a way that the flashes can be used at a low flash output. This makes the flashes faster and the images sharper. As with other setups, a test shot with no flash should produce an almost completely dark image. When the basic setup is complete, you can position and set your flashes and attach the cable release to the camera. Now proceed as follows:

1. Hold the chocolate in your right hand and the cable release in your left hand.

2. Drop the chocolate and then release the shutter a split second later.

3. Check the results; if you didn't quite catch the splash, try again.

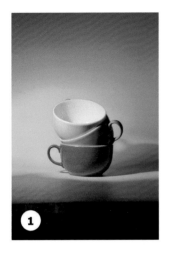 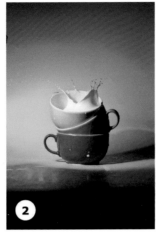 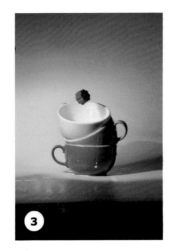

◀ *The three components
of our splash shot:*
1. *Clean cups*
2. *The splash alone*
3. *The chocolate*

Post-Processing in Photoshop

The nature of splashes means that everything is messed up after the first shot. Instead of cleaning up and rebuilding the scene between each attempt, it's a lot easier to shoot a photo of the clean scene, without the splash, and then add the splash digitally—and this approach also works for the little piece of chocolate. In reality, for the splash to be high enough, the chocolate would have already fallen deep into the cup and the timing would have been impossible. I used Photoshop to select the chocolate and the splash, and I merged them with the photo of the clean cups. The simple setup meant we didn't have to battle with implausible lighting or perspective effects. If you set up your shots carefully, and if you take your time in Photoshop when making the selections, you will end up with convincing results.

Tips, Tricks, and Notes

To capture splashes successfully, the focus has to be precise, you need a sufficient depth of field, and the flash duration has to be as short as possible. Short flashes are easiest to achieve with system flashes set to low output. If you need more flash power, use additional

flashes rather than a higher output setting. The low *output = short flash* equation that system flash adheres to doesn't always apply to studio flash units because they use multiple condensers that are fired in parallel or individually, depending on the output setting. This means the optimum flash duration is not always at the minimum output. If you are not sure if this applies to your flash, ask the manufacturer.

For crisp-looking splashes, use Photoshop to eliminate out-of-focus droplets of liquid.

If you want to capture a good splash every time, use a cross-beam sensor to fire your flash. (For details about this technique, see workshop 39.)

Check out the following Flickr groups for some great splash photo ideas and examples:

▸ Splish, Splash, Drips and Drops: www.flickr.com/groups/splish_splash_drips_n_drops
▸ Splash: www.flickr.com/groups/splash
▸ Cookie Splash: www.flickr.com/groups/cookiesplash

Click the Show EXIF bottom below a Flickr photo window to view the EXIF data for an image. If you want to know more, send the photographer a message in Flickr Mail. Most artists are friendly and helpful and happy to chat about their work.

Workshop 37
Shooting Splashes in an Aquarium

▸ *Using Trans-Lum sheeting instead of a softbox*
▸ *How to light big splashes*

The small size of the splash in the previous workshop made it tricky to capture, and we had to make several dozen attempts before we captured the result we were looking for. Larger splashes made with bigger objects are easier to capture. We used a cheap aquarium, but any large glass container will do. Instead of an expensive studio flash with a softbox, a sheet of Trans-Lum is all you need to produce an interesting and flattering lighting.

The Setup

The bathroom is the best place for a setup like this. The shot requires light both from behind to illuminate the liquid and from the front to illuminate the object that causes the splash. My immediate thought was to use a softbox for the rear light and two diffuser umbrellas for the front light. However, this would have taken too much space so I decided to use a simpler solution. I laid two boards across the bathtub with a gap between them and used a sheet of Trans-Lum taped to the wall as an infinity cove. I then placed the aquarium in the cove.

I used four flashes (a combination of Canon and Yong-nuo) in manual mode and fired them with RF-602 radio triggers. Two of the flashes were positioned in the bathtub, pointed up to light the infinity cove from behind. The relatively large distance between the flashes and

the subject, and the thickness of the Trans-Lum sheeting, meant we had to use a relatively high output setting. Once again, two flashes provide a shorter flash duration and faster recycle time than a single flash at a higher output. The other two flashes were positioned at the right and left corners of the aquarium along with diffusers made of copier paper. The camera was on a tripod, and the flash transmitter was mounted on the hot shoe. We fired the shutter with a cable release.

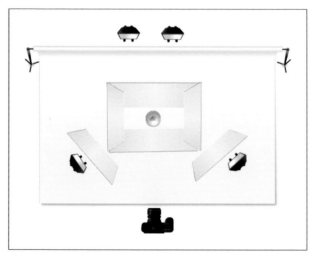

▲ *Schematic showing an aquarium placed on Trans-Lum foil with two flashes firing from below and two flashes placed at the corners.*

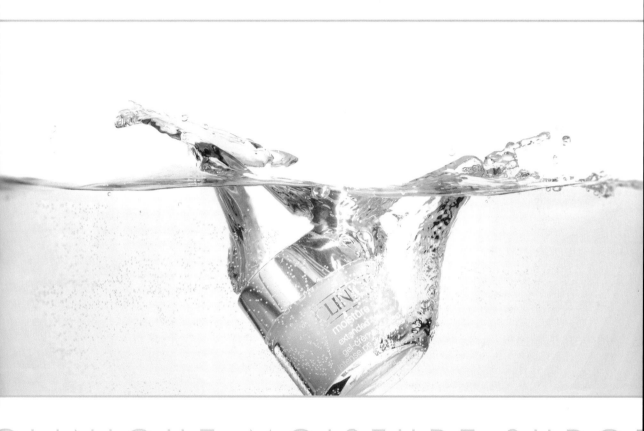

CLINIQUE MOISTURE SURGE

▲ To create a splash shot like this you need a bathroom, a small aquarium, a sheet of Trans-Lum, and system flashes

Canon EOS Rebel T1i (EOS 500D) | EF 50mm f/1.4 set to f/16 | M mode | 1/125 second | ISO 100 | RAW | manual prefocus based on the live view display (autofocus switched off)

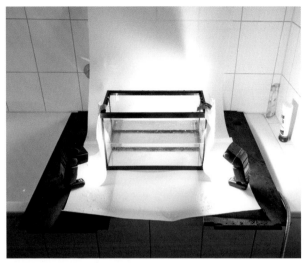

▲ *Our aquarium splash setup*

Camera and Flash Settings

I used a 50mm prime lens at f/16 to capture the additional depth of field in this large splash. I don't recommend using a smaller aperture because it will reduce the overall sharpness of the image (compare the measurements on www.slrgear.com). I prefocused with the zoomed-in live view display before I switched to manual (M) mode and used my favorite indoor shutter speed of 1/125 second. Using a full-frame prime lens on an APS-C camera gave me an effective focal length of 80mm and allowed a safe distance from the camera and the wet subject. Attach a UV or skylight filter to your lens as a safety precaution when you shoot liquids.

Make a test shot to be sure the ambient light is suppressed, then set your flash to 1/8 output. Remember that every full increment on the flash output scale halves (or doubles) the amount of light.

The Shoot

Check your setup and prefocus with the object in a fixed position (for example, hung in place with a piece of string) before you attempt to capture the splash. Drop the object from one hand and release the shutter with the other hand shortly afterwards. You will quickly get a feel for the timing, and then you'll capture great splashes with almost every shot.

Post-Processing in Photoshop

Perfectionists will probably clean the walls of the aquarium after each exposure, but I took the easy way out and used Photoshop to remove unwanted droplets. I also increased the overall contrast, balanced the colors, and cropped the image before I did the final sharpening. I added a turquoise color to the

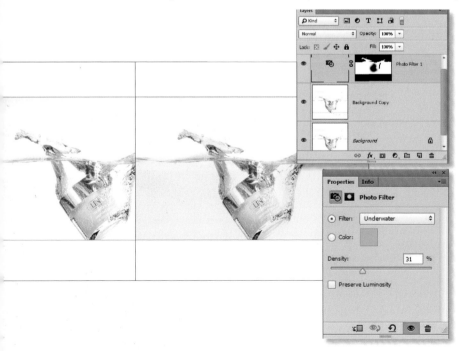

◄ *The photo before and after a Photo Filter adjustment layer. A mask restricts the new color to the water.*

water with a Photo Filter adjustment layer (I unchecked the Preserve Luminosity option).

Tips, Tricks, and Notes

▸ Rolls of Trans-Lum sheeting are available from most well-stocked online photo dealers. Some art and architecture supply stores also carry small rolls or individual sheets.

▸ To see more inspirational splash shots, check out the sample photos and blog from Photigy (www.photigy.com).

▸ For more information about depth of field and diffraction blur, see en.wikipedia.org/wiki/Depth_of_field.

▸ Visit SLRgear (www.slrgear.com) to find test values for the critical aperture for your lenses.

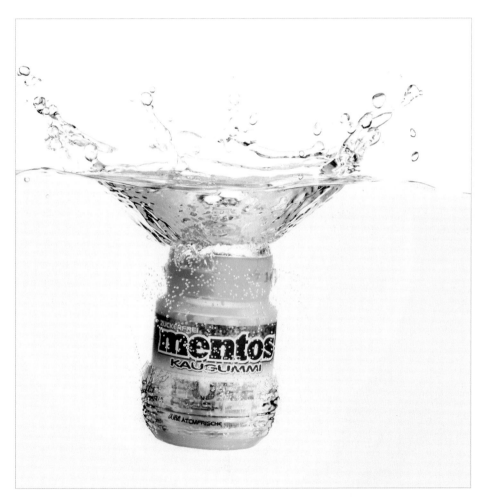

◀ *This shot was taken with the same setup and camera settings as those used to capture the image on page 247*

Workshop 38
Curaçao Wave

▸ *Using Trans-Lum sheeting instead of a softbox*
▸ *An easy and reproducible way to capture waves*

Capturing waves requires a slightly different approach than the one we used to capture splashes. The photo in this workshop gives the impression that it was captured when the liquid was poured into the glass, but it was actually the glass that was set in motion. This workshop demonstrates the simplest way to create this kind of effect and provides tips on how to set up your lights to effectively capture the movement.

The Setup

Creating a perfect wave requires some preparation, although you can find most of the bits and pieces you need at home. Once again I used two boards with a gap between them and my bathtub as a stage, and I taped a sheet of Trans-Lum to the wall as an infinity cove. To create the wave effect I used another board, the glass from a picture frame to create the reflection, and a champagne flute. I taped the glass to the board and attached the champagne flute to the glass with silicone fixative (clear tape would also work). To create a controlled wave, fill the glass, lift one end of the board three or four inches, and then drop it.

In this setup the light needs to come from behind. I initially placed two YN-460 flashes (fired with RF-602 radio triggers) behind the Trans-Lum sheet. They fell into the bathtub during my first attempt, so I let them lie in the bathtub and just pointed them up.

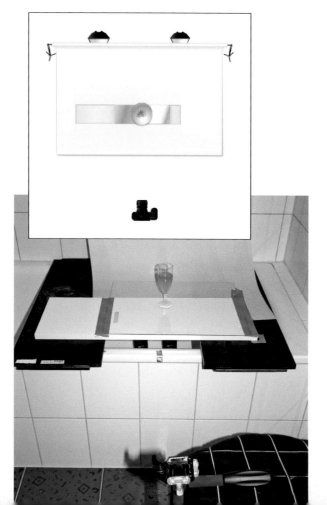

◀ *A schematic and a photo of the setup showing the Trans-Lum infinity cove, two flashes that light the background from below, and the champagne flute attached to a sheet of glass that was taped to a board*

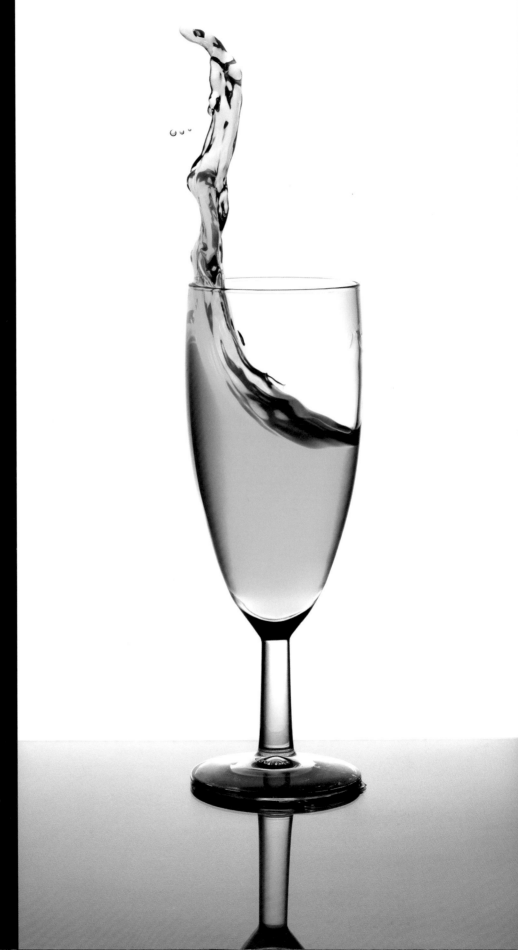

▶ *An effective wave shot requires careful preparation*

Canon EOS Rebel T1i (EOS 500D) | EF 50mm f/1.4 set to f/10 | M mode | 1/125 second | ISO 100 | RAW | manual prefocus (autofocus off)

Camera and Flash Settings

I used a 50mm full-frame prime lens that gave me an effective focal length of 80mm on the APS-C camera and a safe distance between the camera and the subject. I prefocused manually with the live view display zoomed in, and I set the aperture to f/10 to give me sufficient depth of field. I began with the flashes set to 1/8 output and regulated them according to the results of my test shots. In this type of situation, always make sure the lighting is just right before you create the wave. The movement of a wave is slower than that of a splash, so you can use slightly longer flash durations. If you cannot generate enough light using two flashes, either add more flash units or increase your ISO setting.

The Shoot

When everything is set up, you can attach a cable release to your camera and create a wave by lifting the board and letting it drop. With a little practice, you will learn to time the drop and the shutter release to perfection, and you should be able to capture a great wave with every second or third attempt.

Post-Processing in Photoshop

You will need to crop most of your wave shots, and you will probably have to use the Clone Stamp tool (or a similar tool) to remove the tape or silicone you used to attach the champagne flute to the glass. Of course, you can also remove any other unwanted artifacts and adjust the colors, contrast, and sharpness to taste. Our before and after shots are shown below. Remember, the better the initial capture, the less post-processing will be needed.

Tips, Tricks, and Notes

▸ Although it looks like expensive liqueur, this shot was made with water and food coloring.
▸ The setup I used for this shot was inspired by Jamal Alayoubi (www.flickr.com/photos/jamalq8/3734558512). For an alternative method based on using a skateboard, see Vincent Riemersma's setup (www.diyphotography.net/creating-the-splash).
▸ Check out AurumLight (http://blog.aurumlight.com/2011/04/20/milk-workshop-in-london) for another inspiring splash idea based on milk.

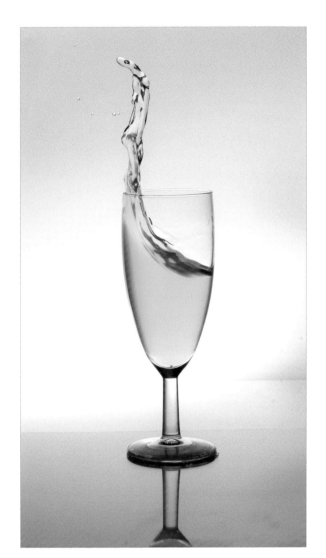 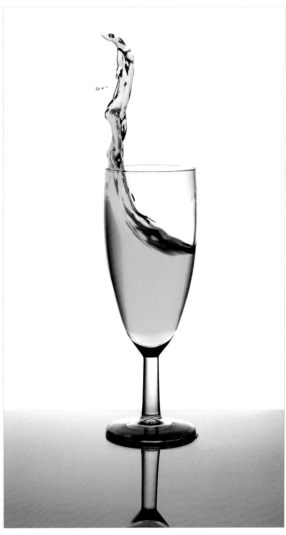

▲ *The original image (left) and the post-processed version (right)*

Workshop 39
Kiwifruit Splash with a Cross-Beam Sensor

▸ *How to set up a cheap and effective cross-beam sensor*
▸ *How to capture splashes of cream*

If you were frustrated with the trial-and-error approach to shooting splashes in the previous two workshops, you can use a cross-beam sensor. After you set it up properly, you should be able to capture a great splash with every shot. But be warned: setting up the trigger is not trivial. For this workshop I used the Jokie model, which is available for about $215 from eltima electronic (www.eltima-electronic.de). This is a German company, but they ship overseas at reasonable prices. Another option is the StopShot by Cognisys; available in the U.S., but even without overseas shipping it is quite a bit more expensive.

Setting Up the Trigger

This setup uses a cross-beam sensor to release the shutter and capture a slice of kiwifruit as it falls into a cocktail glass filled with cream. The Jokie sensor has only one active component. The transmitter/receiver unit is the only part of the system that requires separate electrical power as it uses a simple cat's eye reflector as counterpart. The unit is delivered with a battery holder and 20mm and 40mm reflectors. All components have quarter-inch threads, so they can be mounted on standard-size tripods and light stands.

In addition to batteries, a cross-beam sensor requires a connection cable. To trigger Canon cameras or flashes, the Jokie requires a male-to-male 2.5mm stereo cable. Cables for Canon and other cameras are available from Amazon or, in the case of the Jokie, from the manufacturer.

To set up the sensor, align the transmitter and the reflector until the warning lamp on the transmitter goes out, and then connect the cable to the camera. Now set up your flash and figure out the height from which you need to drop the object. We used two Yongnuo YN-460 flashes fitted with RF-602 radio triggers. For a shot like this, you can equip your flashes with snoots or grids, or simply bounce the light off a sheet of Styrofoam. Then measure the delay in the system by setting up a ruler next to your scene and dropping a suitable object (such as an eraser) through the trigger's beam. For our setup we measured a height of about 42 cm, which is a 30 ms delay between the time the object is released and when the shutter fires. You can reduce the distance and delay by using mirror lockup. With our Canon EOS

▸ *The IR trigger, showing the transmitter/receiver unit, the battery holder, and the two reflectors*

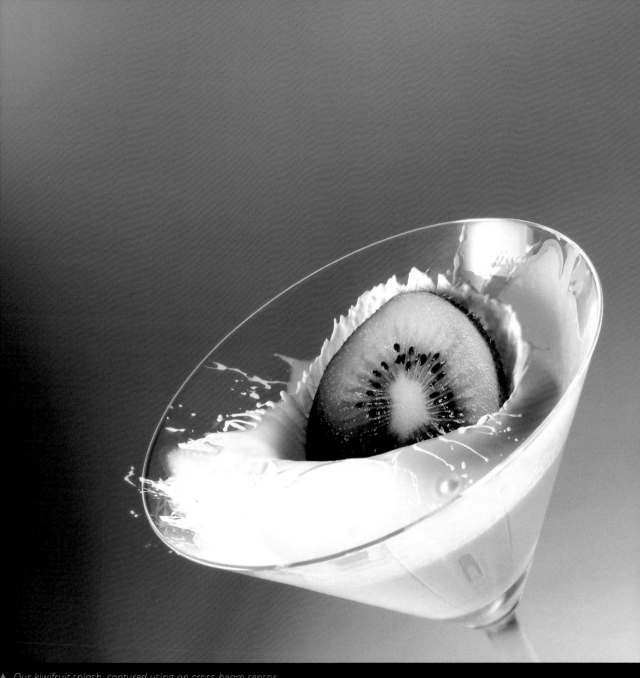

▲ *Our kiwifruit splash, captured using an cross-beam sensor*

Canon EOS Rebel T1i (EOS 500D) | EF 50mm f/1.4 set to f/8 | M mode
| 1/125 second | ISO 100 | RAW | manual prefocus (autofocus off)

Rebel T1i (EOS 500D), this reduced the drop height to 35 cm. When you know these values, you can set up your scene accordingly and use a glass of water to pre-focus and to test the system. The flash should be set to an output value close to its minimum to keep the flash duration short. You can then set your camera to f/8, 1/125 second, and ISO 100 and start dropping objects into liquids!

For our setup the distance to the transmitter was about 70 cm, and we had to use the small reflector to get the system to work with such a small object. More expensive cross-beam sensors, such as the Cognisys StopShot, have a built-in delay circuit that you can use to precisely time your drops. The Jokie in the original version has no such feature, but it has a consistent delay of 0.13 milliseconds. If you are using a simple trigger like this and you need a longer delay, you either have to increase the drop distance or work without mirror lockup.

This setup is less useful with cameras that have longer shutter delay times (some Olympus cameras, for example, have a shutter delay of up to 300 ms). The best work-around is to darken the room, set the camera to bulb (B) mode, open the shutter, and then use the trigger to fire the flash instead of the camera. Cables are available to connect most triggers to a range of flash units. If necessary, you can trigger additional flashes as optical slaves.

Camera and Flash Settings

I used a 50mm full-frame prime lens that gave me an effective focal length of 80mm on that camera and a safe distance between the camera and the splash. I prefocused manually using the zoomed-in live view display, and I set the aperture to f/8 to give me a sufficient depth of field. I set the flashes to 1/8 output to begin, and I adjusted them based on my test shot results. In this type of situation, always make sure the lighting is

just right before you create the splash. I used a blue gel on the background flash and a snoot made of rolled-up black card on the unit that illuminated the splash.

▼ *Schematic and photograph of our kiwifruit splash setup, showing a blue-filtered flash for the background and a snooted flash to light the glass*

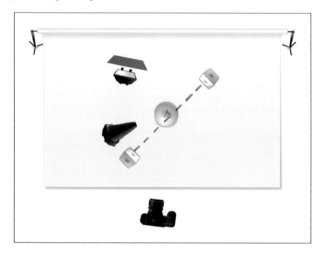

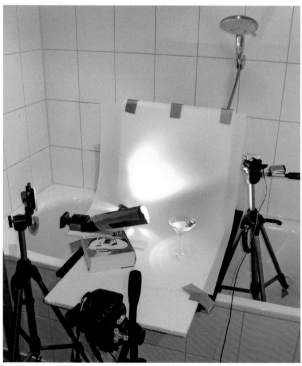

The Shoot

If you have prefocused correctly and your gear is set up properly, all you have to do is drop the object and wait for the camera to take the picture. However, as autofocus lenses tend to defocus easily you should also check the focus regularly.

Post-Processing in Photoshop

The results of this shoot already looked quite good straight out the camera, so all that I had to do was crop the images, adjust the contrast, and sharpen them for output.

Tips, Tricks, and Notes

▸ If you have trouble lining up the transmitter and the reflector over larger distances, move them closer toward each other until the lamp on the transmitter goes out and then slowly move them apart again. Adjust the alignment with each step so the lamp stays off.

▸ The two differently-sized reflectors provided with the Jokie are designed for use in different scenarios. The large one is better for greater distances, and the small one is better for small objects. My setups for the currants and kiwifruit worked only with the small reflector. If you are photographing birds or bats in flight, the large reflector is a better choice.

▸ The spin you apply to an object when you drop it affects the size, direction, and timing of the splash. With a little practice you will be able to control the splash with wrist action alone.

▸ Milk works for splashes, but it is thinner than cream and produces less impressive splashes. Olive oil and Jell-O are great for making splashes too.

▸ If you want to build your own cross-beam sensor, search the Internet for "DIY cross-beam sensor trigger photo." A detailed construction plan by Brian Davies is available at DIYPhotography (www.diyphotography.net/high-speed-into-primer-better-trigger-and-cherry-drops).

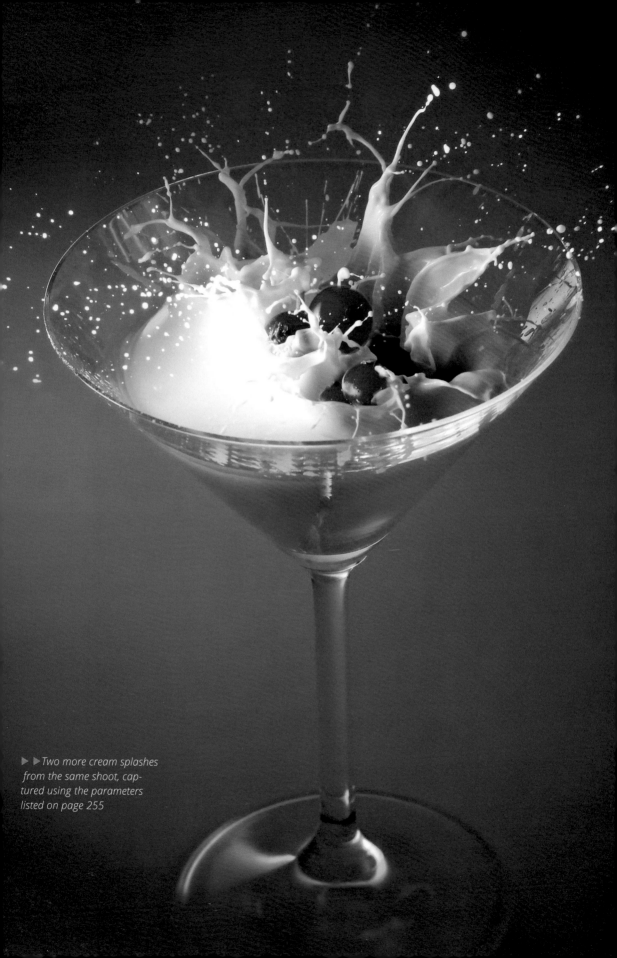

▶ ▶ *Two more cream splashes from the same shoot, captured using the parameters listed on page 255*

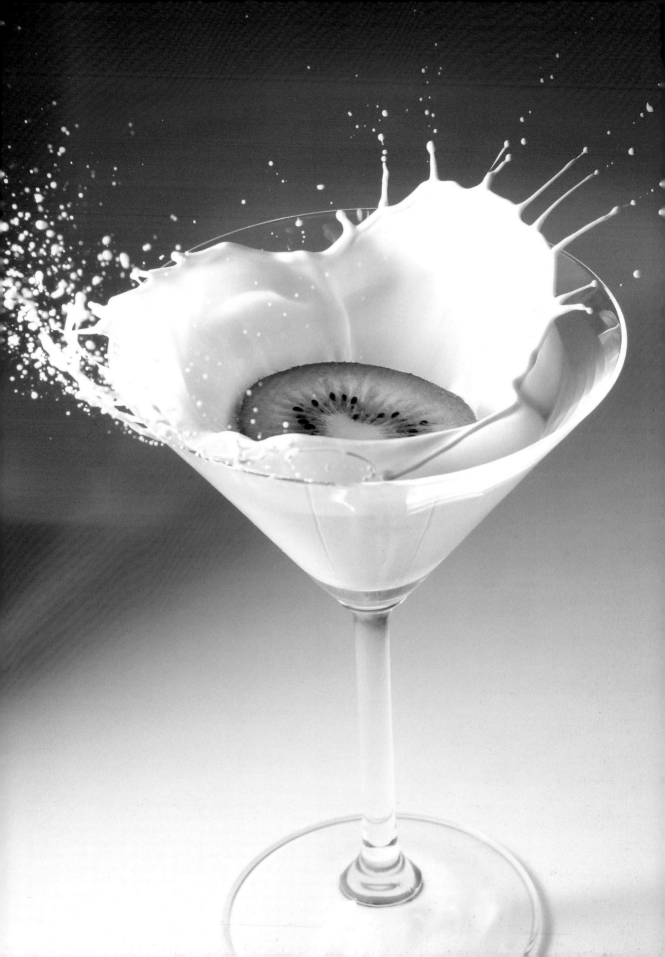

Workshop 40
Dark Field Martini Splash

- ▸ *Using a cross-beam sensor*
- ▸ *Capturing a splash using dark field lighting*

Dark field lighting is perfect for capturing objects made of glass or other highly reflective materials. The technique uses light from the side that grazes the surface of the object and produces an aesthetically pleasing look. This workshop combines dark field lighting techniques with splashes.

The Setup

In this setup a large flag blocks the direct light from the flash and allows only diffuse, indirect light to reach the subject. This makes the glass look almost entirely black, with bright accents around the outline. To create the effect, bounce flash light off a reflector that is placed behind the glass, and insert a flag between the reflector and the subject. Additional reflectors on each side of the glass provide lateral accents.

For this shot I used two flashes set to 1/2 output and Styrofoam reflectors covered with paper to produce the reflections in the sides of the glass.

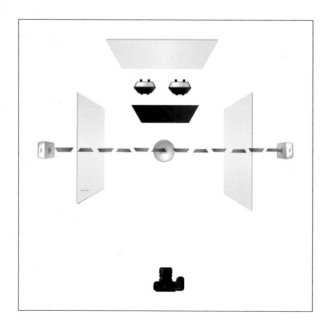

◀ *Schematic for our dark field martini splash shot, showing the cross-beam sensor and the large flag that produces the dark field lighting effect*

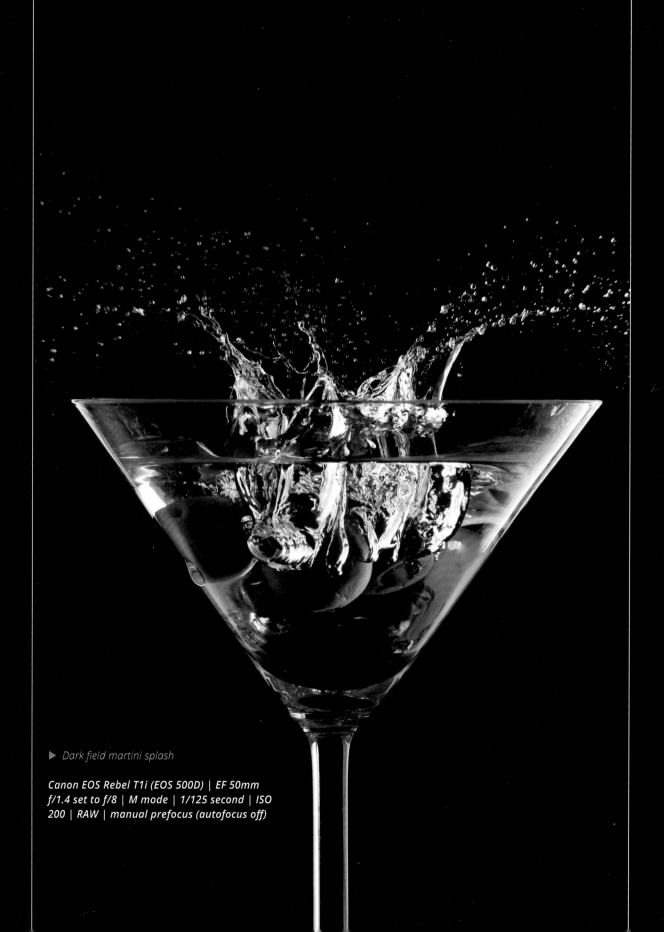

▶ Dark field martini splash

Canon EOS Rebel T1i (EOS 500D) | EF 50mm
f/1.4 set to f/8 | M mode | 1/125 second | ISO
200 | RAW | manual prefocus (autofocus off)

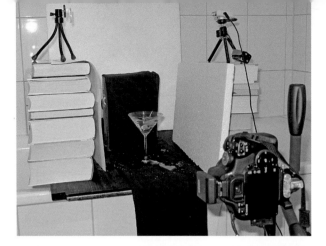

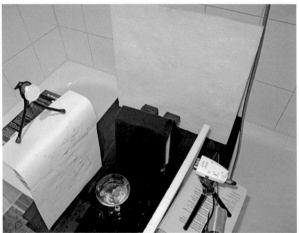

Camera and Flash Settings

This type of indirect flash requires a high output setting if enough light is to reach the subject. As with many of the other setups described earlier, you can always add extra flashes to reduce the output, and thus the flash duration of each flash unit and produce sharper images. The other basic settings (including the Jokie cross-beam sensor) are described in the previous workshop.

The Shoot

If you have prefocused accurately and chose the right settings, all you have to do is let the object (in our case, an olive) fall into whatever container you are using. Autofocus lenses tend to defocus easily, so check the focus regularly with the zoomed-in live view display.

Post-Processing in Photoshop

In addition to removing fingerprints and dust particles, pay attention to the blackness of the background. One of the simplest ways to ensure deep blacks is to shift the black point slider in the Photoshop Levels dialog

▲ *Our dark field splash setup from the camera's point of view (top) and from above the scene (bottom)*

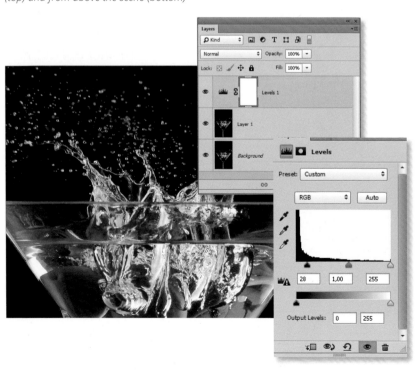

toward the center of the histogram, or use the eyedropper to sample the areas that you want to be deep black. Shifting the black point ensures that the dark areas in the background are truly black

Tips, Tricks, and Notes

▸ Experts may notice that the viscosity and diffraction index of the martini in these shots is closer to that of water than a more expensive alcoholic beverage.

▸ Dark field lighting is often used in tabletop and product photography (workshops 17 and 35 are good examples). The appendices at the end of this book contain a wealth of useful tips as well as links to websites that provide more detail on these and a range of other photographic lighting scenarios, including retroreflection and coaxial lighting.

▼ *Another shot from our dark field splash session, captured using the parameters listed on page 261*

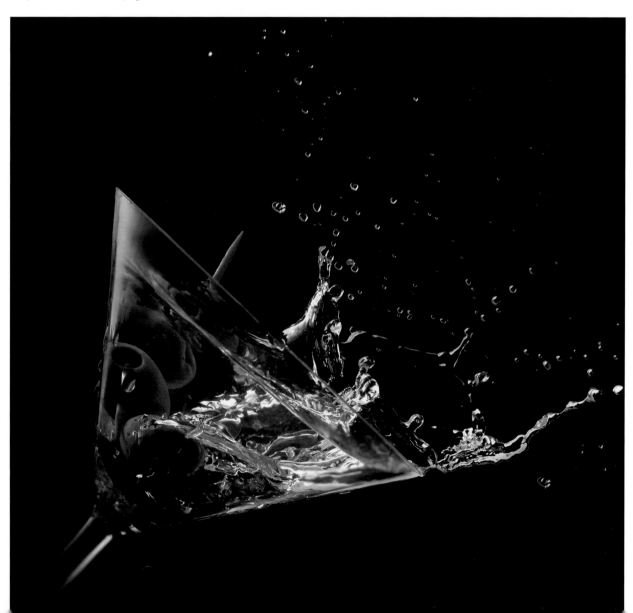

Appendices

The following pages include detailed information about how to calculate flash exposures using exposure values and guide numbers, tips on how to create your own lighting diagrams, and a wealth of sources, links, and further reading. There is also a glossary to help you navigate your way through the strobist jungle.

Appendix A
How to Calculate Photographic Exposures

You might initially hate to calculate using exposure values, but you are sure to love it in the end. At first glance, calculating exposures with apertures, exposure values, and exposure times can seem complex and unnecessary, but after you discover how the basic parameters fit together you will have a lot of fun optimizing your images. Getting a perfect exposure is something a camera cannot do, regardless of how high-tech it is. The camera simply doesn't know if it is mounted on a tripod, if the lens has a built-in stabilizer, if you prefer a long exposure time over a short one with low noise, or if you are using additional off-camera flash. Ultimately, the only skills you need to calculate exposures are simple addition, subtraction, and division.

Basics

Virtually all of today's cameras have an exposure compensation function with values expressed in terms of exposure values (EVs). EVs are the cornerstone of photographic exposure calculation and represent the convergence of aperture, ISO, and shutter speed. Together, these settings determine the amount of light that reaches the sensor (and the amplitude of the output signal). Their relationship can be expressed mathematically using the following formula (which you can safely ignore if you are not interested in such things):

$$EV = \log_2 \left(\frac{\text{f-number}^2}{\text{Exposure time}} \right)$$

EV = 0 is defined as f/1.0 and an exposure time of 1 second.

When the first formula is rewritten to include the ISO value, the expression is as follows:

$$EV_S = EV_{ISO100} + \log_2 \left(\frac{\text{ISO Speed}}{100} \right)$$

Fortunately, you will rarely need formulae like these because it is much easier to work with a rule of thumb that expresses the same concept in a simpler way:

Each full step in the aperture sequence, the exposure time sequence, the ISO values, or the flash output sequence means ±1 EV.

Aperture values are given by the sequence of numbers that result from calculating powers of the square root of 2 as follows: 1, 1.4, 2, 2.8, 4, 5.6, 8, 11, 16, 22, 32, and so forth. Each step along this scale represents double (or half) the area of the aperture opening and, therefore, the amount of light that can reach the sensor. Numerically, every second aperture value is double the previous one: 1, 2, 4, 8, and so forth; or 1.4, 2.8, 5.6, 11, and so forth.

Exposure times are expressed as fractions of a second, and they are doubled (or halved) with each increment: 1/1000, 1/500, 1/250, 1/125, 1/60, 1/30, 1/15, 1/8, 1/4, 1/2, 1, 2, 4, and so forth. Each increment allows twice (or half) as much light to reach the sensor.

ISO values are expressed numerically in a simple sequence that usually starts at 50 or 100 and doubles with each step: ISO 50, ISO 100, ISO 200, ISO 400, and

so forth. Increasing the ISO value increases the output voltage of the sensor, and each step doubles (or halves) the sensitivity of the sensor.

Flash output values are expressed as fractions of a flash unit's maximum (full) output (1, 1/2, 1/4, 1/8, 1/16, etc.). If the flash is the only source of light in the photo, each increment results in twice (or half) the amount of light that reaches the sensor.

That's all there is to it! After you have memorized these simple concepts, it's just a matter of practice. The following tables show randomly chosen combinations of values that result in the same overall exposure. Put simply, every time you alter one value by one or more full steps, you have to adjust another value in

the opposite direction by the same number of increments to achieve the same exposure (table 1 shows exposure values calculated without flash, and table 2 includes flash in the calculation).

Flash-to-subject distance is also part of the calculation. Its effects are governed by the inverse square law as follows:

Halving the flash-to-subject distance quadruples the amount of flash that reaches the subject.

In other words, each halving or doubling of the subject-to-flash distance can be compensated for by not one, but two steps in one of the other sequences. If you

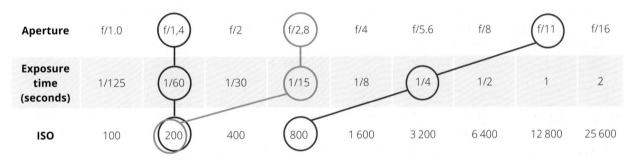

▲ **Table 1:** *Examples of combinations. Note that today's cameras are usually calibrated with clicks that represent one-third of a full f-stop. If you increase a value by one click, you do not have to calculate, you just can decrease another value by one click. Even if your camera also gives you the option of using half-stop clicks, it is still better to use increments of 1/3 because flash output values are usually incremented in thirds.*

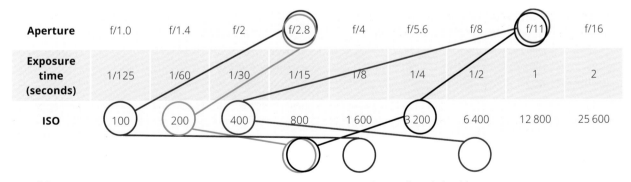

▲ **Table 2:** *Examples of combinations. Note that today's Note: For exposures that are lit entirely with flash, the flash duration determines the exposure time. If the flash duration is the same as or longer than the camera's flash sync speed, the exposure time is not relevant to the final exposure. The examples in this table are valid for a darkened room and a shutter speed of 1/125 second.*

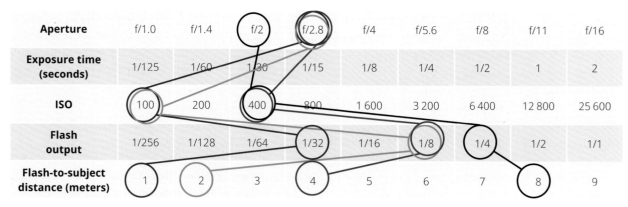

Aperture	f/1.0	f/1.4	f/2	f/2.8	f/4	f/5.6	f/8	f/11	f/16
Exposure time (seconds)	1/125	1/60	1/30	1/15	1/8	1/4	1/2	1	2
ISO	100	200	400	800	1 600	3 200	6 400	12 800	25 600
Flash output	1/256	1/128	1/64	1/32	1/16	1/8	1/4	1/2	1/1
Flash-to-subject distance (meters)	1	2	3	4	5	6	7	8	9

▲ **Table 3:** *This table also assumes that ambient light is low.*

Aperture	f/1.0	f/1.4	f/2	f/2.8	f/4	f/5.6	f/8	f/11	f/16
Exposure time (seconds)	1/125	1/60	1/30	1/15	1/8	1/4	1/2	1	2
ISO	100	200	400	800	1 600	3 200	6 400	12 800	25 600
Flash output	1/256	1/128	1/64	1/32	1/16	1/8	1/4	1/2	1/1
Flash-to-subject distance (meters)	1	2	3	4	5	6	7	8	9

▲ **Table 4:** *To a certain extent, the effect of ambient light can be adjusted separately from the effect of flash light when you adjust the exposure time. The range of adjustments is determined by the camera's flash sync speed.*

want to stick with single steps in the aperture, time, or ISO sequence, you have to calculate with multiples of sqrt(2) = 1.4 in the sequence of distances.

If we put all this together and assume you are combining ambient light with flash, the whole thing gets slightly more complicated. In the example, I assumed that shooting at 1/60 second and ISO 400 includes a fair amount of ambient light in the resulting image and that the flash exposes the main subject correctly. Then, the sample settings indicated by the red and green outlines produce the same overall exposure (see table 4).

When you shoot on location, you will usually meter for the ambient light first and then add flash light to suit your needs. This approach allows you to alter the proportions of daylight and flash by adjusting only the exposure time (see the next section for examples).

The zoom setting of your flash reflector and the choice of light modifier you use also influence the exposure. These less precise factors cannot be expressed mathematically, but adding a light modifier, such as a shoot-through umbrella, reduces the amount of light that reaches the sensor by up to 2 EV.

The only other factor you need to consider when you work through the following examples is the longest exposure time at which you can shoot handheld without camera shake. A good rule of thumb is as follows: maximum exposure time ≤ 1 / focal length. If you have any doubt, then halve the maximum exposure time.

So far we have calculated with relative exposure values up and down the steps on a scale, but exposure values can also be expressed in absolute terms in relation to the physical concept of luminance. This means we can find the EV of certain situations without having to measure them (these examples are from the Wikipedia "Exposure Value" page):

Burning house	$EV_{ISO100} = 9$
Christmas tree lights	$EV_{ISO100} = 4$ bis 5
Clear sky	$EV_{ISO100} = 15$
Cloudy sky	$EV_{ISO100} = 12$
Aurora borealis	$EV_{ISO100} = -6$ bis -3

Sample Calculations

Without Flash

Even if flash photography is your primary interest, the following nonflash examples are useful for thinking about exposure values, and they will teach you to effectively mix flash and ambient light when dragging the shutter.

Adjusting the ISO Value in Dim Light | Imagine you are shooting inside a church using a midrange zoom set to 30 mm. In P mode (ISO set to 100), the camera suggests an aperture of f/4 and an exposure time of 1/4 second. This shutter speed is obviously too long and would cause camera shake, but the lens is already set to its maximum aperture. The solution is to increase the ISO to 800, which gives you 3 additional stops (i.e., 1/4 → 1/8 → 1/15 → 1/30 second). The new shooting param-

eters are ISO 800, f/4, and 1/30 second, which you can shoot handheld. You can either set these values manually in M mode or you just change the ISO value. In Auto modes like Av or P, the camera then adjusts the other parameters automatically.

Dim Light with Stabilizer | The situation is the same as in the previous example, but this time you are using a lens with a built-in optical stabilizer; the camera has no way of knowing about the image stabilization. Once again, P mode suggests f/4 and 1/4 second at ISO 100. The stabilizer allows you to shoot up to 4 stops slower than normal, so you can safely adjust the ISO to 200 and still shoot low-noise images without camera shake.

Landscapes | This time you are shooting a broad landscape using a 10mm lens on an APS-C camera. In P mode and with auto ISO, the camera suggests f/8 and 1/1000 second. However, you wish to capture the maximum depth of field. You still have plenty of exposure time in reserve, so in Av or M mode you can switch to f/22, which gives you 3 stops less of light (8 → 11 → 16 → 22). The ISO remains at 100 (note that the minimum ISO for some Nikon cameras is 200), so you have to reduce the exposure time, from 1/1000 → 1/500 → 1/250 → 1/125 second, which is fine when you shoot handheld with a 10mm lens.

Landscape under a Bright, Clear Sky | In this situation the camera is set to auto and recommends ISO 100, f/8, and 1/500 second, but a test shot reveals that parts of the sky are burned out. The solution is to use Av mode and 1 or 2 stops of negative exposure compensation. The resulting settings are ISO 100, f/8, 1/500 second, and –2 EV compensation. This is equivalent to M mode settings of ISO 100, f/8, and 1/2000 second. These settings expose the sky correctly but underexpose the landscape—a discrepancy that is easy to fix in Photoshop if you shoot in RAW format.

Tripod-Mounted Landscape Shot with Neutral Density Filter | A neutral density (ND) filter helps keep exposure time long in bright sunlight and makes it possible to blur the movement of a waterfall captured in daylight. A 1000x ND filter provides 10 EV of additional leeway and extends the potential exposure time to 1,024 times its original value (1 → 2 → 4 → 8 → 16 → 32 → 64 → 128 → 256 → 512 → 1,024). For the human eye, such a filter looks just completely black and it also causes the camera's exposure meter to fail. However, you can do test shots without the filter, and in the example, these shots show that ISO 100, f/11, and 1/30 second produce a well-exposed image.

Now, one solution is to mount the filter and set the camera to ISO 100, f/11, and 32 seconds. However, this means you have to wait 32 seconds to view each test shot. You can work faster if you make your test shots at ISO 800, f/11, and 4 seconds. After you know the basic exposure is correct, you can fine-tune the settings and make a couple of long exposures at ISO 100.

Product Shot in Daylight | This exercise involves photographing a piece of jewelry for an eBay auction in dull, diffuse daylight. The camera is fitted with a 50mm f/1.4 prime lens and is mounted on a tripod. The shutter is fired in mirror lockup mode using a cable release. The camera doesn't know that it is mounted on a tripod; in Auto mode it turns on the popup flash to expose at ISO 400, f/4, and 1/60 second, which results in a horrible exposure.

If you switch to P mode with the flash off and use ISO 100, the camera recommends 1/8 second at f/1.4. This is okay, but it doesn't provide enough depth of field. To shoot at the desired aperture of f/11 and ISO 100, you have to set the exposure time to 8 seconds (i.e., 6 stops slower to accommodate the narrow aperture). If a test shot reveals some slight overexposure, you would just switch to M mode and use ISO 100, f/11, and 4 seconds.

Portrait Backlit by the Sun | The idea is to capture a portrait in sunny backlight with a slightly overexposed background; the sun is peeking out from behind the subject. In this situation the camera's automatic exposure control attempts to find a compromise for the background exposure and the foreground exposure, and it fails completely.

The solution is to spot meter the subject's face. This should result in values of about 1/200 second and f/2.8 at ISO 100. To deliberately overexpose the background, alter the exposure time to 1/100 second and adjust the settings in M mode so you don't have to repeat the procedure for every shot.

Bird in a Birdbath in Cloudy Daylight with Water Splashes | When this scenario is shot in auto mode with a telephoto zoom set to 250mm and a maximum aperture of f/6.3, the camera will select f/8 and 1/200 second, and it will turn the flash on and use ISO 400. In P mode with auto ISO and the flash turned off, the camera will select 1/400 second, f/7.1, and ISO 400. What would you do?

In such an extreme situation, use M mode and choose ISO 800, 1/1000 second, and f/6.3. You will trade a little extra image noise and a slight lack of sharpness due to the open aperture for successfully freezing the movement of the splashing water and the flapping of the bird's wings.

Setting Exposure Using Known Values | In this exercise we look at a landscape under a cloudy sky. We want to expose the photo without the help of an exposure meter. Cloudy daylight generally has an EV of 12 at ISO 100. If you don't already know the EVs of certain situations, you can look them up on the Wikipedia "Exposure Value" page. Recall from earlier in this appendix that 0 EV results from shooting at f/1.0 for 1 second at ISO 100.

Set your camera to ISO 100 (other values require you to recalculate using the formula shown at the beginning of this appendix). If you then select an aperture of f/8, you need to select an exposure time that equates to the difference of 6 stops between f/1.0 and f/8 (1 → 1.4 → 2 → 2.8 → 4 → 5.6 → 8). This accounts for half the difference between 0 EV and 12 EV (our target value). You can account for the other half by selecting an exposure time of 1/60 second (1 → 1/2 → 1/4 → 1/8 → 1/15 → 1/30 → 1/60). The final settings are, therefore, ISO 100, f/8, and 1/60 second.

Even if it seems complicated at first, this basic knowledge will help you quickly estimate the settings you need to correctly expose images in standard situations.

With Flash

Studio Workshop: The Instructor Has a Nikon, You Have a Canon | In this scenario, your portrait workshop instructor suggests that you use f/8 and 1/125 second to shoot in the lighting setup he has arranged, but your images are underexposed.

Nikon and Canon cameras don't use the same metering parameters. The ISO range of some Nikon cameras begins at 200, which can cause discrepancies if someone else shoots with a Canon that meters starting at ISO 100. This is why your shots are 1 stop darker than those of the instructor. You can't alter the flash settings because of the other workshop participants, and altering the exposure time doesn't make any difference because of the short flash duration. Opening the aperture would reduce the depth of field, so the only solution is to double the ISO value to 200.

Team Shoot in a Studio with Preset Lighting | You are taking part in a group studio shoot. Your friend has set up the lighting to suit his 85mm f/1.8 lens, which he

is using at f/2 with ISO 100 and 1/200 second. However, your zoom lens has a maximum aperture of f/2.8.

As in the previous example, you cannot alter the lighting, and changing the exposure time doesn't influence the flash duration. Once again, the solution is to increase the ISO to 200.

Fashion Shoot with Bokeh and Multiple Lenses | On a fashion shoot that is lit with flash, you switch from your stabilized 70–200mm f/2.8 zoom to a 50mm f/1.4 lens. Your camera was previously set to 1/80 second at ISO 640, and you want to keep the same flash settings and continue using a wide aperture to produce pleasing bokeh. You begin shooting at f/2.8 and then switch to f/1.4. Later you swap your lens for a 50mm f/4.0 Lensbaby.

You can compensate for the first lens switch by setting the ISO to 160, and you can compensate for the second switch by increasing the ISO to 1280. The exposure time remains the same, and the combined effect of flash and ambient light remains constant.

Splash Photo | You are photographing an indoor splash scene with studio flash when you notice that your images aren't as sharp as you would like them to be. You remember that system flashes can be faster than studio flashes, so you rebuild your setup using a speedlight at low output. But now, with your camera set to ISO 100, you are missing 2 EV of lighting power.

If you don't have enough flash output, the first step is to increase the number of flash units. Twice as many flashes will increase the exposure by 1 EV. For this scenario you need to use four flash units instead of just one. Alternatively, you could use two flash units and double the ISO to 200.

Flash Bulb | You are using cheap, nonadjustable flash bulbs in a home studio. Your initial test shots at ISO 200

without light modifiers show that the scene is overexposed by 2 stops.

There are various ways to deal with this situation, all of which have advantages and disadvantages. Doubling the flash-to-subject distance will correct the overall lighting, but it provides harsher light. Closing down the aperture by 2 stops will correct the exposure, but it produces a greater depth of field. Using a diffuser will solve the problem, but it creates much softer light. Placing an ND4 filter on your lens will alter the exposure by –2 EV, but it diminishes the overall image quality. The best solution is to use Low ISO mode. For example, the ISO setting for a Canon EOS 5D Mark II can be reduced from 200 to 50. A compromise is to use ISO 100 and increase the flash-to-subject distance by a factor of 1.4.

Fighting Sunlight Using Guide Numbers | In this scenario you are shooting with flash in bright midday sunlight. The sun is behind the model, and you want to use your Canon Speedlite 580EX II flash as your main light (not as an accent light). Metering for the ambient light at ISO 200 gives you an aperture of f/16, which is typical and adheres to the sunny-16 rule. Is it possible to shoot with flash in this scenario using a 50mm standard lens? Can you estimate the exposure values based on the guide number of the speedlight used?

The answer is yes, even if you have to make compromises. If you set the flash zoom to 50mm to match the lens, the flash unit user's manual says the appropriate guide number is 42 (in meters). The flash distance in meters at ISO 100 is given by the formula $A = GN/B$, which gives you $A = 42/16 \approx 2.6$ m. Remember that this approach requires using the flash unit at full output with no modifier, because they reduce the amount of light that reaches the subject. These settings do not allow additional leeway for underexposing the surroundings—a technique that can be used with portable, high-power studio flash units (or porties, as they are called in Germany). You can, however, reduce the depth of field by using an ND filter to increase the aperture without affecting the overall exposure. In situations like this, rotating the flash 90 degrees may provide more even lighting for a standing model photographed in portrait format. If you need help working out the relationship between focal length and your flash unit's angle of spread, check out the Wikipedia "Angle of View" page.

Evening and Nighttime City Streets with Flash and Lots of Bokeh (à la Dustin Diaz) | Your goal is to make portraits with bokeh in an urban evening scenario like the ones made by Dustin Diaz (www.flickriver.com/photos/polvero/popular-interesting/). You are using a 70–200mm f/2.8 IS (stabilized) lens at the maximum aperture and focal length. When you meter for the ambient light, the camera selects 1/200 second, f/2.8, and ISO 2500. Would other settings make more sense for the stabilized lens?

The camera doesn't know the lens is stabilized, so it selected a very high ISO value. Armed with the knowledge that the image stabilization provides up to 4 stops of extra exposure, you can set the exposure time to 1/50 second (2 stops slower) without problems. This allows you to reduce the ISO to 640 and retain the wide aperture of f/2.8. If you are not sure if you can shoot at 1/50 second handheld, switch to 1/100 second and increase the ISO to 1280. If you are shooting in a situation like this with a nonstabilized lens, use a monopod and keep the shutter speed at 1/50 second. At this sensitivity level, the flash does not need to produce much light, because the camera is set so sensitive, and so 1/32 output should work for a bare flash. If you want to use light modifiers, then 1/8 output is a good starting point.

Diffuse Daylight with Flash | You are at an open-air fashion shoot on a cloudy afternoon. In auto mode, the camera's spot meter chooses settings of 1/100 second, f/5.6, and ISO 200, which will expose the model correctly but produce uninspired images.

You can add flash to make the photos more interesting, but be warned: As the subject is already correctly exposed, you have to alter the camera settings to avoid overexposure. The solution is to underexpose the sur-

roundings by about –2 EV, which results in settings of ISO 100, f/5.6, and 1/200 second. Then you can add an off-camera flash to light the subject without worrying about undercutting the camera's sync speed. A single flash without modifiers should provide enough light (see also the "Fighting Sunlight Using Guide Numbers" example above).

Calculating Sync Speeds | Using a compact camera with a fast leaf shutter and with a dedicated hot shoe (such as the Canon PowerShot G10) allows you to use ultrashort exposure times to keep the surroundings underexposed and give the sky a more dramatic look. In this scenario, you are shooting at 1/400 second, f/4, and ISO 100 with two off-camera flashes set to full output (without modifiers) that are located in front of and behind the subject. Can you duplicate this scene with a DSLR that has a focal plane shutter?

This is possible but tricky. The standard flash sync speed for most DSLRs is 1/200 second, which overexposes the scene by 1 stop. However, closing the aperture by 1 stop or reducing the ISO to 50 would provide 1 EV too little flash output. Reducing the flash-to-subject distance by a factor of 1.4 would solve the output problem, but the subject would probably not be lit adequately. The most obvious (and probably the easiest) solution is to double the two flash units, and to fire all four units in parallel.

Bouncing Flash over Long Distances | Imagine you are shooting portraits during the blue hour. The location is great, but the ambient light is too weak. You have a flash with you, but no tripod and no radio trigger, so you have to mount the flash on the camera. The only potential reflector is a white wall about 10 meters away. Does it make sense to bounce the flash over the full 20 meters to the wall and back?

The camera is set to 1/50 second, f/2.8, and ISO 200. With the reflector set to its 105 mm zoom setting, the flash guide number is 58 (for ISO 100). You can bounce the flash over this relatively large distance

if you increase the camera's sensitivity without altering the exposure for the ambient scene—that is, 1/200 second, f/2.8, and ISO 800. At its telephoto setting, the flash range, A, is given by

$$A = \frac{GN}{B} \sqrt{\frac{E_F}{E_L}}$$

where GN is the guide number (in meters), B is the aperture value, E_F is the selected ISO value (800 in this case), and E_L is the ISO base value (100 in this case).

This gives us: A = [(58 / 2.8) x 2.8] m = 58 m

Of course, a wall is not as effective as a mirror, but even accounting for a potential loss of 2 or 3 EV, this setup still allows you to bounce the flash over the full 20 meter distance.

In a situation like this, use a black foamie thing or a snoot to prevent direct light from hitting the subject, and use flash exposure compensation to balance the result. Depending on the camera you are using, you will probably need to set the exposure compensation to +1 or +2. Another approach is to set the flash to manual mode and full output—you will probably need it. Double check the bounce angle to make sure you get the most from the bounced flash.

Bouncing Flash at Various Distances | You are using on-camera TTL flash bounced off the walls to shoot at a wedding. The walls aren't very close to the subject, but you can use the ISO setting to artificially increase the effect of the flash. Assume that you can produce a well-lit portrait shot using nearly full flash output, ISO 100, and a relatively narrow aperture of f/6.3. With a wall about 2 meters away from the subject, the bounced flash has to travel 4 meters. What can you do to keep shooting at the same aperture if you move to a distance of 4 or 8 meters from the wall?

The obvious solution is to increase the ISO, but remember that doubling the distance to the light source requires you to quadruple the ISO setting. In other words, at a distance of 4 meters from the wall, the light has to travel 8 meters, so you have to increase

the ISO to 400. At a distance of 8 meters, you have to quadruple this value to ISO 1600.

In practice, you probably won't have to use such a high ISO setting because the floor, ceiling, furniture, and other people in the room act as subsidiary reflectors. You could also open the aperture a little, but that will alter the depth of field and affect how the image looks. I chose f/6.3 for this example because my test shots showed that was the ideal value at full flash output. In practice, you can always increase your flash range by using a wider aperture.

Adjusting Background Brightness | You are shooting portraits at a distance of 2 meters in front of a white background using an on-camera ring flash. How can you underexpose the background by 2 stops?

The inverse square law says the strength of the light produced by a point source is inversely proportional to the square of the distance between the light source and the object being illuminated. If you know the flash-to-subject distance, you can use the inverse square law to figure out how to set your camera to underexpose the background by the desired number of stops. If the subject is correctly lit (i.e., 100% of the light from the flash reaches the subject) at a distance of 2 meters, the background will be underexposed by 2 stops (–2 EV) if the background is located 2 meters behind the model—in other words, only 25% of the light from the flash reaches the background.

Calculating Flash Exposure in HSS Mode | Assume you are using Neil van Niekerk's gang light approach to shoot with flash in bright sunlight. Neil uses four speedlights in parallel and in HSS mode to circumvent the limitations of the flash sync speed, which allows him to use very short exposure times and wide apertures. The downside is that this approach requires multiple expensive HSS-capable system flashes and the same number of HSS-capable PocketWizard radio triggers. For his original gang light shot, Neil selected 1/8000 second, ISO 100, and f/2 in HSS mode (for more information, see Neil's blog at http://neilvn.com/tangents/using-multiple-speedlights-with-high-speed-flash-sync/). Can you

create the same look without using HSS and without so much expensive gear?

This is a hard but interesting problem to solve. Neil used a Canon EOS 5D Mark II and four Canon Speedlite 580EX II flashes set to HSS mode and, I assume, full output. The solution to the challenge lies in the use of a neutral density (ND) filter.

Calculation for the ambient light exposure:

When you expose for ambient light, the following pairs of parameters always give you the same overall exposure:

1/8000 at f/2
1/4000 at f/2.8
1/2000 at f/4
1/1000 at f/5.6
1/500 at f/8
1/250 at f/11

So obviously, the shortest exposure time you can use for a flash that is not set to HSS mode is 1/250 second. (To be more precise, 1/200 second is the flash sync speed for a Canon, but 1/250 second is easier to calculate with in this example.)

You also have to figure out how to use the same aperture as Neil to preserve the same shallow depth of field and the same overall look. You can achieve this by using an ND32 filter with a density of –5 EV. That will increase the exposure time by a factor of 32 (1 → 2 → 4 → 8 → 16 → 32). Adjusting the aperture by the same factor results in settings of 1/250 second and f/2.

Calculation for flash exposure:

You now have to verify if the flash setup still works with the new camera settings. So first, have a look at the influence of switching to HSS: Switching to HSS mode with an exposure time at the limit of non-HSS flash (i.e., approximately 1/250 second) reduces the flash output to 1/4 (i.e., –2 EV) because HSS mode uses an unconventional strobe-style flash. Furthermore, in HSS mode you have to calculate the exposure as you would for

continuous light (as the flash now works as a continuous light source); in other words, you have to take the exposure time into account. So you lose 2 stops of exposure at 1/250 second, you loose 3 stops (–3 EV) at 1/500 second and 4 stops (–4 EV) at 1/1000 second. To compensate for this change with the aperture, you have to switch from f/11 → f/8 → f/5.6 → f/4 → f/2.8. This means the following sets of parameters produce identical exposures (both times, flash on maximum output):

- Normal flash, 1/250 second, f/11
- HSS flash, 1/1000 second, f/2.8

If you work back up the scale, you will end up at Neil's original settings:

1/1000 at f/2.8
= 1/2000 at f/2.0
= 1/4000 at f/2.0 with two flashes
= 1/8000 at f/2.0 with four flashes

Note: Here we were lucky, as this was a spot landing. Remember, that you also can alter the flash power or the number of flashes used and, if needed, you can also alter the flash-to-subject distance or the flash reflector's zoom setting. With these parameters, you could also easily adjust the settings to fit the Canon EOS 5D Mark II's sync speed of 1/200 second (as we calculated with that little simplification of 1/250 second).

Freezing a Water Splash Using HSS Flash in Bright Sunlight | Recently, I saw some photos that were shot as part of an advertising campaign for the PocketWizard TTL and HSS-capable radio triggers. They showed a model splashing around in a lake, photographed into the bright afternoon sun at 1/4000 second. The photos look great (check them out at http://www.pocketwizard.com/inspirations/profiles/lammerhirt), and I wondered how I could create the same effect on a smaller budget without TTL-capable radio triggers.

The sample photo was captured with a Canon EOS 5D Mark II, an EF 24–70mm f/2.8L lens set to f/6.3 and 35mm, a shutter speed of 1/4000 second, ISO 200, and a bare Metz 60 CT4 flash zoomed to 35 degrees. The flash has a guide number of 60 meters at ISO 100 and 35 degrees (presumably at full output).

This flash unit's extremely high guide number at such a wide-angle zoom setting puts it in a class of its own, but you can duplicate its power with multiple conventional flashes. The rest of this scenario assumes you have access to multiple Canon Speedlite 580EX II flashes and a TTL cable.

According to Canon, a single Speedlite 580EX II has a guide number of 36 meters at its 35-degree zoom setting. Adding one or two more units is equivalent to increasing the ISO to 200 or 300. The resulting calculation is as follows:

$$GN_{new} = GN_{old} \cdot \sqrt{\frac{ISO_{new}}{100}}$$

Here, GN_{old} is the original guide number (in our example, 36 at ISO 100) and GN_{new} is the new guide number that results from using the new ISO value. This gives us new guide numbers of approximately 50 or 62 meters if we use two or three flashes. In other words, you can simulate the same effect using three Speedlite 580EX II units or two 580EX IIs and one 430EX II. In HSS mode, you can produce this effect as follows:

▶ Set all flashes to manual mode, HSS, full output, and 35 degrees.

▶ Configure one of your 580EX II units as the master and connect it to your camera with a TTL flash cable (the 430EX II can be configured only as a slave).

▶ Configure the other flash units as slaves and mount them on the same stand as the master. If necessary, use a small piece of aluminum foil to steer the master's optical control signals toward the slaves' receivers, which are located above the AF assist emitters on the fronts of the units.

I am not sure why the photographer used ISO 200. This was either an oversight or it was necessary to keep the exposure time short enough to freeze the splashes, which were illuminated by the sun, not the flash. Of course, the same calculation works perfectly for ISO 200.

Continuous Light versus Flash | This is an interesting but tricky exercise. A shot is set up so a Canon Speedlite 430EX II fires at 1/16 output with its zoom reflector set to 35 degrees. The camera is set to ISO 100 and f/16, and the subject distance is 0.5 meters. The flash is then replaced by a small 35-watt halogen lamp that also has a spread of 35 degrees. How long does the exposure have to be to create the same effect as the flash?

A quick Internet search reveals that the 430EX II has an output of 40 watt-seconds (Ws), and at 1/16 output, this equates to 2.5 watt-seconds. The halogen lamp is less efficient than that. A search for "luminous efficacy" on Wikipedia reveals that a xenon flash is usually about 7% efficient, and a halogen lamp is about 2.8% efficient. These values give us the following calculation:

35 W x exposure time = 2.5 Ws x (7% / 2.8%)

exposure time ≈ 0.2 second

I tested this, and found that the two light sources deliver an almost identical exposure with the given shooting parameters. So our calculation seems to be right.

Inverse Square Law | In workshop 17 we used the inverse square law to figure out how to light the scene more evenly. The distance values are included in the workshop text, but we left out the precise calculation to keep the description simple.

Remember that the illuminance was initially reduced from 100% to 25%, then to 56%. The inverse square law states that the illuminance provided by a point source (E_v) is inversely proportional to the square of the dis-

$$E_v \propto \frac{1}{r^2}$$

tance to the object it illuminates:

$$E_v = k \frac{1}{r^2}$$

or

where E_v is the illuminance in lux.

In our example, the distance from the flash to the left edge of the coin is 30mm and; the distance to the right edge of the coin is 60mm. I selected the constant k so that E_v. left is 100 (i.e., 100%). This gives us k = 90,000. In absolute terms, the calculation for the light at the right edge of the coin is as follows:

$$E_{v.\,right} = 90\,000 \times \frac{1}{60^2} = 25\%$$

The same formula applied to the lower image gives us the following:

$$100 = k \times \frac{1}{90^2}$$

Therefore, k = 810,000, which gives us the following:

$$E_{v.\,right} = 810\,000 \times \frac{1}{120^2} = 56.25\%$$

This calculation shows that increasing the flash-to-subject distance results in a less severe lighting drop-off over the breadth of the subject. This is useful to remember when you are photographing groups of people. Moving the flash a little farther away reduces the difference between the light that illuminates the people in the front of the group and those at the back, but of course more flash output is needed. And be careful—don't confuse illuminance (E_v) with exposure value (EV)!

Appendix B
Tools for Creating Lighting Diagrams

If you spend a lot of time creating lighting setups, find a way to record them. The simplest way is to use a notebook and pencil, but there are many technology tools that make the job easier, whether you are working on a computer, a tablet, or a smartphone. Digital lighting setups are perfect for uploading to your blog or sharing with others. This appendix introduces some of the powerful tools on the market and lists their strengths and weaknesses.

You may initially choose a tool based on the appearance of the diagrams and ease of use. However, if you plan to publish your setups commercially or on your blog, find out if the tool allows it. The licensing details discussed in the following sections were correct when this book was printed, but check to see if the information is current before you use a tool.

The big advantage of online tools is they often have communities that are dedicated to improving its functionality, and users exchange diagrams and ideas.

Sylights
www.sylights.com

▸ This software is browser based and also runs on iPad.
▸ You can use the product free of charge for blogs, webzines, and private websites. The Sylights team asks that you contact them if you want to use the product commercially. I was allowed to use Sylights for free in this book. For more information, please contact olivier.lance@sylights.com.
▸ I thoroughly recommend this product. Text boxes and other features are planned for the next version. There is a large community with many sample setups.

Many thanks to Olivier and the whole Sylights team for their kind support and the use of their fantastic product for this book.

Lighting Diagram
www.lightingdiagram.com

▸ This tool is browser based.
▸ The product is free for private use. There is a $2 charge per high-resolution diagram that is used for commercial purposes.
▸ It has great-looking symbols, is easy to use, and is not too expensive. The symbols cannot be scaled, although this functionality is in the product development pipeline.
▸ There is a relatively large community with plenty of sample setups.

GPL Lighting Symbols
www.fotopraxis.net

You can download this tool from the German Fotopraxis.net website by entering "lighting symbols" in the search box. (Note that though this is a German website, this is just to download a zipped Photoshop file that anyone who has Photoshop can use.)

▸ There is a symbol collection for use in Photoshop and Photoshop Elements layers.
▸ The product has a GPL license and is for personal use only. For commercial use, please contact kontakt@fotopraxis.net.
▸ This is my own collection of symbols, which is in continual development. The big advantage of the Photoshop-based approach is that it's really easy to mix the symbols with other objects.

Kevin Kertz's Diagram Set
www.kevinkertz.com

▸ These diagrams are designed for use in Photoshop layer stacks.

▸ The symbols are for personal use only.

▸ Kevin Kertz explicitly denies users the right to publish his symbols (in books, magazines, etc.) and there is no commercial license.

Lighting Diagram Creator
www.lightingdiagrams.com

▸ This product is browser based.

▸ The cost is $10 per commercial project; private use is free. A high-resolution PSD file that contains the complete set of symbols is available for $150.

▸ The software works in conjunction with Strobox (strobox.com). There are plenty of symbols, but it has a fairly rudimentary look.

The following three websites offer lighting diagrams and symbols that are useful but not as powerful as those already listed:

▸ Photo Diagrams: www.professionalsnapshots.com/PhotoDiagram

▸ Photo Studio Buddy (for Android): http://de.androidzoom.com/android_developer/pixvision-software_hfud.html

Appendix C
Additional Sources

Websites

▸ **David Hobby:** Blog, workshops, and the fantastic Strobist 101 and Strobist 102 tutorials:
 http://strobist.blogspot.com
 http://strobist.blogspot.de/2006/03/lighting-101.html
 http://strobist.blogspot.de/2007/06/lighting-102-introduction.html

▸ **Databases:** Comprehensive lens test databases with information about resolution, vignetting, optimum apertures, and so forth:
 http://www.slrgear.com
 http://www.the-digital-picture.com/Reviews

▸ **Neil van Niekerk:** Blog and videos with many interesting workshops, tips, and tests:
 http://neilvn.com/tangents
 http://vimeo.com/neilvn/videos

▸ **Flickr groups:**
 Strobist: http://www.flickr.com/groups/strobist
 One Strobe Pony: http://www.flickr.com/groups/one_strobe_pony
 How Do You Light: http://www.flickr.com/groups/howdoyoustrobist
 Dustin Diaz: http://www.flickr.com/photos/polvero/sets

▸ **Tilo Gockel**
 Blog and Workshops (for those who read German): www.fotopraxis.net

▸ **Alex Kolowskov:** Blog, workshops, and product tests: www.photigy.com

▸ **Ryan Brenizer:** Blog, workshops, and product tests: www.ryanbrenizer.com

Books

▸ *Light It, Shoot It, Retouch It* by Scott Kelby (New Riders 2012)
▸ *The Hot Shoe Diaries* by Joe McNally (New Riders 2009)
▸ *OneLight Field Guide* by Zack Arias (Mag Cloud; 2010; www.magcloud.com/browse/Issue/131277)
▸ *Captured by the Light* by David Ziser (Peachpit Press 2010)
▸ *On-Camera Flash Techniques for Digital Wedding and Portrait Photography* by Neil van Niekerk (Amherst Media 2009)
▸ *Off-Camera Flash: Techniques for Digital Photographers* by Neil van Niekerk (Amherst Media 2011)
▸ *Professional Portrait Retouching Techniques for Photographers Using Photoshop* by Scott Kelby (New Riders 2011)
▸ *The Nikon Creative Lighting System, 2nd Edition* by Mike Hagen (Rocky Nook 2012)
▸ *Mastering Canon EOS Flash Photography* by NK Guy (Rocky Nook 2010)

DVDs

▸ **David Hobby**
 Lighting in Layers (http://strobist.blogspot.de/2011/01/introducing-strobist-lighting-in-layers.html)

▸ **Zack Arias**
 OneLight Workshop (http://zackarias.com/workshop/onelight-dvd)

Appendix D
Glossary

5-in-1 or 7-in-1 reflector: A collapsible reflector, usually circular, with two sides and interchangeable coverings (silver, gold, white, black, zebra stripe, etc.).

AF: Autofocus

ambient light: The available light that illuminates a scene.

American night: Lighting technique used in movies that involves underexposure to make daytime look like night. Named after *La nuit américaine*, a film by François Truffaut that first popularized the effect (this technique is also known as day for night).

Aperture: The opening in a camera lens through which light enters the camera.

Aperture priority: Auto exposure mode in which the photographer sets the aperture and the camera automatically selects the appropriate exposure time. Called Av mode on Canon cameras and A mode on Nikon cameras.

APS: Advanced Photo System. A film and sensor format. Nikon uses the similar DX format. See also DX; APS-C.

APS-C: Advanced Photo System Classic. A film and sensor format that is 22.5 x 15.0 mm, used in mid-range Canon DSLRs. See also APS; DSLR.

Auto FP mode: Abbreviation for Automatic Focal Plane Sync Mode, Nikon's name for high-speed sync. See also high-speed sync.

automatic white balance: White balance setting that is automatically selected by the camera.

AWB: See automatic white balance.

bare-bulb flash: A flash fitted with a completely uncovered flash tube (for details: Internet search "bare bulb flash hack").

bare flash: A flash used with no additional light modifiers.

barn doors: Large metal light modifiers, usually with four adjustable leaves, that alter the horizontal or vertical modulation of flash light.

beauty dish: Light modifier that consists of a parabolic shade with a built-in reflector that blocks the direct transmission of light. Used to produce soft, high-contrast lighting effects with strong core shadows and soft main shadows.

BFT: See black foamie thing.

bidirectional lighting: Portrait lighting technique also known as double-kicker or pincer light. The setup includes two symmetrically placed lights on either side of the subject to accentuate the cheekbones and temples.

black foamie thing: A small shade, or flag, mounted on a flash to prevent light from directly illuminating the subject. Invented by Neil van Niekerk.

blinkies: Blinking overexposure warning lights on a digital camera monitor display.

bokeh: English spelling of the Japanese word that means blurry or fuzzy. Used to describe the blur effects (and their aesthetic qualities) that occur, for example, around out-of-focus points of light in photographic images.

boom stick: Slang for a handheld monopod.

bounce flash: Flash reflected off a surface to improve the diffuseness and angle of the light. Also known as indirect flash.

bracket: See flash bracket.

broad lighting: Portrait lighting technique that lights only the side of the subject's face that is facing the camera. See also short lighting.

brolly: See umbrella.

brolly box: Combination silver-coated reflector/diffuser umbrella that functions like a circular softbox.

catch light: A light source that causes a specular highlight in the subject's eye.

clamshell lighting: Portrait lighting technique that uses two softboxes positioned close to the subject's face to light it from above and below.

click: An increment of a setting (usually 1/3 EV) that can be made with a camera control dial or button. A click can pertain to exposure time, aperture, ISO value, flash output, and so forth. See also exposure value.

CLS: Creative Lighting System. Brand name for the Nikon TTL flash system.

cold shoe: Mount for system flash without electrical contacts (unlike a hot shoe). See also system flash; hot shoe.

color clash: Colors that seems to collide rather than harmonize.

critical aperture: The aperture that provides the best compromise between optical aberrations and diffraction blur. This is an absolute value at which a single plane is in sharp focus. It often lies 2 or 3 stops below the maximum aperture. The values for a range of popular lenses can be found online at SLRgear (www.slrgear.com).

crop sensor: Sensor format that is approximately half the size of a full-frame sensor. Usually APS-C (Canon) or DX format (Nikon). See also APS-C; DX.

cross light: Lighting style with two lights that cross at the subject, such as one from the front right and one from the back left. The second (minor) light often acts as a rim light or kicker. See also rim light; kicker.

CTB: Color temperature blue

CTO: Color temperature orange

CTS: Color temperature straw

custom white balance: Manually defined white balance value.

CWB: See custom white balance.

dark field lighting: Lighting that grazes the subject at a very shallow angle to accentuate embossing, scratches, etched patterns, and so forth.

day for night: See American night.

dragging the shutter: Flash technique that artificially increases the exposure time to include more ambient light in the image.

DSLR: Digital single-lens reflex (SLR) camera. See also SLR.

DX: Nikon proprietary term for its 24mm x 16mm sensor format (almost identical in size to the Canon APS-C format).

EC: See exposure compensation.

E-TTL: See TTL.

EV: Exposure value.

EXIF: Exchangeable image file format. Data format for saving additional information (date, camera type, aperture, copyright, etc.) in digital image files.

exposure compensation: User-defined value to fine-tune automatically selected exposure parameters.

exposure value: Exposure value (EV) is a unit that describes the amount of light required to make a photographic exposure. An EV is defined by a combination of exposure parameters, all of which produce the same overall exposure (see appendix A).

FE Lock: Flash Exposure Lock. Canon proprietary term for spot flash meter reading saved to the camera's memory to allow the photographer to recompose a shot while retaining the same flash exposure parameters.

FEC: See flash exposure compensation.

flag: Light modifying accessory used to prevent light from illuminating a subject directly.

flare: Lens flare, which is mostly an unwanted artifact caused by backlit aperture blades.

flash bracket: General term for any kind of bracket used to mount, swivel, aim, or otherwise direct single or multiple flashes.

flash exposure compensation: User-defined value that alters automatically selected flash exposure parameters.

flash gun: See system flash.

foam core fork: Lighting accessory for holding Styrofoam boards. Mounts on standard light stands or a tripod.

Focal Plane Sync: Canon term for high-speed sync. See also high-speed sync.

focus and recompose: Focusing technique that involves locking the focus and then reframing to shoot.

focus stacking: Macro photography technique that merges multiple images shot with different focus settings to form a single image with an enhanced depth of field. Dedicated focus stacking programs include Helicon Focus and CombineZM. Focus stacking can also be performed with Photoshop tools.

focusing rail: Adjustable camera mount that is used for focus stacking. It enables the user to move the whole camera back and forth to change the focus, without changing the image ratio.

FV Lock: Flash Value Lock. Nikon equivalent of Canon Flash Exposure Lock. See also FE Lock.

FX: Nikon proprietary term for its full-frame (24mm x 36mm) image sensors.

gaffer tape: Universally useful black or gray strong, cloth tape. Originally from the theater and event sectors.

gang light: Relatively new term in the strobist scene. Describes the use of multiple system flashes combined to form a single powerful light source. Often combined with high-speed sync (HSS) mode and thus is technically more refined than conventional studio flash. See also high-speed sync.

gel: Color filter that was originally made of gelatin (hence the name) and is now made of plastic. Often used in the colors CTO, CTB, and CTS. Examples of usage: full CTO gel is full-strength orange filter; 1/2 CTB is half-strength blue filter. See also CTO; CTB; CTS.

GN: See guide number.

gobo: Comes from go between or graphical optical black out, depending on which source you believe. Made of metal or etched glass and used to project patterns onto surfaces via a gobo projector (like a slide projector but more powerful). Used to produce studio backgrounds and for advertising photography.

gray filter: See neutral density filter.

grid: Also known as honeycomb grid. Accessory used to concentrate the light from a flash or lamp.

guide number: The maximum distance at which a flash can illuminate a subject at given ISO and aperture settings. This range is equal to the product of the flash-to-subject distance and the aperture required to expose the subject correctly at that distance.

hair light: Portrait light from above and behind that is used to give the subject's hair additional luster.

high key: See key.

high-speed sync: Flash mode for system flash that allows photographers to use flash at exposure times shorter than the camera's designated flash sync speed. High-speed sync (HSS) flash consists of a pulsed sequence of very short flashes that give the impression of continuous light. The major disadvantage is a significant reduction in maximum flash output. See also system flash.

hot shoe: Mechanical mount for system flash with electrical contacts. A non-TTL hot shoe has two contacts (for firing the flash), whereas a TTL hot shoe has five or more contacts for transmitting data between the camera and the flash. See also system flash; cold shoe.

HSS: See high-speed sync.

inverse square law: The intensity of light emanating from a point diminishes proportionally to

the square of the distance between the source and the object it illuminates. Halving the distance to the subject quadruples the intensity of the light that illuminates it.

IR: Infrared

i-TTL: See TTL.

joule (J): See watt-second.

key: The basic mood of the light in an image. Most of the tones in a low-key image come from the dark end of the tonal scale, whereas most of the tones in a high-key image come from the light end.

key shifting: Technique used to artificially shift the key of an image. See also key.

key light: Lamp that determines the key of an image. Synonymous with main light. See also key.

kicker: An accessory portrait light used either to accentuate cheekbones or as a general effect or accent light, such as a rim light or a hair light. See also rim light; hair light.

LED: Light emitting diode

live view: Camera mode that displays a continuous real-time view of the scene on the camera monitor.

loop lighting: Similar to Rembrandt lighting, but set at a shallower angle (approximately 30 degrees), thus producing softer

shadows. See also Rembrandt lighting.

low key: See key.

macro rig: General term for accessories that assist macro photography. Consists of any or all of the following components: camera, extension tubes, flash bracket, one or more flash units, and focus rail. See also flash bracket.

master flash: Flash unit that transmits firing signals or flash exposure parameters to slave flash units. See also slave.

meter and recompose: Photographic technique that involves saving an exposure meter reading for a scene in the camera's memory prior to reframing the subject and shooting. Often used with spot metering.

modeling flash: See modeling light (here, a fast burst of flash impulses simulate a continuous light).

modeling light: Additional continuous light built into studio flash units. Used to simulate the effect of flash to help the photographer judge the effects a lighting setup will produce [or in the case of flash exposures; Flash Exposure Lock (Canon) or FV Lock (Nikon)].

mood shot: A photo that conveys a message by evoking emotions rather than by providing information.

ND filter: See neutral density filter.

neutral density filter: Filter used to extend the maximum potential exposure time—for example, to blur the movement of water captured in daylight or to make flash exposures at wide apertures.

octabox: Eight-sided softbox.

on location: Urban or rural photographic environment (i.e., outside of the studio).

optical cell: Sensor element in an optical servo flash trigger or remotely controllable flash unit. See also servo flash trigger.

optical slave: Optical servo flash trigger. See also servo flash trigger.

optimum aperture: The aperture that provides the best compromise between depth of field and diffraction blur.

overexposure warning: Blinking warning displayed on the camera monitor for potentially overexposed image areas.

PAR reflector: Parabolic reflector. See also parabolic reflector.

parabolic reflector: Light modifier with a parabolic cross section.

PC socket: Prontor-Compur flash connector socket as defined by the ISO 519 standard.

pilot button: Button built into most system flashes that illuminates when the flash is fully charged. It can be pressed to manually fire a test flash at the current settings.

PocketWizard: Radio flash trigger brand name. Some models are compatible with TTL and high-speed sync. See also TTL; high-speed sync.

popup flash: Low-power flash unit that is built into many digital cameras and pops up when needed.

Porty: Brand name of battery-powered portable studio flash units made by Hensel (Germany). Often used as a generic term to describe similar units from other manufacturers.

Porty look: A specific look associated with photos shot on location using a Porty system, which often includes a dark, underexposed sky. The effect can be created only with system flash in weak ambient light, because of the system's relatively low output. See also Porty.

preflash off: Setting for a servo flash trigger that suppresses the TTL preflash. See also servo flash trigger; TTL.

pseudo-HSS: Also known as Super-Sync, hypersync, ODS (overdrive sync), or early sync. A technique that uses the entire duration of a flash to circumvent the limitations of slow X-sync synchronization speeds (see workshop 4). See also X-sync.

red eye reduction: Technology that uses a short preflash to widen a subject's pupils and thus prevent red eyes in the image.

Rembrandt lighting: Classic portrait lighting setup usually positioned at 45 degrees (horizontally and vertically) to the subject. Produces a relatively prominent nose shadow and a triangular highlight beneath the subject's eye.

remote: See slave.

retro adapter: Also known as reversing ring. Accessory that allows a lens to be mounted in a reverse position to facilitate extreme enlargement. Available in passive and active versions. Active adapters (the Novoflex EOS-RETRO, for example) transmit aperture data to and from the camera.

reverse mount: See retro adapter.

reversing ring: See retro adapter.

RF: Radio frequency

RF trigger: Radio control module used to fire flash remotely. The transmitter unit is mounted on the camera, and the receiver is mounted on the flash.

rig: See macro rig.

rim light: Light used in portrait situations to accentuate the outline of the subject and differentiate the subject from the background.

Scheimpflug principle: A geometric rule that describes the orientation of the plane of focus in an optical system when the lens plane is not parallel to the image plane. The application of the principle allows the construction of lenses that can be tilted. They are used to deliberately alter the location of the plane of focus in an image.

second-curtain sync: The point in the shutter timing, at which the second curtain is only just open and still allows time for the flash to be fired. This flash technique produces more believable results for moving subjects.

servo flash trigger: Small accessory module that receives optical firing signals transmitted by system and studio flash units. Often built into the flash unit, but also available separately.

servo, optical: See servo flash trigger.

short lighting: Portrait lighting technique that illuminates the side of the subject's face that is facing away from the camera. See also broad lighting.

skylight filter: Weak, slightly red filter often used in landscape photography and to protect the front element of the lens.

slave: Remote receiver or remotely triggered flash.

SLR: Single-lens reflex camera

snoot: Tube-shaped light shaping tool that concentrates the light emitted by a flash.

Speedlight: Nikon registered trademark used to describe its system flash units. See also system flash.

Speedlite: Canon registered trademark used to describe its system flash units. See also system flash.

spigot: Standard brass adapter bolt for various light stands and adapters.

spotlight: Concentrated circular main or accent light.

strip light: Long, slim softbox.

strobe mode: Also known as stroboscopic mode. Flash mode that emits a sequence of extremely short flashes, producing an effect similar to that in many discotheques.

strobist: Term coined and registered by David Hobby. Describes users of off-camera system flash.

Sunbouncer: Brand name for large, square reflectors manufactured by California Sunbounce.

SuperSync: See pseudo-HSS

sync socket: See PC socket.

sync speed: The shortest exposure time in which a camera's focal plane shutter is completely open and can be used to capture flash light. At shorter exposure times, the shutter curtains chase each other across the frame and expose only a moving strip of light across the sensor, making flash exposures with standard techniques impossible.

system flash: Battery-powered accessory flash that is mounted on a camera's hot shoe. Smaller, lighter, and faster than studio flash, but not as powerful. Often includes built-in sensors and smart technology called TTL. See also hot shoe; TTL.

tethered shooting: Technology that connects a digital camera wirelessly or via cable to a computer, enabling real-time remote viewing of the image and the effects of adjustments to shooting parameters.

tilt/shift lens: A lens with an adjustable optical axis that is used to shift the plane of focus. See also Scheimpflug principle.

Trans-Lum: Flexible, semitransparent diffuser material that is available in sheets and rolls.

TTL: Through-the-lens metering. TTL flash metering uses a preflash to measure subject distance and brightness and uses the returned signal (received through the lens) to calculate optimum flash exposure parameters. Called E-TTL by Canon and i-TTL by Nikon.

umbrella: Light modifier built like a conventional umbrella, usually translucent (used as a diffuser) or reflective (used as a reflector).

UV filter: Ultraviolet filter

variable ND filter: Steplessly variable neutral density filter constructed of two polarizer filters that rotate. See also neutral density filter.

watt-second: SI unit of energy, same as joule.

Ws: See watt-second.

X-sync: Prescribed exposure time for use with xenon flash. See also sync speed.

zebras: Slang for overexposure warning. See also overexposure warning.

Index